The psychology of
art and the
evolution of the
conscious brain

The Psychology of Art and the Evolution of the
Conscious Brain

MIT Press/Bradford Books Series in Cognitive Psychology
Stephen E. Palmer, editor

A Dynamic Systems Approach to Development: Applications, edited by Linda B. Smith and Esther Thelen (1993)

A Dynamic Systems Approach to the Development of Cognition and Action, edited by Esther Thelen and Linda B. Smith (1994)

Cognition and the Visual Arts, by Robert L. Solso (1994)

Indirect Perception, edited by Irvin Rock (1996)

Perceiving Talking Faces: From Speech Perception to a Behavioral Principle, by Dominic W. Massaro (1997)

Inattentional Blindness, by Arien Mack and Irvin Rock (1998)

Fleeting Memories: Cognition of Brief Visual Stimuli, edited by Veronika Coltheart (1999)

The Psychology of Art and the Evolution of the Conscious Brain, by Robert L. Solso

The Psychology of Art and the Evolution of the Conscious Brain

Robert L. Solso

The MIT Press
Cambridge, Massachusetts
London, England

This book was set in Bembo by Graphic Composition, Inc.
Printed and bound in the United States of America.

Library of Congress Cataloging-in-Publication Data

Solso, Robert L., 1933–
 The psychology of art and the evolution of the conscious brain / Robert L. Solso.
 p. cm. — (MIT Press/Bradford Books series in cognitive psychology)
 Includes bibliographical references and index.
 ISBN 0-262-19484-8 (hc. : alk. paper)
 1. Consciousness. 2. Cognition. 3. Brain—Evolution. 4. Visual perception. 5. Art—Psychology.
 I. Title II. Series.

BF311.S652 2003
701'.15—dc21

 2003042131

This book is lovingly dedicated to two of the best friends any man could have:
Connie Juel and Ron Randolph-Wall

Contents

Series Foreword

This series presents definitive works on cognition viewed from a psychological perspective, including undergraduate and graduate textbooks, reference works, research monographs, and edited volumes. Among the wide variety of topics addressed are perception, attention, imagery, memory, learning, categorization, language, problem solving, thinking, and cognitive development. Although the primary emphasis is on presenting psychological theories and findings, most volumes in the series are interdisciplinary, attempting to develop important connections between cognitive psychology and the related fields of anthropology, computer science, education, linguistics, neuroscience, and philosophy.

Stephen E. Palmer

Preface

This book grew out of my lifelong interest in cognition and art. That interest found an outlet in the book *Cognition and the Visual Arts,* published in 1994 by the MIT Press, in which I wrote, "Art and cognition have always stood as two convex mirrors each reflecting and amplifying the other." That general observation still holds, but with the current work, I would augment it to read, "Art and cognition, and the brain, and consciousness, and evolution have all stood as complex mirrors, all reflecting and amplifying each other."

In the decade since the first book was published, we have reached a higher vantage point because of the extraordinary growth in studies of cognitive neuroscience and human consciousness. These studies are supplemented by new views in anthropology and art history. From this enhanced viewpoint, we may see farther and more clearly into the nature of the brain, and of art.

Some chapters of this book draw on sections of *Cognition and the Visual Arts,* but the focus here differs significantly from that book's. From its beginnings, I sought an answer to the question as to what type of conscious brain guided the hand that created the art that first appeared on earth many years ago.

Human consciousness has intrigued people almost as much as art, and yet few scientists have been audacious enough to explore the relationship between the two. In searching for a rational connection between consciousness and art, it was necessary to examine the evolution of the human brain and cognition. Out of these scientific explorations, I have developed a new model describing the evolution of consciousness and its relationship to the emergence of art.

Consciousness did not strike humankind like a thunderbolt, but developed gradually and unevenly over millennia. Theories of consciousness, evolution, brain development, and art have sometimes been based on overly simplified views. The present theory, which I call conscious AWAREness, differs from some previous theories in the respect that consciousness is conceptualized as having several

distinct components that evolved over a long period of time. Some components appeared millions of years ago and some continue to evolve today. Relatively recently, people developed a multifaceted kind of adaptive consciousness that included the ability to imagine nonpresent objects. Such imagery was exhibited in artistic expression. However, before such consciousness could evolve, it was necessary that the brain change.

Throughout this book, you will find data drawn from anthropology, neuroscience, nutrition, art history, and cognitive psychology. Recent developments in these areas have provided important conceptual and factual information from which a larger theory might be fabricated of how the brain produces art.

We have a pretty good idea, for example, as to when and how the human brain evolved and when early art emerged, and we have a sound understanding of the workings of the sensory-cognitive system. With this knowledge in hand, it is propitious to consider the evolution of the human brain and the emergence of AWAREness, as they might be related to art. As the brain increased in size and capacity during the upper Pleistocene, additional components of consciousness were added or developed. People became more AWARE in the sense that they were more cognizant, not only of a world that existed in contemporaneous actuality, but of a world that could be imaged. That change took humankind on a wondrous voyage. Men and women could imagine nonpresent things such as what might be behind a bush, where fresh water might be found, and what a nonpresent bull might look like. While other animals had some forms of consciousness, the visionary aptitude of humans to extend consciousness beyond responding to moment-to-moment sensory experiences was spinning into new possibilities previously unseen on this earth. Equipped with expanded conscious AWAREness, people first created art and then technology. The beginning of art is a clear manifestation of the brain's capacity for imaginative behavior.

My personal interest in cognitive neuroscience and art was further kindled when I studied a well-known British artist undergoing a brain scan as he drew a portrait. In the past, experiments of this type were unknown to scientists and art theorists. Exciting new discoveries, such as those provided by brain imaging technology, have greatly expanded our understanding of how the human sensory system and brain process information, such as in art, language, and technology.

Human information processing has traditionally been the domain of cognitive psychology, which, over the past half century, has given us a fresh view of sensation, perception, cognition, and thinking. Cognitive studies, along with recent neurocognitive and anthropological discoveries, have made it possible to develop a theory of consciousness based on the evolution of the brain. I propose that art pro-

duction demonstrated acts that could have been produced only by a brain capable of conscious thought.

Attempting to develop a comprehensive theory of consciousness, one that would incorporate the evolution of the brain, anthropological findings of early behavior, cognitive information about the sensory-perceptual processes, and the emergence of art as manifest in early carvings, amulets, and drawings, was like trying to keep four balls in the air at the same time. Yet the more I investigated each topic, the more convinced I became that all factors—brain, anthropology, cognition, and art—were tied together by human consciousness, or, as described in chapter 1, conscious AWAREness. There is, and continues to be, a remarkable co-evolution of the brain, consciousness, cultural developments, and art. I have tried to consolidate these matters in the following chapters.

While the theme of this book revolves around the evolution of the brain, the appearance of consciousness, and the emergence of art, there are several intriguing related themes. These include the special neurological and artistic consideration of the human face; how the curious effects of visual illusions may be related to survival needs and how artists have capitalized on the seemingly anomalous visual-cognitive effect of visual illusions; how perspective has been used by artists; and the nature of "hypothesis-driven" perception and art. The ideas in this book are illustrated by art chosen eclectically, not for "correctness" but because each piece exemplifies a concept vital to the story being told. East Asian, African, and Indian pieces are used, as well as art from ancient Egypt, the Renaissance, and modern periods.

The writing style is designed to be interesting while informative. Occasionally, I have incorporated a pun or humorous read in the middle of an otherwise cheerless topic; sometimes the prose turns slightly purple when my enthusiasm gets out of hand, and, at times, the language vacillates from the technical to the whimsical. Many ideas in the book are drawn from highly complicated sources. I have tried to make complex ideas understandable without making them simplistic. The terms man, mankind, him, his, and the like are used generically.

Many traditional ideas of perception, consciousness, art, and even "reality" are challenged in the following pages. Some ideas may provoke, others amuse, and others (hopefully) enlighten. I hope that at least part of the answer to the question raised earlier, about the type of brain that initially created art, may be found here. My fondest wish, however, is that you might see farther and more clearly about art and science after reading this book.

A book of this sort draws on the previous dedicated work of artists, scientists, anthropologists, psychologists, and historians. I owe to them a debt of thanks. In

addition, many colleagues, friends, and even relatives have read sections of this book and offered suggestions. It is difficult for me to express adequately my thanks for their attention to detail, their encouragement, and their sound advice. Each made significant contributions to this book. I thank the following: Gordon Alston, Mike Crognale, Charles Greene, Amy Ione, John Maloney, Samantha Mathias, Anne Solso, John Solso, Gabriel St. Clair, Christopher Tyler, and Mike Webster. Paul Horn redrew many of my sketches, and his skill is acknowledged with thanks. During the final editing of the book I fell ill and asked Barbara Tversky of Stanford University to read the entire manuscript and make corrections. She did so with dedication and deserves special thanks and appreciation. Also, Matthew Abbate took on additional editorial duties during this time, and his personal attention to this book is gratefully acknowledged.

Robert L. Solso

The Psychology of Art and the Evolution of the
Conscious Brain

Introduction: Art . . . a Tutorial

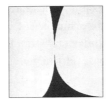

A work of art is above all an adventure of the mind.

—*Eugène Ionesco*

There are as many ways of looking at art as there are viewers of art. That huge diversity is one indication that we humans are a highly distinctive lot of creative people. It does not mean, however, that there are no universal principles of perception and cognition that apply to all of us as we view and appreciate art. This tutorial on art is presented in the spirit of trying to find general principles of how the eye and brain perceive and interpret art.

When we look at art, a fascinating sequence of neurological, perceptual, and cognitive phenomena emerges through which the art piece is seen and understood in less time than it takes to read these words. Neuroscientists have unraveled many of the strands of the neurological pathways and interactions involved in the visual sensation, and cognitive psychologists have discovered some basic laws of perception. As science helps us understand our experience of art, so too does art give us a view of the mind that comprehends it.

Lest we become overwhelmed by the study of neurology, synapses, blood flow, and the evolution of the conscious brain, it is essential that we not forget that art, of all types, is one of life's most noble expressions. It can lighten the heart, celebrate the familiar, stimulate deep thoughts, as well as arouse all types of emotions. Art for art's sake is sufficient motivation for us to seek it out, enjoy it, and understand it. From the scientific studies discussed in this book, however, some applied ideas have also emerged.

In this tutorial I have selected three different types of art as examples of the way we look at and interpret it. The first example is a realistic painting by the French artist Théodore Géricault done at the beginning of the nineteenth century;

the second a cubist abstract painting done by Marcel Duchamp in the earlier part of the twentieth century; and the third an example of minimal art by Ellsworth Kelly in the middle of the twentieth century. Each example illustrates specific types of psychological principles, but they all depict basic principles of vision, perception, and the way the human brain processes and understands art. By considering these three different examples it may be possible to develop a general schema that will be applicable to all viewing of art.

Nativistic Perception and Directed Perception

Over the years that I have taught a course called "Cognition and the Visual Arts" I have found two aspects of viewing art that were most instructive. The first, _nativistic perception_ (also known as "bottom-up" processing to cognitive scientists because it begins with basic physical stimuli), deals with the way the eye and brain work in matched synchrony. Each transforms electromagnetic energy into neurochemical codes. As pedantic as that phrase might seem, technically speaking it is exactly what happens. Nativistic perception of visual events is based on the fact that people have certain inborn ways of seeing in which visual stimuli, including art, are initially organized and perceived. Causally speaking, nativistic perception is "hardwired" in the sensory-cognitive system.

Look at the painting in figure I.1. What you sense—what you "see"—is activated only by reflected photonic energy that bounces off this painting and is detected by sensory neurons in the retina. Yet this initial native stage of visual perception sets off an intricate series of neurological and psychological actions that are, in my opinion, the most fascinating chain of events known to man. This first stage of the perception of art is largely independent of conscious control, and we are, in effect, enslaved by photons and physiology. Here, we all "see" essentially the same thing. The shapes, colors, patterns, and organization of forms are sensed and processed by your eye and brain in the same way as they are processed by everyone else's. It's simply a matter of nativistic perception, as determined by our common genetic makeup, and physical chemistry as governed by the laws of the physical world. To me, it is somewhere between surprising and astonishing that so few art scholars have taken heed of this fundamentally important aspect of "seeing."

There are a plethora of exciting things going on in stage one of perception, but the really personal part happens in the second stage, the stage we call _directed perception_. Sometimes called "top-down" processing by cognitive scientists because it is directed by an overall idea as to what one might see, directed perception refers to perception based on one's personal history and knowledge. The way you "see"

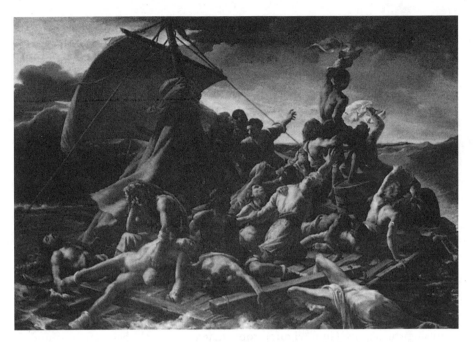

I.1 Théodore Géricault, *The Raft of the Medusa* (1819). Musée du Louvre, Paris.

this painting is like the way no other person sees it. We focus (or direct our perception) on parts of a painting that are interesting, worthwhile, or about which we have past knowledge. You, for example, may ponder the meaning of the piece because of your personal curiosity. Another person may be interested in the types of paint used, while another may attend to the naked bodies. One's past knowledge and interest direct one's attention. Each of us brings to the viewing of art an entire set of past experiences and expectations that largely influences what we perceive and how we interpret what we see.

Both nativistic perception and directed perception contribute to, and are necessary for, art appreciation, and to some degree their characteristics overlap. Both forms of perception also depend on a conscious brain in order for art to be "seen," in the nativistic sense, and "understood," in the directed sense. As we shall see, both forms of perception are the consequences of a sensory system and brain that evolved over hundreds of thousands of years for quite different purposes: distinguishing objects from their background, discerning colors, finding and killing game, picking yummy berries and nuts, and seeing faces, all of which revolve around mating and bearing children and surviving long enough to do it.

Nativistic Perception Applied to the *Raft*

Return to *The Raft of the Medusa*. Here we see a realist depiction of a raft filled with people in trouble. What you see is what you get in this picture painted with near photographic realism. Which perceptual fundamentals (nativistic) are operating? Initially, at least four types of visual elements are perceived (although there is overlap with some learned perception): sensation, form, color, and Gestalt organization.

SENSATION

The first condition of perception is that the perceived object must emit sufficient physical energy to be above the sensory threshold (or superliminal) to be detected. We cannot see the *Raft* in a totally dark room. The primary sense organ in perceiving visual art is the eye, but, somewhat surprisingly, other modalities are also engaged. With our eye we "see" the raft, the people, the sail, the ocean, and so on. With our brain we also "see" these things, and more. The part of the brain that processes visual signals, the primary visual cortex (PVC), is teeming with neurological activity (an intriguing topic that we are only beginning to understand). Perhaps even more fascinating is that other senses are engaged at the cortical level.

While we do not "hear" the wind as it flaps the sail, or the waves as they splash around the raft, or even the cries for help as acoustic stimuli, we do certainly "hear" these things in our mind. The formal name for such a phenomenon is *synesthesia*, which is defined as a condition in which sensory information from one mode (such as a visual sensation) psychologically activates another modality (such as an auditory sensation). As we look at the *Raft*, sight is primary but all other senses are psychologically active. We not only "hear" sounds but can also smell the sea and the putrefaction of decaying bodies, taste the salt air, and feel the cool sea water as it sprays over the raft. These primary visual sensations provoke psychological reactions, including emotional reactions, that reflect dynamic tension and harmony inherent in the painting. When we "see" this painting, as is true of many of life's experiences, the sensation is not confined to a single perceptual system but sweeps across many sensory modalities and psychological reactions to enrich the cognitive landscape. We all see deeper, and therein lies a great intellectual distinction of human thought and consciousness.

FORM

Our eye and brain intuitively see the raft and the people on it as being distinct from the background of the painting. Such division is called figure-ground perception, as the principal figure is separated from the background. This natural tendency is based on a crucial way in which the human eye is designed to see the contours or lines that separate one object from another. Being able to separate a branch from the sky or a sabre-toothed tiger from a bush was important in the evolutionary history of humankind, and that ability serves us well as we look at art.

COLOR

The human visual system is acutely calibrated to see a multitude of different colors. The colors in the painting by Géricault are muted browns that give the image an overall somber, even dramatic, feeling. Color perception is an important quality that also helps with figure-ground distinction.

GESTALT ORGANIZATION

According to Gestalt psychologists, we naturally organize a visual scene into stable patterns of perception. Our "mind's eye" seeks patterns in the world that are visually familiar and organized. In the case of the *Raft,* Théodore Géricault used triangles as a structure to direct the viewer's perception. In figure I.2 we have drawn two triangles that follow the natural Gestalt organizational schema suggested. To emphasize these basic forms, Géricault defined the left triangle by two ropes attached to the mast. The apex of the right triangle is made explicit by the central figure atop the pile of humanity on the right side of the painting. This natural organizational pattern is not necessarily "conscious" in the sense that you would say to yourself, "I see, this is a painting that is organized around two triangles, which gives it compositional symmetry and stability," but it evokes understanding of the deeper meaning of the painting, a theme we will discuss next.

Directed Perception Applied to the *Raft*

All viewers have extensive world knowledge that they apply when viewing an event. This background contributes to their deeper understanding of art; but while many viewers bring some knowledge of the sea and a few of the terrible

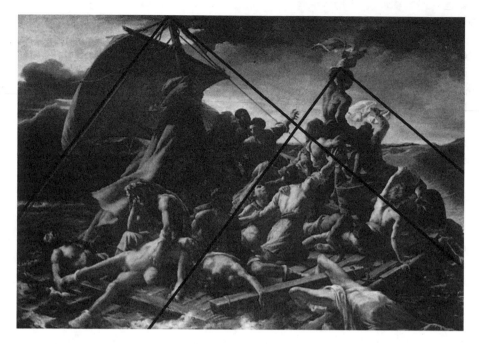

I.2 Théodore Géricault, *The Raft of the Medusa:* **the triangles show how one might visually organize the scene; this has psychological implications.**

conditions that may have been suffered by the poor people on this ill-fated vessel, very few bring specific knowledge of the historical context of the event depicted here.

FRENCH ROMANTICISM

The artist, Théodore Géricault, lived from 1791 until 1824 when his young life was cut short by a fall from a horse. He is considered a central figure in the art of the French romantic movement—a style that emphasized depicting emotions in realistic renderings. In many works of this period we find paintings that dramatize and personalize social actions. Géricault was so dedicated to realism that he visited the Paris morgue to sketch and paint corpses and heads of guillotined victims in order to accurately represent

A work of art is part of the universe as seen through a temperament.

—Emile Zola

dead bodies. He reconstructed a raft in his studio on which to pose his models for increased realism.

SOCIAL CONSCIENCE

Géricault also championed the oppressed, and his *Medusa* was based on a terrible real event that occurred in 1816. The French government was responsible for launching the *Medusa,* an unsafe ship, and it wrecked off the coast of Africa. While the ship's captain and crew escaped in lifeboats, the hapless passengers scrambled to make a raft from salvaged planks. The survivors on the raft experienced horrible suffering that included death and cannibalism. Géricault captures a particularly poignant moment when the survivors sight a passing ship and wave futilely to catch the attention of those on board. The powerful statement made in this painting was directed toward an uncaring government, which eventually prosecuted those responsible for this dastardly act.

ORGANIZATION OF SENTIMENTS

Returning to the two triangles that define the Gestalt organization of this piece, note that, under the right triangle whose apex is the African man with the fabric banderole, those still living are filled with hope and anticipation that the passing ship will rescue them. Under the triangle on the left, defined by the support lines, all hope has been drained away. Here are corpses and dying people filled with despair. Not only has the painter produced a realistic image of a scene laden with human pathos, but, equally important, he has symbolized two fundamental qualities of the human spirit: one of hope, the other of despair. We "feel" the psychological tension between life forces and death forces delineated for us by the organizational triangles.

PERSONAL SCHEMAS AND FEELINGS

Each of us views art (and all of life's experiences) through a personal prism or personal *schema,* by which we mean a dominant personality trait that interprets experiences. Thus, you may have a personal schema that "looks for" compassion and understanding, while another may look for justice and revenge, and still another may look for courage. This painting tells a story to each of us, yet your story may differ from mine. Each of us has a point of view that is part of our individual history

and temperament. Personal schemas color our view of reality. And here, as you view the *Raft,* your interpretation of reality is greatly influenced by your personal schema.

Finally, when all of the above physical and psychological features converge, we comprehend art at a level that is difficult to describe in words. At this level our appreciation of art becomes more of a sentience than an intellectual explanation; more of an engrossment than an analysis of a piece; more of a feeling than an appraisal. It becomes an experience that seems to transcend ordinary experiences. We call this "Level 3" comprehension. (See chapter 8 for further discussion of this.)

With this additional contextual information, the way you now view *The Raft of the Medusa* may be enhanced. The new information gives deeper insight into the painting and the human psyche. The *Raft* is a slightly romanticized but nonetheless realistic image of an actual scene with strong visual and symbolic organization. Most art is less formally structured, physically and psychologically. Let's consider one of these examples.

Nude Descending a Staircase No. 2

In figure I.3 you will see *Nude Descending a Staircase No. 2* by Marcel Duchamp, done in 1912. This painting differs from *The Raft of the Medusa* as it does not have clearly identifiable people and things.

As suggested, the viewing of art depends on two types of perception: nativistic perception and directed perception. First, consider Duchamp's *Nude* in terms of nativistic perception.

NATIVISTIC PERCEPTION

The same four components mentioned above, sensation, form, color, and Gestalt organization, also operate in this painting, but with much different emphases. Here we will concentrate only on the sensation and organizational aspects of the piece.

In order to be seen, the painting is above the sensory threshold and sets off a myriad of cortical actions initially centered in the primary visual cortex. We also get the impression that the piece has other sensory qualities, but in this case they are not so much connected to our sensory system, as with the *Raft,* but to our sense of movement. The nude, descending the staircase, seems to be in motion. We sense some structural tension. The overall diagonal organization of the painting creates a sense of unresolved psychological strain. Our natural reaction to scenes with structural tension suggests a type of ongoing dynamic process such as we might experi-

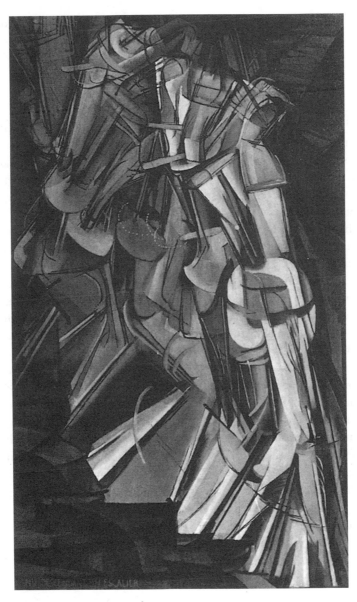

I.3 Marcel Duchamp, *Nude Descending a Staircase No. 2* (1912). Philadelphia Museum of Art. The artist commented that he gave up the naturalistic appearance of the nude while retaining the abstract lines of some 20 different positions associated with a descending movement. While it is possible to see some representational aspects in this abstract painting, it calls on the viewer to interpret the meaning.

ence while looking at a person descending a staircase. One might even go so far as to speculate that diagonal forms cause people to react with a primitive fear—the fear of falling—which increases the feeling of uneasiness.

DIRECTED PERCEPTION

As with all other forms of nonrepresentational art, this piece by Duchamp relies on the viewer's past knowledge to direct his or her perception and form an understanding of what the painting is all about. Because understanding is based on knowledge, this kind of art is sometimes called "cerebral art," or more pejoratively "high-brow art." Whatever you choose to call it, it requires a little background to process this piece from the top down.

In the decades before Duchamp was rendering his work in Paris, the world became engrossed with new marvels of emerging technology including motion pictures and multiple-exposure photographs taken by the English-American photographer Eadweard Muybridge. Muybridge's photographs made it possible to study the position of body parts while a person was in motion. Motion became an important theme for a number of avant-garde artists who were labeled the futurists.

The young Duchamp settled in Paris in 1904, where Pablo Picasso and Georges Braque were changing the way art was practiced. Duchamp came under the influence of abstract art, which interpreted the human body and other objects in terms of geometric forms; cubism was one version of this approach. Duchamp combined the technical insights of multiple-exposure photography with cubism to produce his best-known work, *Nude Descending a Staircase No. 2*. The figures in this painting are reduced to a type of geometric machine. However, Duchamp has ingeniously preserved the essential aspects of a figure: the legs, the unmistakably feminine hips, the torso, and so on. The piece is intellectual, with only a hint of emotionality, which requires the viewer to supply much of the meaning from his or her own background and knowledge. With even this brief discussion of the painting's context, I hope that you can now see things not seen before. Knowledge is the best canvas for visual perception.

Rebound

For the last art piece in this tutorial I have selected a very abstract painting by Ellsworth Kelly called *Rebound*, shown in figure I.4. The only colors in the painting are white and black, there are no human figures, and no social theme is detectable. Still, it is possible to analyze this piece along the dimensions mentioned above.

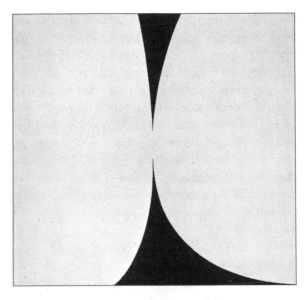

I.4 Ellsworth Kelly, *Rebound* (1959). Courtesy Matthew Marks Gallery, New York. Minimal art in which our eye clearly separates the piece into two (or more) distinctive features. What do you see in this piece?

NATURALISTIC PERCEPTION

Two things strike me about this painting. The first is its simplicity. The minimal composition is made up of simple black and white shapes. Second, there is no immediately recognizable object. On the basis of the painting's austerity one might conclude that there is not much of interest in this work. On closer examination (and with a little tutoring) there are a number of fascinating physical and psychological characteristics of great interest.

The black figure is clearly separated from the white background and stands out. It is possible, however, to switch the figure-ground relationship and think of the white forms as the figure and the black as the background. If you look at the painting from this perspective, you see two great curved white objects against a black background that barely touch in the center of the painting. Our need for Gestalt closure might lead us to want to pull the two black pieces together so they meet and create separate white forms. Or one could imagine that the two black objects were once joined and are being pulled apart and, if the pulling continues, will disappear from the scene, leaving a stark white field.

On another level, the mere shapes cause some viewers to react with pleasure. There is something intrinsically beautiful about these simple forms that we cannot put into words but that exudes a type of tranquillity. One explanation for this may be that universal codes lurk deep in our neurological architecture. These codes, which some theorists have attempted to describe mathematically, reflect qualities in the perceived world and inform us of the cerebral congruity of "internal events" and "external events." Some external events, such as a fragrant odor, a melodious song, a delicious taste, or a pleasing shape, seem to strike just the right internal chords. We enjoy these things and call them "beautiful." We pursue these external things because they ring our internal bell. (And we avoid those things that do not.) These neural mechanisms are constantly being called upon to evaluate sensory events, such as art and music, from which we make judgments of beauty, aestheticism, pleasure, and the like.

In *Rebound,* two great curves describe a parabolic orbit which may approximate an archetypal internal geometric form. According to this notion, the internal form is the quintessential form upon which all approximations are measured. This grand idea suggests that ultimate standards of beauty are to be found in understanding our fundamental internal structures. When you reconsider *Rebound,* you might apply these more ethereal standards. Does the piece "touch" you at some profound level of sublime aestheticism? Did Kelly find the formula? These are important questions raised by minimal art.

Directed Perception

Minimal abstract art, more than any other type of art, is what we make of it. At least, that is the conventional wisdom. Let's consider the way one might interpret this minimal art through a religious schema. The two white curved objects may be searching for a connection or continuity. In Michelangelo's great fresco painted on the ceiling of the Sistine chapel in the Vatican in Rome, at the most auspicious moment in creation God extends his finger to the lifeless Adam giving him life. Can you see that in *Rebound?* It is a bit of a stretch for my imagination, but if that's your thing, so be it. A more earthy interpretation is that it is a man's chest touching a woman's bosom on the right. What do you see?

Much of modern art is what we make of it and, bluntly speaking, some conjecture about the meaning of abstract art could be better used to fertilize plants than enlighten minds. I can just as easily see the silhouettes of the backsides of two people sitting on a bench each contemplating the meaning of minimal art. Or one could suppose that the left figure represents Eastern philosophy and the other one Western philosophy. A characteristic of abstract art is that it is an arty Rorschach

test in which everyone can give his or her personal interpretation of an object, even if that interpretation is totally irrational. No rule says that art or its interpretation *must* be sensible. We just try to be so here. One way to work oneself out of the labyrinth is to study art from the standpoint of natural and social sciences.

Art Meets Science

Art is, after all, physical material that affects a physical eye and conscious brain. The brain interprets what it sees in light of socialized experiences and a long evolutionary history. In this book we attempt to understand how the eye and brain and human psychology determine what we see and how we interpret it. We will also try to understand the evolution of a conscious brain that developed to avoid predators, to find food in a struggle to survive one more day, and to reproduce. While the science of art is a main current in this book, it is not the only topic of concern. Whether visual, musical, or other, art still touches us in extraordinary ways. No amount of psychophysical reductionism (at least that I know of) will explain away the profound and enigmatic effect art has on people. Art may bring us feelings of sublime joy as well as dark depression. Most of all, art is to be experienced, appreciated, felt, and understood.

We end this tutorial with a guide to viewing (and understanding) art that may add some rationality to the process. It is by no means the sine qua non for understanding art but an organized view of art that might direct your attention to important things. I have found that many people, even sophisticated art critics, profit by having a type of crib sheet as they try to comprehend art. Here I suggest that you view a painting from the perspective of four main qualities:

- Sensory (perceptual) characteristics: What are the physical attributes of the piece?
- Psychological characteristics: What are the psychological aspects of the art?
- Schema-story relationships: How do I understand this piece through my own point of view?
- "Level 3" comprehension of art: Does this piece touch me in some profound way?

Level 3 comprehension, described in the last chapter, is one's highly personal, if not emotional, reaction to art. Also, keep in mind that understanding art is not a unidimensional matter. Any of these characteristics may be primary or secondary in importance in your judgment. Some of the subcategories, such as the many sensory modes, may not apply to every piece. I hope this is a useful way for you to view and understand art.

The SPS + Level 3 Method of Viewing and Understanding Art

	Title and Artist: Brief Description:	
	Primary	Secondary

Sensory (Perceptual) Characteristics

Visual Gestalt Color		
Auditory Tactile Gustatory Olfactory		

Psychological Characteristics

Tension/harmony		
Emotional		
Personal meaning		

Schema–Story Relationships

Theme		
Story		
History		
Intellectual/cognitive		

Level 3 Comprehension

Universal properties of mind and emotion	

1 Art and the Rise of Consciousness

When combined, the conscious mind and its symbolic technologies generate a powerful chemistry. The brain-symbol interface is the birthplace of art, science, mathematics, and most of the great institutional structures that humans have built.

—*Merlin Donald*

Art is important because it stimulates the mind and stirs emotions. It is further important in the psychological history of the world as it marks the emergence of human consciousness. Late in the evolution of our species, we humans began to produce art. These initial artistic accomplishments revealed a remarkable change in consciousness made possible only by a highly complex thinking brain.

Art is a perception consciously experienced and defined by human beings as aesthetic. A further attribute of art is that it is interpreted in some way as being representational or symbolic. By this definition, art may be created or it may exist in the natural order of the universe, but it must be experienced by humans as aesthetic, representational, and/or symbolic to be considered art. Thus, an example of art may be a prehistoric Venus figurine (see chapter logo), a mobile by Alexander Calder (figure 1.1), or the natural composition of pine needles (figure 1.2) if interpreted, even remotely, as being aesthetic and symbolic by the human brain—*your* brain, which is the critical artist, showing art to a conscious mind. Art, whether created by the hand of humans or by nature, is understood in the eye and mind of the beholder—an eye and brain that changed over millions of years as they adapted to an earthly environment. These adaptive changes produced a brain that had an internal sense of beauty, harmony, and pleasure as well as of repulsiveness, discord, and dissonance.

Nature is the art of God.

—*Dante*

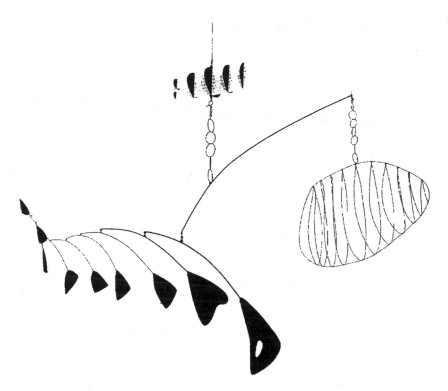

1.1 Alexander Calder, *Lobster Trap and Fish Tail* (1939). The Museum of Modern Art, New York. Mobile made of steel wire and sheet aluminum.

The pursuit of understanding art and what art means in the larger context of human experience has many paths. I propose a simple algorithm that will guide the reader in a step-by-step fashion to an appreciation of what art is, when it developed in the long history of humankind, and how the emergence of art reflected a deeper change in the evolution of a comprehensive brain designed to interpret sensory information and bodily needs, referred to as a *computational brain.*

This chapter discusses how consciousness and art are related, and the next chapter deals with the question of how the evolution of the brain was a necessary antecedent for the evolution of art. In effect, to completely understand art, all that you need is to discover the nature of the human mind (then all things, including the understanding of art, will become clear!). While I do not promise to complete the journey, at least the first essential steps will be taken.

The conscious mind is actuated by the brain—the organ that gives all of life's experiences meaning, gives light and color inside a darkened skull, and gives

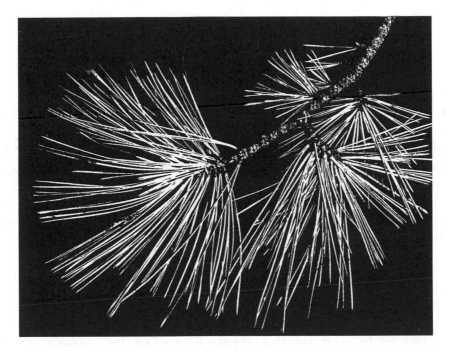

1.2 *A Million Years in the Making—347 Needles* (2001). Photocopy of Lake Tahoe pine needles by R. Solso. From nature all art springs.

knowledge to facts. All human brains are remarkably similar in size and capacity. The modern brain, with its specialized processing modules and elaborate network of neural pathways, evolved over a very long period for the purpose of adapting to a changeable world. A fortuitous by-product of the evolved conscious mind is a richness of experiences, feelings, and technology that far exceeds anything imagined by our Pleistocene ancestors, who were satisfied if they found shelter, food, and sex.

A journey of a thousand miles begins with one step in the right direction.

—Confucius

The story of art presented in these introductory chapters has the following features:

• Art as an "external" and "internal" event.

• The importance of consciousness in the development of the brain and the emergence of art.

- Understanding how our eyes "see" and our brain "processes" sensory signals, especially art.

- Understanding the coevolution of the brain and art.

Changes in Science, Changes in Art

In the beginning, art emerged as the result of a brain able to image things internally and to represent those imaged things externally. Art critics and philosophers of art followed. When art became a topic of academic investigation, opinions were spun off with a passionate centrifugality in which theories of art were flung to the far corners of social theory, political ideology, psychoanalysis, aesthetic principles, religion, and philosophy—to name but a few of the aroused regions. Art theses hit the fan.

Many of these ideas were developed during a time when knowledge of cognition and the brain was still in its infancy. Art theories throughout the long history of art criticism were frequently based on the authority of one who freely offered erudite appraisals, sometimes based on "intuition," sometimes on scholarly analysis, and sometimes on specious reasoning. Frequently these opinions were questionable, but many times they offered real insight into the qualities of art and the humanity it represented—especially in light of the limited knowledge of the sensory-cognitive system and the details of human evolution and its relationship to consciousness. Now, a new neurocognitive approach to art is warranted because of our tremendously increased understanding of the brain, evolution, and consciousness. It is anticipated that such advanced knowledge will partially overcome some of the previous problems art critics and psychologists have encountered in formulating theories of art.

Artistic theories have been an accepted part of the western tradition for years and were based on speculation by philosophers, priests, art critics, and, lately, psychologists and brain scientists. But as we enter the twenty-first century we know far more about the eye, the brain, and the way we think about things—such as art—than ever before. Only in the past half-century have we learned the details of how the sensory system and brain receive and transform information. And only in the past few decades have we begun to understand human consciousness and how it has touched all phases of life, including art. No less important is our current knowledge of why we *Homo sapiens* evolved physio-cerebral-cognitive brains that were designed to see and react to a changing environment. Understanding art today incorporates information from modern psychology, physiology, brain sciences, and anthropology unknown to scholars from Plato to Pollock, from Aristotle to Arnheim.

As Charles Dickens noted in *Martin Chuzzlewit,* "Change begets change," and new discoveries in brain sciences are beginning to have profound influence in every corner of human existence. Indeed, we are beginning to change our concept of who we are and how we got here. The change in the way the brain and sensory systems are conceptualized has had a ripple effect on technology, anthropology, psychology, religion. So consequential are the changes in the way the human mind is conceptualized that it approaches a "paradigm shift" as described by Thomas Kuhn in his revolutionary book *The Structure of Scientific Revolutions* (1962). Kuhn saw science as operating by a series of accepted paradigms, a set of principles and methods upon which most scientists agreed. Every so often, strikingly new information becomes available, the *Zeitgeist* changes, or some cultural-political revolution occurs, resulting in a paradigm shift in which a new set of principles and methods is embraced. A classic example is the replacement of the medieval geocentric astronomy by Copernicus's heliocentric model. In light of what we now know about the brain (its structure and circuitry), about consciousness (its multifariousness), about evolution (its unevenness), and about imagery (its capacity to envision nonpresent events mentally), we may be ready to address the emergence of art as a result of a highly complex computational brain.

However, our understanding of the cognitive neuroscience of perception does not destroy art, any more than knowing what paints Delacroix used or what fibers made his canvas despoils the artistry of *Orphan Girl at the Cemetery* (see figure 1.3). Our perception of this grieving face is far more powerful than any distraction caused by technical knowledge. Nor does information about the clays used, the chemistry of glazes, or the firing techniques employed make less graceful the elegant Tang porcelain shown in figure 1.4. To some, it adds to the richness of understanding.

Traditional Ways of Understanding Art: Psychophysical Dualism

Traditionally, art scholars have approached the understanding of art from the position that art exists in the "real" world while the experience of art takes place inside the mind of the observer. That is, experienced art is subjective—and some subjective experiences are preferred over others. (One viewer might maintain that Pablo Picasso is great while Peter Max is not, while another might argue just the opposite.) Thus an early book on the philosophy of painting declared: "Art and nature are imperial terms; they divide the world into two parts" (Bell 1916, p. 1), and a book on art appreciation confirms: "The artist produces a visual statement which in turn becomes the subject matter for a response or reaction from the observer"

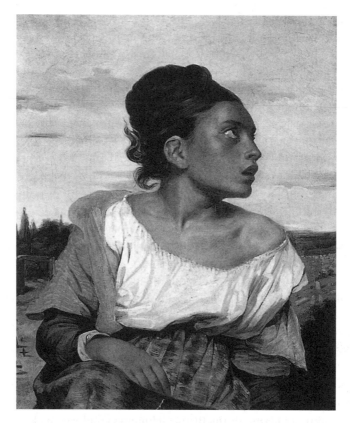

1.3 Eugène Delacroix, *Orphan Girl at the Cemetery* (1824). Musée du Louvre, Paris. Faces occupy a special place in the psychology of art, and knowledge of the painting techniques used does not detract from the emotional expression captured in this woman's tearful eye and helpless hand.

(Knobler 1967, p. 3). Other dualistic notions suggest that art satisfies a human need much as nourishment assuages hunger. "The human imagination requires food as imperiously as the human body, and art is the inexhaustible spring from which our imagination draws sustenance" (*Encyclopedia Britannica*, 1958, p. 442). The separation between what is in the world of art and what is in your head, and how what is in your head influences what you get out of art, are expressed by Janson in his popular book on art history: "If we are going to get the most out of art, we will have to learn how to look and think for ourselves in an intelligent way" (Janson 1991).

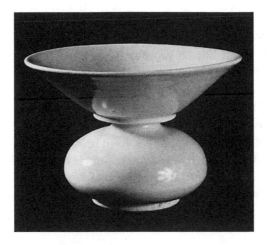

1.4 Exquisite porcelain spittoon from the Tang era (c. 859) found in the northern province of Hebei, China. Why is this strikingly beautiful to some?

While such an approach engages a time-honored philosophic position that separates the physical universe from the mind, from what we now know about the way the brain processes sensory signals we can reasonably conclude that this represents an artificial division.

Art and Mind: A Unitary View

Both mind and art are part of a single physical universe. Separate analyses of art and of mind lead to a misunderstanding of each. Heroic attempts to show the relationship between art, as an "out there" physical stimulus, and what it does to us as an "in here" psychological reaction lead to a strained connection between the two. Art and mind are of a single reality—they are constructed from the same base. We now have a much better understanding of how perceived objects (such as art objects) are processed by physiochemical reactions that take place first in the eye and subsequently in the brain. In addition, we have specific knowledge of the overall workings of the brain as reflected by neurological principles. As we see later in this chapter, studies of human neurology, greatly facilitated by brain imaging technology during the past decade,

Colors, lines, forms, faces, even sounds and smells are always present in the material world but are meaningless to us unless they first activate our senses and are then represented as cognitive events.

have shown that mental functions (including the perception and understanding of art) emerged from neurological structures and processes.

Sensory events are initially processed in a remarkably homogeneous way. All sensory modes detect energy changes in the environment and pass those messages on to higher-order processing units in the central nervous system. In the early stages of cerebral processing there are predictable routes by which once purely visual signals are processed in ever more abstract and meaningful neurological streams. These streams are similar for all humans. Even in the "higher-order cognition" by which one interprets art, such as understanding Freudian symbolism in a piece by Max Ernst or the struggles of Mexican peasants as represented by Diego Rivera's *The Flower Carrier* (see figure 1.5), similar brain structures are engaged in all of us. In addition to the anatomy of thought being similar, the neurochemical processes that undergird brain activity also follow known laws of chemical exchange and

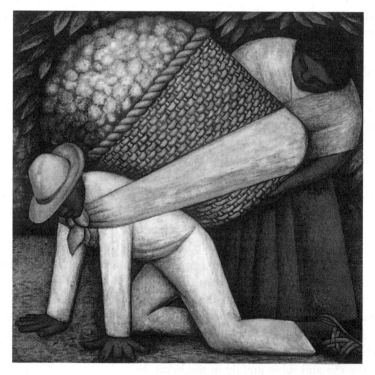

1.5 Diego Rivera, *The Flower Carrier* (1935). San Francisco Museum of Modern Art. Consider this picture of a Mexican laborer from the viewpoint of a wealthy landowner. Now, consider it from the viewpoint of the worker. What differences in perception do you note?

function. Of course, your *thoughts* about *The Flower Carrier* and my *thoughts* about the piece may range from similar to radically different, and an overworked laborer might see (and feel) things in this painting inconceivable to his employer. Nevertheless, each use the same type of eye and brain to process visual signals.

There are real differences between people in the way they think about art that might be understood in terms of individual differences, or, more precisely, individual histories and genetic predispositions. What you think about an art object and what your best friend thinks about the same object may be a reflection of attitudes, knowledge, prejudices, and the like. But these stored personal histories are instantiations of neurological codes that are formed in your brain and in the brain of your friend by means of identical neurochemical processes. These complex forms of seeing art objects are extraordinarily complicated distributed pathways of neurological activity—to suggest otherwise would require supernatural laws.

We are now beginning to understand these natural processes, which were once naively called "mentalistic operations." It is absurd to suggest that, with less than several decades of research into the way the brain creates thoughts and actions, we know everything about the process. The *direction* of such research, however, is clear. We live in a world the mind has constructed as rational, and so, within that presumed systematic universe, scientific research into the nature of internal thoughts, as well as consciousness and a whole lot of other "mysterious mental events," will yield their secrets to curious men and women. We will understand the nature of art as it is in our rational world, not as we wish it to be.

While I reason toward a type of physical reductionism in the understanding of art, I do not dismiss the propensity for humans to find "heart and soul" in nearly every corner of our existence. In the appreciation of art, there is even more heart and soul than in, say, eating a beautiful pizza pie—at least for most. We romanticize and distort the properties of all things sensory—and I am among the most chimerical in idealizing sensory experiences. Psychologically, this is the way the world is revealed to us by the human mind. However, such complications also give thoughts creativity, ennoble the mundane, glorify the tedious, and give ordinary life purpose—all very complex human processes that make us better at surviving life's unexpected vicissitudes. The cerebral-perceptual hoax also makes us feel good, a feeling not to be negated. It is a very poor man indeed who lives a life that is centered around biological reductionism (even if it may be "true"). It is not so much that mental experience reduces to biological functions as that mental experience emerges from neural events. While we decry the cerebral hoax for "deceiving" us, the other side of this problem is that the senses and brain are exquisitely effective, given the size and space limitations imposed by an ambulatory body.

Of all sensory experiences, few are more effusive in creating a soaring heart than sensuous experiences derived from perceiving art, music, and pleasures of the body. It is who we are, body and spirit, and discovering the forces that cause such emotions will not diminish the exhilaration of the sensation. To do so would be to forsake the essential qualities that make us human.

The Evolution of Art and Consciousness

A cynic might write the headline "Psychologists Discover Darwin 140 Years After the *Origin of Species*" as a comment on the new wave of psychologists, anthropologists, and brain scientists who, during the last decade or so, have combined modern evolutionary biology with cognitive psychology. The new discipline is called "evolutionary psychology" and has the prospect of uniting the many disparate branches of psychology and anthropology into a single organized system of knowledge (see Barkow, Cosmides, and Tooby 1992; Cosmides, Tooby, and Barkow, 1992).

The gist of the notion is that we might best understand the modern mind and how people behave by first understanding the roots of our biological and cultural evolution. Modern brains, thoughts, emotions, and art did not simply grow but arose through millennia of natural selection. The seemingly new twist on classic Darwinism is that the mind evolved structures and propensities that enabled man to find solutions to life-threatening circumstances. Thus, intelligent creatures survived and bred while their stupid cousins didn't—in spite of what you may think about some of your relatives.

The evolution of a computational brain, one whose function it is to interpret and process sensory signals in a comprehensible way (see Churchland and Sejnowski 1992; Solso 1991), is functionally equivalent to the transmutation of more obvious physical structures such as binocular vision, an opposing thumb, and bipedalism, which improved an animal's chance for biological continuation. We should be aware of the mathematics of sustaining the life of an evolving creature. If the biological—and I might add cognitive—edge is even slight, given the vast crucible of time in which the equation is cooked, the outcome of even a tiny increment in problem-solving ability, language development, imagery, and so on will enhance greatly that creature's likelihood, over millennia, of begetting its own thinking little progeny.

The evolution of the brain, and the functions a brain carries out, such as thought, imagination, problem-solving, reacting to environmental forces, forming emotional attachments, interpreting sensory signals in meaningful ways, and the like, evolved to be behaviorally adaptive. Other adaptive patterns of behavior were

designed to dodge a falling rock or to find a seductive mate for sex and pleasure. Of course, these ideas are not brand-new but more like old wine in new bottles, as Charles Darwin himself frequently alluded to such a hypothesis: see *The Descent of Man and Selection in Relation to Sex* (1871) and especially *The Expression of the Emotions in Man and Animals* (1872).[1]

For our purposes, modern evolutionary psychology along with cognitive neuroscience provides an ideal paradigm for integrating the many ingredients that constitute the evolution of art, consciousness, and brain development. The multiple facets of consciousness metamorphosed unevenly over hundreds of thousands of years, reaching their current state about 60,000–30,000 years ago, although the process continues today. A thorough understanding of consciousness as a cerebral process is important for the thesis put forth in this book. Consciousness is postulated to be a necessary condition for the understanding of art; and before humans became conscious, in the current use of that term, the brain had to change.

The Rise of Consciousness as a Scientific Topic

In recent years "consciousness" has become more conscious in the minds and writings of psychologists, philosophers, and cognitive neuroscientists than any other topic dealing with the mind. In the earlier part of the twentieth century the topic of consciousness was nearly banished from psychology by adherents of the dominant psychological ideology, namely behaviorism, led by John Watson and later B. F. Skinner. The "holy war for the mind of man" was fought during the last half of the twentieth century, with cognitive psychologists battling for the return of consciousness as an important topic (if not *the* important topic) in psychology on one side, and behaviorists struggling to maintain a purely objective (read behavioral) science on the other. Consciousness would not disappear, and the anti-consciousness (dare I say unconscious) forces were destined to lose the contest—not because objective psychology was untenable, but because the methods and doctrine were imperious to the point that authentic topics were considered taboo. Few scientific positions can survive narrow-mindedness, and the behavioristic zealots who closed their eyes to vital psychological phenomena, such as memory, imagery, and consciousness, lost the academic high ground to be replaced by cognitive psychology and, later, cognitive neuroscience, which retained the rigor of scientific psychology while embracing a much wider range of mental events. While much of psychological behavior may be accounted for in behavioristic terms, many other topics, such as consciousness, are not adequately addressed. Among the many topics studied by cognitive psychologists was how art is consciously represented by the mind.

If my estimates are correct, in 1950 there were 23 articles published on consciousness in the psychological literature; in 1975 that number rose to 532 and in 2000 to 11,480. There has been an intellectual feeding frenzy over consciousness—the very topic that once caused consternation among many academic psychologists. Psychology lost its "mind" and became "unconscious" about 100 years ago—it now appears that we not only have regained our mind but also have revived consciousness.

To do anything but touch on the myriad papers, theories, methods, and conjecture about the scientific study of consciousness in this chapter would take us well astray of the central thesis: that the evolution of consciousness was a requisite for the production of art. But there are many excellent sources on consciousness for the interested reader (see especially Baars 1988, 1996; Dennett 1991; Donald 2001; Mithen 1996; and Schacter 1989).

AWAREness: The Five Facets of Consciousness

With the proliferation of theoretical and experimental articles on consciousness there have been a corresponding number of divergent views. Here, I present a general model of consciousness called AWAREness which incorporates some central themes as well as some new ideas. The main features of the model include Attention; Wakefulness; Architecture; Recall of knowledge; and the Emotive. In addition, several secondary attributes of the model include: novelty; emergence; subjectivity; and selectivity.

- **A**ttention: the focusing of cognizance on internal or external things.
- **W**akefulness: the continuum from sleep to alertness.
- **A**rchitecture: the physical location of physiological structures (and the processes enabled by these structures) that underpin consciousness.
- **R**ecall of knowledge: the accessing of personal and world information.
- **E**motive: the affective associated with consciousness. Consciousness is often expressed as a sentience, a feeling or emotion.
- **n**ovelty: the propensity not only to focus on central thoughts and events, but to seek out novel, creative, and innovative items.
- **e**mergence: consciousness is distinctive from other neural processes in the respect that it deals with private, internal, and self thoughts.
- **s**electivity: in addition to Attention (see above), humans are constantly selecting a very few thoughts to consider at any given time, which may change rapidly given the intrusion of new thoughts or external cues.

- subjectivity: each person's consciousness is unique. To each his own.

A WORKING DEFINITION

The most obvious usage of the word "consciousness" in both lay and professional circles is: *A state of attentional wakefulness in which one is immediately aware of his subjective sensations.* When you look at an art object your conscious thoughts combine your attention to the details of the piece with your past knowledge. Your consciousness is subjective, in the sense that it is unique and private to you, but the process and components of consciousness are similar for all humans.

It is my aim to develop a theory of consciousness in which its various components are operationally defined. In so doing, I hope to demystify this sometimes slippery concept the understanding of which is essential to a complete understanding of the psychology of art. While my goal is to make the concept more scientifically credible, consciousness is still a *subjective* awareness. The elements of awareness may be specified and measured empirically—and that is my aim—but how these discernible elements are applied individually is subjective. Subjectivity thus used is "variance," in experimental psychology terms, which we attempt to control or minimize if we are to be successful in creating an objective science of art. The five elements of consciousness in the AWAREness model are an attempt to reduce the variance in defining the subjective experience we call consciousness. Only one of these elements, architecture, deals with a physiological process; the rest deal with psychological processes. All contribute to consciousness and many interact.

ATTENTION

We are able to direct our attention, and hence our consciousness, to internal or external events. This part of consciousness is similar to a "spotlight" theory of attention in which a concentrated beam of light is shone in the direction of interest. While visiting the beach, for example, you may attend to the beach birds at one moment and then swing your "spotlight" to a ship on the sea, and then to a companion. We are constantly moving the focus of our attention and likewise shifting the contents of our consciousness. Attention, applied to art, finds us searching paintings for meaning or some aspect of the art that coincides with our view of the world. Our attention to objects is rarely arbitrary, but is driven by a searching eye looking for details that, combined with other details and integrated into our larger world knowledge, form the basis of a more comprehensive consciousness. Because objects are seen very clearly only when they are in the very center of our visual field

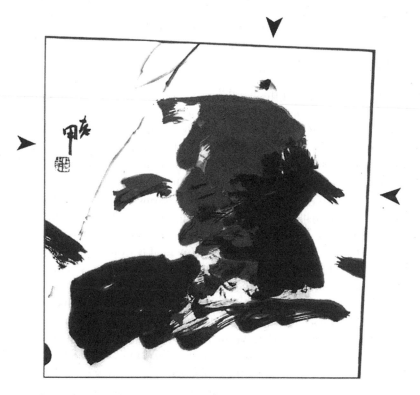

1.6 Lao Jia, *Rider* (1996). Private collection.

(see chapter 3), our eyes are in fact literally moving from detail to detail of what lies before them. As an example of how attention and consciousness are connected to eye movements, consider how your eyes scan the features in figure 1.6. Do this before reading further.

What features did your eyes detect? What do you make of this painting? Did you notice the three arrows outside the painting? The title? Now, reexamine the painting with attention to where your eyes focus and what conscious thoughts you have. Do you see the horse? The rider? Did you notice the Chinese calligraphy? The chop block? By directing your attention to these matters your consciousness changes: this was true of those who once examined ripe berries, chipped flint tools, tended young children. The changing nature of consciousness applies today to those who visit museums in Beijing, Moscow, Delhi, and everywhere else.

In addition to external cues, we may turn the spotlight inside and reflect on personal thoughts, memories, and images. You may, at this instant, bring to con-

sciousness the image of a famous sculpture. You are equally adept at bringing to consciousness thoughts and memories from your past, which is a shared feature with the access of knowledge (see below). Recent psychological experiments on priming, in which one word (usually briefly) and then a related word are shown, have demonstrated that second-word recognition is facilitated by the first word even if the person is unaware (nonconscious) of the relationship between the two words.

Even more powerful is the extent to which associations are activated in a very brief period of time. In an experiment done by Solso and Short (1979), it was found that after they were presented a red swatch people were able to recognize the word BLOOD when the word was delayed for one and a half seconds as rapidly as they were able to recognize the original color swatch or the word RED. Clearly, our nonconscious network of associations is much more extensive than had been previously estimated. Such experiments suggest that there is a strong influence on consciousness of unconsciously processed events that seems to increase our internal attentional focus when simple stimuli are perceived. Imagine how far-flung are our nonconscious associations, as well as our conscious thoughts, triggered by looking at complex scenes such as *The Flower Carrier, Orphan Girl at the Cemetery,* or *Rider.* We have dozens of conscious thoughts but an untold number of unconscious ones.

WAKEFULNESS

Consciousness as a state of *wakefulness* implies that consciousness has an arousal component. In this part of the model consciousness is a *mental state,* experienced throughout one's lifetime, in one's daily experience. For example, last night you slept and now (presumably) you are awake—two radical states of consciousness. If you drink a cup of strong coffee, you might be even more awake. Thus, we first think of consciousness as having various levels of AWAREness and excitation. We may alter our state through trances, hypnosis, drugs, or intensive attention. Wakefulness in the above context is very similar to arousal, which has been studied extensively by cognitive psychologists and which influences attention (see above).

ARCHITECTURE

A third defining aspect of consciousness is that it has some *architecture* or physiological structure. Consciousness is thought to have a home in the brain and may be identified through a type of investigation of the functional architecture of the brain.

For over a century neuroanatomists have been dissecting the brain's functions using refined techniques. In 1908, Korbinian Brodmann (1868–1918) analyzed the cellular organization of the cerebral cortex and, by use of staining techniques available at that time, was able to identify 52 distinct types of cells which were hypothesized to represent different types of processes. The science of cytoarchitectonics, or cellular architecture and functionality, was born. Some cells are specialized in hearing, some in speech, some in motor performance, some in vision, and the like. Following this lead, and using up-to-date imaging techniques, the logical extension of this work is to localize the part, or more likely the parts, of the cortex implicated in consciousness.

Notable work, especially the work on attention, has clearly pointed out that the brain is organized into modules that are geographically specific. Investigation into the processes and interactions within and between modules suggests promising sites for consciousness. The exact nature of the neural networks involved in modules and their effect on consciousness remains to be completely understood. To gain some understanding of the daunting task faced by cognitive neuroscientists as they attempt to untangle the many strands of consciousness, consider the image of neural structures of the human cortex as shown in figure 1.7. Consciousness is not a single process carried out by a single neuron, but is sustained

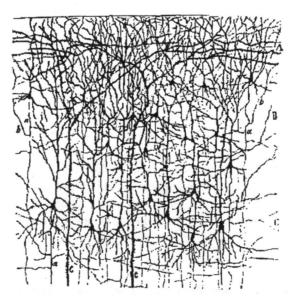

1.7 A sample of the profuse web of connectivity among cortical neurons. (From Crick and Asanuma, 1986.)

by many neurological processes associated with the interpretation of sensory, semantic, cognitive, and emotional phenomena that are both physically present and imaged.

For example, many psychological processes and the resulting behavior are carried out at an unconscious level—driving your car, returning a rocket tennis serve, recoiling at the sight and sound of a cranky rattlesnake. These actions seem to be automatized through experience (although I think some of us were born with a natural aversion to snakes). Other actions require conscious intervention, such as deciding which movie to go to, which museum to visit, or whether a given painting is beautiful or ugly. For these, we need conscious AWAREness of a complex sort. Simple reflexive behavior of the sort that a frog might make when capturing a fly won't do. It appears that different parts of the brain handle conscious decisions that might involve deciding whether Renoir was a better painter than Rembrandt (which is cortically localized) than deal with unconscious actions such as returning a fast tennis ball in flight (also cortically localized but in a separate location). More on this intriguing topic in chapter 4. Another example of how consciousness is sustained in the brain is language, which occupies a sizable portion of the left hemisphere of the brain. Language contributes to consciousness in hugely important ways such as giving semantic identification and organization to an object. Indeed, the whole brain seems to be involved in different aspects of conscious AWAREness.

RECALL OF KNOWLEDGE

Consciousness allows humans to gain access to knowledge through recall (and recognition) of both personal information and knowledge of the world. Recall of knowledge is accomplished mainly through attentional processes (see above) that are initiated internally or externally. This part of the definition of consciousness has three components: recall of self-knowledge, recall of general knowledge, and recall of one's collective knowledge. Self-knowledge is a sense of one's own personal knowledge. You know, for example, that at this moment you are seeing words on a page, that the word you just read (that became part of your immediate consciousness) was the word "consciousness"; you know if you are late for an appointment or have a headache; you know if you are having a clandestine affair; you know how you feel about your father; you know if your underwear is too tight or too loose; and you know countless other bits of personal information that can be immediately recalled without having to relive the event.

Another component, world knowledge, allows us to recall the many facts of our long-term memory. Thus, when you enter the Museum of Modern Art in

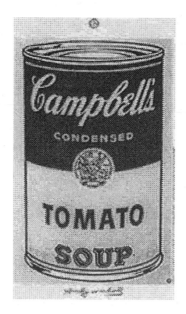

1.8 Andy Warhol, *Campbell's Soup.* **What knowledge do you bring to understanding this piece? How has the recall of that knowledge influenced your perception of this common can of soup?**

New York City, you may elevate to consciousness memorized information about twentieth-century art. In effect, you may prime your expected views with knowledge previously buried deeply in your permanent repository of memory. You may recall that the century began with abstract art and cubism and included several movements such as fauvism, neoplasticism, abstract expressionism, op art and pop art, and the like. In a sense, your "level of consciousness," to use a trendy phrase, has been raised for this type of art, and hence you actually "see" more, because related neurological activity has been energized. When you attend to one of Andy Warhol's paintings of a Campbell's soup can (see figure 1.8), you understand it as part of the vernacular culture, not as a misplaced advertisement.

The third aspect of the role of consciousness in the activation of knowledge is perhaps the most interesting of all. Here, one is conscious of another's consciousness as well as his actions. And the important part of this personal insight is that it opens the door for human empathy as well as seeing oneself in another's actions. In evolutionary terms, across years of cooperative acts, such as mutual hunting activities or gathering of foodstuffs, survival was improved if one member could

more or less know what his or her partner was *thinking* in addition to observing and understanding what she was doing.

Empathetic sensitivity serves survival needs and is a key to knowing how we modern humans see art. As the need for even more cooperative actions intensified, such as during the migration of tribes from central Africa to northern Africa and then to the Middle-East and southern Europe, a greater degree of "intuitive" sensitivity was required. Such developments were greatly facilitated by language, which served not only as a means to tell one's colleague to remove the log that had fallen on one's leg but also to let her know how you are feeling. It may well be that cursing began this way, and an expression such as "Get that #$%*@#& log off my leg" not only conveyed a cry for cooperative behavior but was also an explicit expression of one's raw feelings. Feelings count, and knowing about another's conscious pain (as well as his pleasure) was an important step in the socialization of the species.

We humans are a gregarious lot because—given the fragilities of individual coping abilities in a hazardous world where only the fittest prevail—cooperative acts strengthened the chances of individual and mutual survival. And tied to clannish behavior was a *communal consciousness* or group mentality whose characteristics were cognitively empathetic. By reason of common neurology and similar social experiences, clan members share a similar knowledge base. Gregariousness as a style of life, and communal consciousness as a mental propensity, coevolved for secular reasons. The fact that the vestigial remains of such symbiotic evolution have created a highly socialized creature who enjoys—even craves—companionship is evident in everyday life.

> *The vital role of the artist is to help us all see the messages that originate from experiences along with the knowledge we are all born with.*
>
> —*Carl Jung*

EMOTIONS

Consciousness is also *emotive,* or more generally, a sentience. It has a subjective, phenomenological component that stirs one's passions. Sentience refers to your raw feelings; what it's like to be feeling that you are you. Thus, when you look at a painting by René Magritte (figure 1.9) or perhaps a building designed by Frank Lloyd Wright (figure 1.10), it may cause a raw feeling of disgust or maybe one of delight. In any event, these perceptions produce an internal impression which you may tell to others but which is difficult to measure empirically. To you, the experience is obvious.

1.9 René Magritte, *Rape* (1934). Menil Foundation, Houston. Are you amused or disgusted by this piece? Few people can look at this painting without feeling some emotional response. Your AWAREness is partly defined by your emotions.

1.10 Frank Lloyd Wright, Kaufmann House (Fallingwater), Bear Run, Pennsylvania (1936–1939). A house with a stream running through it and a waterfall beside it: the great American architect Wright combined art and nature in a house. One's immediate and long-term emotional needs are nurtured in this home.

Emotions are caused by internal states as we respond to external events: such as the feelings you get when you stub your toe, lose a parent, get divorced, get an unexpected A on a test, marry the man or woman of your dreams, or find a $20 bill in an old pair of trousers. When describing these subjective emotions to another person it is impossible to convey exactly what you feel. No one can really crawl inside your skull or run a neurological conduit between your brain and another's. We may look at brain images and get an idea as to what part of your brain is turned on when you get depressed, break your leg, or feel giddy over falling in love. And poets, novelists, songwriters, philosophers, and a few imperious close friends, psychologists, politicians, bartenders all assume they can "feel your pain." They can't, no more than a boss can actually feel what his subjugated laborer consciously experiences (see figure 1.3, *The Flower Carrier*), or than the worker can know what his boss feels.

These five aspects of the AWAREness model of consciousness all contribute to your experience of art as well as all of life's great pleasures and pains. The next time you look at a piece of art you might engage in a bit of metacognition in the sense that you might try to identify each of these factors and how it contributes to your conscious AWAREness of art.

From Nucleotides to Newton

You are a conscious thing; a rock is not; the frog that lives by the pond may be, but not as conscious (by the above AWAREness definition) as you are, and yet more conscious than a rock. Some animals, like your dog, may actually be more alert than you are. We all have heard of animals' "super consciousness" as, when there are imperceptible stirrings about the house late at night, they react robustly. There are also accounts of animals becoming agitated just before an earthquake strikes. A few people think cockroaches are conscious creatures and treat them as if they are cognizant—especially when they are particularly annoying—by cursing them vociferously. As for me, I think cockroaches are an AWA type of conscious thing, i.e., they are aware, wakeful, and have some architectural locus for limited consciousness. It would take a world of evidence to convince me that any damned cockroach has extensive KE consciousness—the type of consciousness that deals with knowledge and emotions. Though they do have a type of empathetic knowledge (to use that term generously) when they cooperate in performing a common task. The frog who lives in the pond also has limited consciousness—an AWA type—which is enough consciousness to enable him to nab a fly resting on a nearby lily pad.

I would argue that the whole lot of controversy over who has consciousness as well as when it first appeared among the world's species could be easily settled if the AWAREness model were orthogonally applied to various creatures over archaeological time periods. Thus, when someone maintains that apes are conscious, or that your pet snail, hamster, or pigeon, or your beloved horse, cat, or dog, or the uncelebrated person who dishes out towels at the health club, or the talk show host, are all more or less conscious, I would suggest that you apply the AWAREness model.

In the model of conscious AWAREness, components might be measured using a multidimensional scale that would show varying types of consciousness for various species throughout different evolutionary periods. Each of the AWARE factors in the basic model could be weighted on a quantitative scale—say from 0 to 10—which would give further psychometric sensitivity to AWARE beings. We live in a multidimensional world and for eons have exhibited patterns of wide biodiversity. To impose a rigidly dichotomous classification of consciousness not only

An AWARE Person Contemplates Modern Art

What consciously AWARE thoughts might Rockwell's "connoisseur" have while viewing this abstract piece of art? Many features of consciousness are guardedly private and subjective to the point of being inaccessible. Here we might only speculate as to what might be going on inside the head of this distinguished-looking man as he contemplates this piece.

Attention: The man is focusing his attention on the external painting while probably also paying some attention to his inner feelings and thoughts.

Wakefulness: His body language assures us that he is alert and awake.

Architecture: While it is not shown, we know that beneath his brain case is a very complicated cerebral cortex teeming with neurological activity.

Recall of knowledge: Within the lively brain, past memories, opinions, and relationships are being recalled and transformed.

Emotions: While our man with the homburg looks pretty calm, such outward behavior may mask his "true" feelings, be they delight, rage, disapproval, smugness, or exhilaration.

1.11 Norman Rockwell, *The Connoisseur* **(1962).**

fails to grasp the complex nature of the term but also misrepresents human and animal consciousness.

The point is simple: there are various qualitative types of consciousness among different creatures, and within each type there are quantitative differences. It isn't that your dog, monkey, three-year-old boy, or grumpy old uncle differ in consciousness as defined in some monolithic, ecumenical sense. It is that they differ in consciousness described in both quantitative and qualitative dimensions. Yet that simple observation, which has far-reaching implications for understanding human psychology and art, is consistently overlooked in the extensive literature on consciousness.

Consciousness, in the AWAREness sense, did not descend on the human animal as some majestic antediluvian shard from heaven but evolved unevenly over many millions of years. And if we view "consciousness" as an evolving trait, rather than an immutable attribute of living things (especially human things), it is likely that future generations will continue to develop an even more conscious mind— presuming that the genetic engineers do not tinker with the system before then.

Having suggested that rocks are not conscious, I would propose that nucleotides, those compounds basic to the DNA and RNA chain and to life as we know it, are also not conscious. But Isaac Newton, whose genes were partly composed of nucleotides, was very conscious, at least by AWAREness standards. Out of the chemical muck which was composed of methane, amino acids, peptides, and other stuff, life on earth materialized about 3.5 billion years ago. So far, life continues, which is a pretty good run even by cosmic standards. Somewhere along the bumpy road of evolution, living beings became more or less conscious. And, if future civilization is not destroyed by those whose genes and socialization drive them to cause an apocalyptic destruction of humankind, one may predict that conscious AWAREness will continue to evolve.[2]

Some creatures, like you and almost all other humans, got the whole panoply of AWAREness traits of consciousness, and some got a little less, like your favorite cat, who may be aware, awake, have cortical sites of consciousness, and even have some accessible "knowledge." And, as cats are wont to do, she leaves the room when you enter, thus behaving as if she has the part of empathetic consciousness that is aware of another's consciousness. Just when you need love most, your cat turns tail. The AWAREness model allows some creatures to have only some of the conscious factors, and allows some variation in strength within these factors.

But our story is just beginning. The next chapter will deal with the development of AWAREness and how the evolution of the brain contributed to our becoming AWARE creatures.

2 Art and Evolution

At some point, say around 70 to 60 kyr ago, a cultural innovation occurred . . . that activated a potential for symbolic cognitive process.

—*Ian Tattersall*

Prehistory, that period of human existence before the emergence of written records, vastly predominates in the story of the human species. Using very conservative estimates, our prehistoric experience is 300 times longer than our historical. These early ancestors of ours must figure importantly in any comprehensive theory of art. No less so, however, must the organisms that, over hundreds of millions of years, evolved an eye (and other sensory capabilities) in addition to a central processing neural system—an elementary sort of brain—which enabled such creatures to detect critical signals and react to them. It was very late on the biological clock of humankind when art appeared, and yet very early in the history of modern humans. The appearance of art and the accompanying cultural-technical upheaval signaled the beginning of a new creature who is markedly unchanged from the one who sits next to you on the bus.

The coincidental development of modern man and manifest art objects was enormously important because, it is hypothesized, both were the direct consequence of the rise of consciousness. To comprehend the idea that art, mind, and consciousness are essentially connected, consider the evolution of the modern brain.

About 120,000 to 30,000 years ago the effusive mass of tangled neurons took a significant new step that formed essential patterns for thoughts and greatly increased human consciousness—a special type of consciousness that would spew forth a cornucopia of artifacts, and art, as well as imagery, language, complex technology, and religion. It was *the* big step for humankind—probably the biggest since slithery creatures moved from sea to land. It also represented a fascinating type of adaptive mechanism that was based on symbolic or nonpresent representations.

Man could "see" things that were not present and, in art, manifest such things on the basis of his memory and imagination. The "miracle" of memory and thought was considered mystical or divine and further promoted a dichotomous view of human psychology in which the physical universe was separate from the internal universe within the mind or the soul.

The estimated time over which such a momentous change took place is exceedingly long (90,000 years) in contemporary time, but short in the overall evolution of life on earth. Even this estimate does not embrace all features of human consciousness, with some developing much earlier and some much later. Many structural changes happened in the brain and interacted with social-cultural developments. Some of the features of human consciousness appeared well before 120,000 years ago and some much later than 30,000. Some features continue to develop today and, it would appear, will continue to develop for millennia.

Billions upon billions of neurons working collectively are necessary for human AWAREness, thought, imagery, and art. A sound theory of the evolution of the human brain, as it emerged from the African plains to seamlessly process and produce art, is based on five types of data:

• Archaeological findings chronicling the development of technology, language, culture, and abstract mental processes, including art, from which knowledge of the emergence of a consciously AWARE brain is inferred.

• Studies of environmental and migratory changes of early man that altered his nutritional diet, leading to increased brain functionality.

• Knowledge of brain processes and structures based on current neurological studies.

• Knowledge of genetics, which establishes tribal relationships and kinships.

• Knowledge of cognitive psychology including the principles of learning, memory, problem-solving, and emotions. From knowledge of cognition it may be possible to draw inferences about the adaptability, learning ability, language capacity, and emotionality of ancient people.

Men and women have always left their marks behind them. Everywhere people trod on our planet they left things—tools, scratchings on walls, fire pits, and even their skulls and other fossil remains, in addition to an empty beer can or two. Through ingenious detective work combined with unusual dedication, archaeologists have been able to piece together a remarkably clear picture of the physical and cultural characteristics of ancient man. Less clear are the intellectual qualities of our

distant ancestors. It is possible to make prudent inferences about the cognitive developments enjoyed by early man based on cranial capacity at different times.

The ability of early men and women to carry out complex operations, fashion tools, solve problems, communicate effectively, build a social order, and create a technological world were measurably enhanced by brain changes that began to take place between 120,000 and 100,000 years ago, with profound changes happening about 60,000 to 30,000 years ago. These new, improved brains gave humanity an exquisite gift—art.

Among the behaviors of those in possession of a conscious brain, the operations listed above that required tools, technology, problem-solving, language, and social order are a fairly typical inventory of anthropological themes. Painstaking research in these areas has led us to a good understanding of the artifacts produced and the social structure created by our human ancestors over millions of years. Yet, at the core of the things produced—stone tools, Venus figurines, cave paintings, and the like—and the societies developed—the clan, the tribe, the community, the city—was a brain capable of envisioning the world in abstract terms, of using symbols for real objects, of communicating by means of an oral and written language, and of producing art that was both aesthetic and symbolic.

The "New and Improved" Brain and Technology, Art, Language, and Culture

As important as past research was, our current knowledge of cognitive neuroscience suggests that a new approach to human cultural and physical anthropology is required in which the focus is placed on the evolving brain. In this scheme, the study of artifacts per se is not seen as the main point of archaeological investigations. Rather, artifacts are perceived in the context of cerebral developments that produced objects and cultures: the things and the societies produced are seen as the symbiotic consequences of increased computational effectiveness. A serendipitous side effect of a complex brain capable of imagery and symbolic representation was the human tendency to search for understanding of the world and all things therein. Thus, the new-brained people added a new technique to their survival mode. That new technique could be though of as an "intellectual mode," which is among the greatest events in the history of humankind—and yet is often overshadowed by archaeological and anthropological discoveries that address the early physical and cultural life of humans. People developed the means to think imaginatively as never before.

Conscious AWAREness, as defined in the previous chapter, caused many really big things to happen (like becoming the people we are and producing the

civilization we have); these momentous events were the *consequence* of a brain that had undergone fundamental changes not only in its structural properties (it was generally larger and more elegantly arborized) but also in its processing capacity (signals were processed in parallel, which meant that many operations could be conducted simultaneously). To use the argot of computer geeks, the changes were both in hardware (the structure of the brain) and in software (the functions carried out by the brain).

Human consciousness was necessary for art, yet the two coevolved and each to some extent affected the development of the other. As in most histories, there were fits and starts, with no discernible changes in consciousness and art for eons; then, quite suddenly, several great evolutionary spurts happened. The uneven emergence of consciousness and the making of art were generally preceded by brain growth. But size was not the only factor involved in the cognitive development of the human animal. More importantly, the brain was better organized so that more complicated forms of thinking could be accomplished. The deeply *invaginated* (turned inward) brain was capable of advanced computational operations, such as observing that a sharp-edged rock might be used as a cutting/scraping instrument, an antler as a weapon, some twigs as a basket, a stone as a milling tool, or wooden sticks as fire-making instruments.

Brain Size

Cortical size is one important factor in the evolution of consciousness, art, and intelligence, but the relationship is not perfect. Neanderthal man (230,000 to 30,000 years ago) had a brain about the same size as ours but produced no complex society and no art to speak of. Yet the covariance between brain size and cognizant creatures is strong enough not to be ignored.

Volumetric changes are important, but also of significance are the places such increments are found. In the accompanying box one can see an increase in the frontal parts of the skull—an area critical for the expansion of the prefrontal lobes which are clearly implicated in higher-order cognition. It is the evolution of this part of the brain, as well as the more general physical growth, that most clearly provided the cellular means necessary for cognition, visualization of nonpresent objects, and the capability to plan and execute complex actions—all essential prerequisites for the production of art. There are at least three parts of the puzzle of the emergence of art: the overall increase in brain size, the specific growth in frontal regions, and the increased computational capacity of cortical neurons.

In figure 2.2, data collected by Leslie Aiello and Robin Dunbar (1993) and by Aiello (1996) shows a general linear relation between brain size (as measured by

The Growth of Human Skull Size

During the evolution of humans, the size of the skull increased threefold to accommodate the brain. The larger brain was able to make tools, produce and understand language, think abstractly, and create art. This illustration shows skulls from the early *Australopithecus afarensis* (left), the middle-period *Homo erectus* (center), and *Homo sapiens* (right).

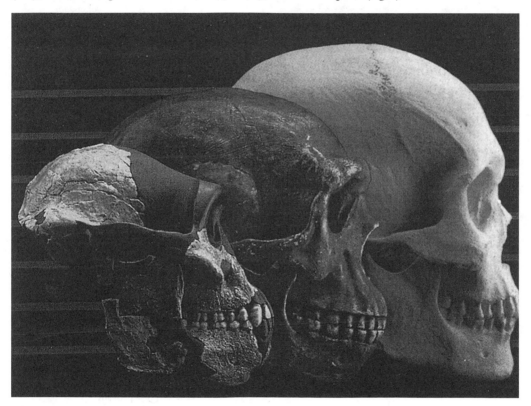

2.1 Reconstructions of the human skull from three periods. (From Lewin 1993.)

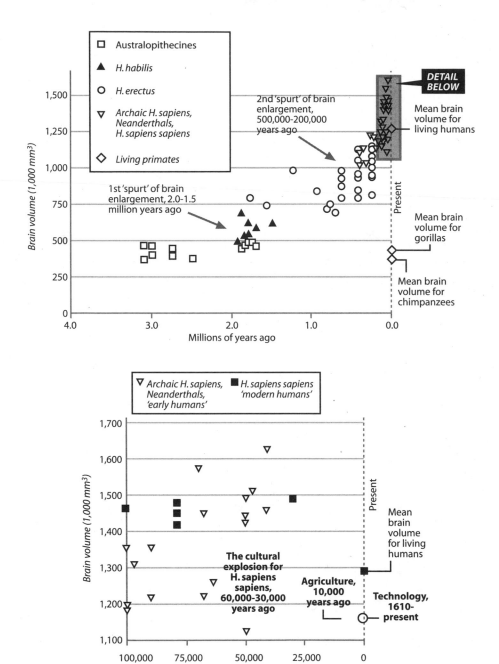

2.2 Humanoid skull capacity over the past 4 million years. Each symbol represents a particular skull from which brain volume has been estimated. Note the two conspicuous increases in cranial size at 2.0 to 1.5 million years ago and 500,000 to 200,000 years ago. Also note the cultural explosion shown at 60,000 to 30,000 years ago in the detailed figure. (Drawn from data presented by Aiello and Dunbar 1993 and Aiello 1996; figure from Mithen 1996.)

Early Stone Tools

About 2 to 1.5 million years ago, stone tools like the one at left were found in east and south Africa. They are made up of a core stone from which flakes have been removed; the technology is known as the Oldowan industry for the Olduvai Gorge in Tanzania where they were first found.

Hand axes similar to the one shown at right have been found that date to 1.4 million years ago. The technique is called the bifacial flaking method, as flakes are removed from both sides of the core stone. Hand axes are usually pear-shaped to mold to the human hand.

2.3 Oldowan core stone tool and Levallois hand axe.

carefully dated skull fossils) and time: in general, brains got larger in size over the years as did the complexity of symbolic behavior. Humanoid types show cortical capacity ranging from about 500 grams three million years ago to about 1325 g presently. Even today there are variations in brain size that are associated with body size. (For example, in men, brain size ranges from about 1300 g to 1450 g and in women from 1175 g to 1350 g, as related to body size and height [Ankney, 1992].)

EARLY TOOLS AND LANGUAGE

As the "new kid on the plains" showed up with his big brain two million years ago, so too did the first stone tools appear—tools that initially were simply naturally formed sharp shards but later were fashioned into instruments. There is evidence that this new species ate some meat—meat from animals he could bring down with stone tools. Some of the game was large animals, which required cooperative action to kill. These beings lived socially, had toolmaking sites, and used the same fireplaces over time. Accomplishing these cognitive acts required brainpower and

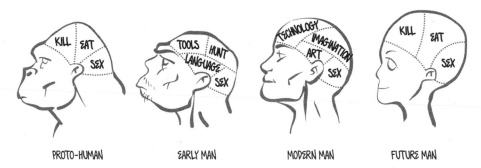

2.4 The evolution of brains.

behavioral sophistication an order of magnitude greater than those of the small-brained simian cousins who did not enjoy fire or stone tools, and, perhaps most significant, had a limited diet. (Some anthropologists assert that a high-protein diet was necessary for brain development. See in the next section a discussion of the influence of Omega3 as cortical nutrition in later man.)

Much change occurred during this period, including the emergence of AWAREness traits of consciousness along with very early types of "art," if one is indulgent enough to count sticks and stones used for killing as "art." I'm not, as they seem to lack symbolic characteristics—but neither do I think these early ancestors were totally consciously AWARE.

Neanderthals, Cro-Magnons, and Dogs That Can't Hunt

Not all members of the human family considered such lofty thoughts. One of the most successful *Homo sapiens* arrived on the scene as far back as 230,000 years ago (by some estimates) in the form of the Neanderthals, whose celebrated skeletal remains were first found in the Neander valley in Germany in 1857. The Neanderthals lived mostly in Europe; in their later millennia they lived side by side with audacious cohabitants, the Cro-Magnons, who first came up with the idea of painting cave walls; an example from Lascaux, France, is shown in figure 2.5.

Figure 2.6 shows a comparison of a modern skull and a Neanderthal skull. Note that the latter is larger than the modern skull and the cranial capacity generally more capacious. Note also that the configuration of the skulls is different, with the modern brain having a larger frontal area, which encases the frontal cortex—largely thought to be implicated in higher-order cognition and imagery, and which

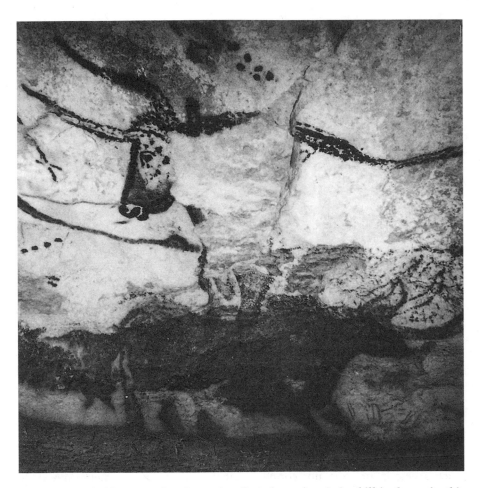

2.5 A remarkable example of creative thought and artistic skill is shown in this painting from the Bull's Chamber in Lascaux, France. This great beast is about 6 meters long. Behind the bull's head you can see that an enormous shard has fallen off the cave wall. Near the animal are dots and symbols that may have had ritual significance.

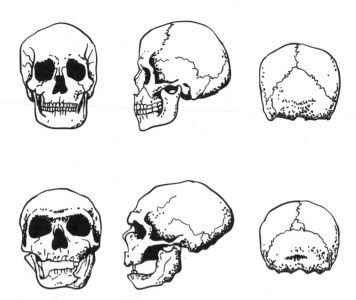

2.6 A typical modern skull is shown above and a Neanderthal skull below. Note that the Neanderthal skull has a more forward projection in the midfacial area and a small chin. While the overall volume of the Neanderthal brain is greater than that of the modern brain, more space is allocated to frontal cerebral lobes in the modern skull (see middle column), which reflects a greater associative cortex necessary for higher-order cognition.

may be directly involved in the conceptualization and production of art. While the Neanderthals are frequently characterized as a brutish, stupid, nonadaptive, hulking lot who may well have been partly killed off by the inventive Cro-Magnons, such a description does not consider that these men and women enjoyed the longest run of all humans—far longer than the smart-assed moderns who are reading these words. Neanderthals walked upright on the earth for over 200,000 years, during which time they manufactured usable tools, lived in sheltered caves, and adjusted to the cold of the ice age by wearing clothes. They also made carvings in stone and bone and ceremoniously buried their dead. For an excellent read on these fascinating people see *The Neandertal Enigma* by James Shreeve (1995).

Though they lived longer than any other of the modern humanoid types, the Neanderthals did not produce an advanced consciously AWARE technology. We may only speculate that, had they continued for another 200,000 years, they would still not have figured out calculus, space travel, or the New York Stock Exchange.

Return to figure 2.2. Note that there is a second spurt in cranium size between 500,000 and 200,000 years ago accompanying the emergence of *Homo sapiens* (meaning "wise man"), but there appear to be no major changes in artifacts during that transition. The same old types of flint instruments were used, with some slightly more efficient than others and some less. However, shortly after that period (by evolutionary time measures), about 120,000 years ago, changes took place in the brain and vocal tract. It was these changes that brought forth huge cultural changes, not the least of which was an advanced vocalized form of communication—something like "Get that #$%★@^& log off my leg"—and the emergence of modern man.

The subspecies *Homo sapiens sapiens* (meaning "wise, wise man"), who could express images symbolically, stand upright, and communicate in a language consisting of vocalizations and gestures, was clearly something new. The world had never seen anything quite like these folks: the human species was becoming AWARE.

TURNING THE CORNER

In an especially illuminating recent book by Merlin Donald (2001) of Queen's University in Ontario, human cognition is characterized as moving through several stages from the *episodic* of primate species, to the *mimetic* of early hominids, to the *mythic* of sapient humans, to the *theoretic* of modern man. The cognitive-evolutionary stages are described in table 2.1.

Of particular interest in the development of art, vis-à-vis the emergence of consciousness, is a new kind of cognitive function exhibited by early humanoids. This function was mimetic performance, according to Donald. Imitational behavior, which was a logical action extension of conscious control, was manifest in play acting, body language, and gestures. Mimesis "enabled early hominids to refine many skills, including cutting, throwing, manufacturing tools, and making intentional vocal sounds. Although not yet language, these sounds were nevertheless expressive. We call such vocal modulations prosody. They include deliberately raising and lowering the voice, and producing imitation of emotional sounds" (Donald 2001, p. 261).

The importance of these developments for the eventual creation of art is that a form of symbolic expression—a key ingredient in the definition of art—was being played out in the form of gestures, play acting, and imitation. It was only one step away from the manifestation of art (as in the making of body ornamentations, cave scratchings, amulets, carvings on bone and horns, and eventually cave

Table 2.1

Successive layers in the evolution of human cognition and culture. Each stage continues to occupy its cultural niche today, so that fully modern societies have all four stages simultaneously present. (From Donald 2001.)

	Species/Period	Novel Forms	Manifest Change	Governance
Episodic	Primate	Episodic event perceptions	Self-awareness and event sensitivity	Episodic and reactive
Mimetic (first transition)	Early hominids, peaking in *H. erectus* 2–0.4 million years ago	Action metaphor	Skill, gesture, mime, and imitation	Mimetic styles and archetypes
Mythic (second transition)	Sapient humans, peaking in *H. sapiens sapiens* 0.5 million years ago through present	Language, symbolic representation	Oral traditions, mimetic ritual, narrative thought	Mythic framework of governance
Theoretic (third transition)	Modern culture	External symbolic universe	Formalisms, large-scale theoretic artifacts, massive external storage	Institutionalized paradigmatic thought and invention

drawings) that would coevolve with the beginnings of AWARE consciousness about 120,000 years ago. The corner was about to be turned.

And what a momentous corner it was. These new people received from their parents:

- tools, for killing and cutting,
- skills, such as hunting and gathering,
- mimetic rituals which engendered a social order,
- a voice box capable of prosody, and most of all:
- a vastly complex modular brain capable of processing neural signals in a massively parallel network.

120,000 YEARS AGO: "IT WAS A VERY GOOD YEAR"

This evolved complex brain was capable of computational skills many times more powerful than those of previous humanoid species (e.g., *Homo erectus*), let alone

those of other primates and animals. Thus, about 120,000 years ago our ancestors began to travel down a road never seen before on earth. The things of the physical universe that could be seen, heard, touched, tasted, and smelled were perceived as a raw canvas upon which a new world could be composed—an environment in which one could readily survive, but also a place where one could construct an interesting life. Like upwardly mobile suburbanites, these new earthlings fabricated improved shelters, better fireplaces, more refined tools, sophisticated forms of oral communication, and beautifully crafted objects. There is also evidence that they began to decorate themselves with flowers, pendants, beads, and body paint. They memorialized their dead loved ones with elaborate graves and flowers and, we can logically infer, began to think about life and death and powers greater than themselves. Although life was not easy, these cognitively AWARE people had some extra time—time for pleasure, time for creativity, time for art.

The Cognitive "Big Bang"

The final stage began about 60,000 years ago (and recent discoveries at the Blombos Cave indicate it could have been even earlier) and centered around a revolution in technology, abstract representations, and the creation of an externalized symbolic universe. Dating the beginning of the modern mind is not a matter of simple inferential logic, of identifying a single portentous event (such as language acquisition) that would signify a drastic change in intellectual ability. Because brain mechanisms and processing schemes *evolved* over hundreds of thousands of years and because some modules of the modern brain emerged before others, the view presented here is that cerebral transformation followed an erratic, crazy-quilt course.

This uneven, gradual change in physiology and psychology could scarcely be noticed over the lifetime of any people and was brought about by selective regeneration of fit people and an occasional felicitous cortical mutation. Some things happened early (like skillfully fabricated hand axes) and some things later (like polychromatic wall paintings), but each was preceded by the development of brain structures that effectuated such actions. For these reasons, the date of 60,000 years ago must be seen as an approximate marker in the history of the human mind, rather than the exact date that something momentous happened. The actual antecedents of the "modern brain" extend back at least 120,000 years, and one could argue that indications of advanced cognition appeared much earlier.

These consciously AWARE people externalized cognition and projected instantiations of needs in the form of sophisticated tools, complex language, and

art—similar to what Donald (2001) refers to as "symbolic technologies." In nearly every corner of human existence, profound changes began to appear about this time and continued until the great civilizations of Sumer and Egypt when something altogether revolutionary happened. But, lest we get too far ahead of our story, consider just a sample of the changes in art, culture, and technology that occurred during the period known as the Middle/Upper Paleolithic transition—a period Mithen (1996) calls "the big bang of human culture."

Tools, Language, Art

Several events spread over a long period of time formed the intellectual basis for modern civilization. It is easy to lose sight of how protracted these periods were. The Middle Paleolithic and Upper Paleolithic were each longer than the period from today back to when "cave men" worked the walls at Lascaux 17,000 years ago. And, during that time, the human species changed greatly in actions and in cognition from the even more lengthy Lower Paleolithic. Although anthropologists debate the relative importance of the cultural changes detected about 60,000 years ago, I would like to add a neurocognitive emphasis to these events; to argue that these important cultural changes were achieved only by an imaginative brain capable of complex and abstract thinking.

The first such event is the development of tool making. As far back as 1.5 to 2 million years ago, stone tools were used by humanoid creatures (see figure 2.3 and box). These are called the Oldowan stone tools (found at the Olduvai Gorge in what is now the Serengeti Plain in Tanzania) and are little more than rough broken rock. Later pear-shaped hand axes dating as far back as 1.4 million years ago, found in what is now Ethiopia as well as other sites, are truly fashioned bifacial flaked instruments (i.e., they were made by removing flakes alternately from either side of a core stone). Sophisticated blade technology eventually followed, in which long thin slivers of flint were formed by removing them from a core stone. Really systematic blade production did not appear until about 40,000 years ago, but some evidence that man has been producing this type of tool dates back to 100,000 years ago. Tools, even early hand axes of the Acheulean technology found throughout the range of early humans—from Africa, Europe, southwest Asia—chopping tools found in east and southeast Asia, and especially those of the later Levalloisian technology, demonstrate cognitive attributes that indicate the mind of man extended to the hand of man.

Considering tools to be more than utilitarian instruments might stretch credulity. However, it is apparent that they vary widely in design and skill of pro-

duction.[1] Many are crudely made, with rough edges shaped from second-rate material, while others are beautifully crafted from elegant stones. (Those more beautiful objects also seem to work better—an early version of the "form follows function" axiom that became popular among architects in the twentieth century.) Some of the variation in stone tools may be attributed to the availability of materials and perhaps to demands placed on the craftsman (such as bad weather, the hunt is about to begin, or a predator is breathing down the worker's neck), but with those exceptions it is clear that some stone tools represented an artistic achievement.

A second crucial factor was the development of complex language. Language is a system of communication in which symbols represent things and events. The symbols may be audible sounds (as in speech) or visual patterns (as in writing). Animals in natural settings sound cries of distress that discriminate among predators. For example, the vervet monkey in eastern Africa makes different sounds to signal the presence of a snake, a leopard, or an eagle, and it is not alone in making distinctive sounds for various threats. Some ethologists argue that these signaling behaviors are examples of language, and they certainly have some of the features of language, but they lack its adaptability, such as being able to refer to a nonpresent object. The entangled arguments about what is or is not language are too involved to work out here. Suffice it say that humans have complicated language and that it wasn't always that way.

Complicated language arose when early man tied sounds (and later signals) to something in the environment. These sounds could be used in a variety of settings but kept the same meaning. These sound-object dyads could be combined in ever-increasing complexity, adding verbs, adjectives, and other parts of speech, which extended the scope of language and enhanced the specificity with which ideas could be transmitted.

The importance of language in human evolution and its functionality can hardly be overemphasized. Many scholars even hold that language development in humans was *the* significant evolutionary step and that other developments, such as the emergence of art and cultural artifacts, were secondary, if not epiphenomenal, to language development. The view proposed here is that language and art co-evolved and both were dependent on cerebral cortical developments that created a new type of being—a being who could think "outside of the box."

Some efforts have been made to measure cranial capacity as well as the development of specific gyri (ridges in the brain) in order to pinpoint the time at which language emerged. (More on this topic later in this chapter.) At first, gestures and imitation seem to have been a primary means of communication, followed by some form of symbolization, such as making a mark in the mud or sand.

The documentation of the evolution of language, like much of the science of anthropology, is a matter of careful detective work based on artifactual information from which inferences are drawn.

What is known is that *Homo sapiens* migrated from eastern Africa to southwest Asia about 100,000 years ago. Based on reliably dated artifacts, humans migrated to Australia at least 50,000 years ago. What makes this voyage over open seas to Australia interesting, insofar as the human brain is concerned, is that it would have required building seaworthy vessels and (probably) some type of navigation skills—all of which would require imagination and cooperation. Such an exploit would have required a mind capable of envisioning, planning, and executing complex technical and strategic operations. Certainly, actualization of this type of collective behavior would have required communication of some sort as well as empathetic knowledge (part of the AWAREness model). The capacity to produce and understand language and other higher-order cognitive skills would require properly nourished neural and vascular systems. (See below for a discussion of Omega3 and its role in brain growth.)

The type of structural language that evolved in man had enormous implications for the type of technical and artistic life that emerged after the Pleistocene. The component of consciousness identified as "access to knowledge" is largely based on semantic knowledge. Fully AWARE consciousness depended on language development, and language development was contingent on a brain capable of sustaining such complex processes as semantic representations, speech, syntactic structures, and abstract thought. It is not an exaggeration to say that all things created by humans, including art, are measurably influenced, if not directly caused, by language.

Language was the air that supported soaring symbolisms. Things suddenly became "like" something else; metaphors mutated; abstractions abounded; and the cognitive genie was out of the bottle never to return. Along with symbolic, abstract, complicated thoughts, a coevolving associate of semantic language—art—began to materialize with increasing frequency. Abstract linguistic symbols were about to gain substance in the form of art. Art became visualized thought.

Once the necessary neurons were in place and the intricate circuitry was functional, humans began to make images and figurines that were both aesthetic and symbolic. It is suggested that massive neurological subroutines were needed. The arrival of art cannot be fixed in exact time, as artistic objects began to appear at halting intervals. Very early on, man chipped out stone tools. Some (not all) of the objects were very arty indeed. Recent discoveries at the southernmost tip of

Early Art and the Chauvet Cave

Items of personal decoration have been unearthed that were created as early as 40,000 years ago (and likely earlier). Ostensibly, these beads, pendants, and animal teeth adorned the bodies of young women and men. In southwest France at a site known as La Souquette, ivory beads carved to mimic seashells have been found. At about the same time, ingenious people were decorating the interior wall of the cave found by Jean-Marie Chauvet. Thus far, these are the oldest examples of complex wall paintings. There are more than 300 paintings of animals in this cave, including reindeer, horses, rhinoceroses, lions, and even an owl. Looking at these draw-ings made from indigenous materials, one is impressed by the natural depiction of the creatures. The artists also show knowledge of the anatomy of animals. But most impressive is the highly artistic expression in these paintings rendered by a hand that was directed by a thinking brain.

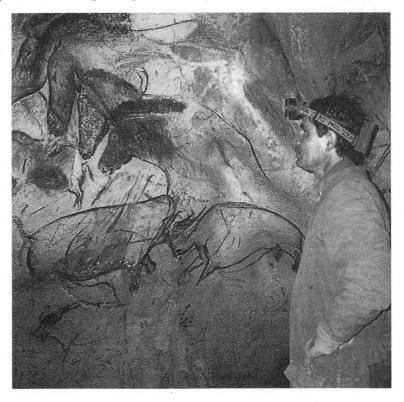

2.7 **Animal paintings in a cave in southeastern France examined by Jean-Marie Chauvet, one of three explorers who found the cave. (Photo from Lauber 1998.)**

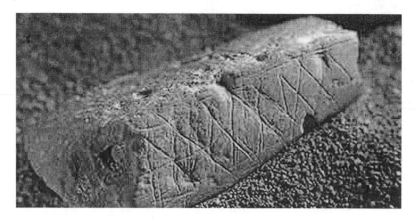

2.8 A 77,000-year-old carved ochre found in Blombos Cave in South Africa. The pattern of crossed lines suggests that humans may have exhibited abstract thought, language, and art much earlier than previously thought. The caves are near the Indian Ocean, a location that may have provided the dwellers with seafood. (Photo from *Science, 295* [2002].)

Africa in the Blombos Cave suggest that people produced finely honed tools as early as 77,000 years ago (Wilford 2001). From this cave, which sits high above the Indian Ocean, early humans hunted grysbok and springbok and fished in the waters below. A group of anthropologists led by Christopher Henshilwood have pushed back the time that people produced intricately hewn bone tools. What is significant about these findings, for our purposes, is that many of these finely worked animal bones were engraved with patterned marks. (See figure 2.8.) These markings appear to be symbolic in nature, which suggests that very, very early in the history of humankind, creative and abstract thoughts were made manifest in art objects. Such findings also imply that oral communication may have emerged by this time in a more complete form than originally thought. An overview of the many stages of art vis-à-vis the emergence of consciousness is shown in figure 2.9.

Caves in France and Spain have told us more about early imaginative art. The Chauvet souterrain, discovered in 1994 in France and carefully dated by radiocarbon techniques, clearly shows that sophisticated cave art was being produced about 35,000 years ago. About the same time, Cro-Magnon men scratched images of vulvas on rock surfaces in the Dordogne region of France, prompting us to contemplate what those boys were thinking about.[2]

Upper Paleolithic Art

The period known as the Upper Paleolithic (beginning about 40,000 years ago) marked the high point of prehistoric cultural developments, and may only be accounted for in terms of a remarkable brain that was able to create wonderful art as well as craft elegant tools fashioned from bone, antler, and ivory. Many times these new products took on regional characteristics, but innovations in tools and art seem endemic, with changes spreading from what is now Spain to France, Germany, and as far east as the Urals. Delicate sewing needles, barbed spear points, refined fishhooks, stone lamps, the likes of which no one on earth had ever seen before, became commonplace. Look at the graceful Vogelherd horse shown in figure 2.10.

This art object rivals the products produced by the world's finest artists. Yet this object, and hundreds more, erupted in full glory. While one might expect art (and tools) to evolve gradually, with some crude exemplars scattered throughout the history of this period, such evidence of evolutionary gradualism is absent. It is almost as if an entire civilization holed up in an isolated cave for 50,000 years studying art, craftsmanship, religion, clothing making, body paints, boat building, domestic skills, weapon making, and maybe even a course or two in organizational psychology and gross anatomy. Then, all crude practice objects were destroyed and the savants were released on the world. This is only fantasy, but what did happen is far more fascinating; though not all the facts are known, it is possible to reconstruct one of the most important events in human history.

During this period some profound neurological event happened in which the organization of the brain's neurons increased computational processing through massive parallelism. These parallel processing interconnections in the cerebral cortex and in subcortical nuclei produced a brain many times more powerful than had been seen before—a brain that could visualize and produce nonverbal abstract representations of thoughts. It could produce art.

The Vogelherd horse is art. It is representational art and it is aesthetic. All features of this piece exquisitely contribute to its beauty. Yet the features alone—the nostrils, the eye, the mouth, the mane, the outstretched legs, the swollen belly—all reflect a skilled eye and hand awakened by a new type of thinking instrument.

Some argue that nothing remarkable happened to the human skull during the Upper Paleolithic and cite this as evidence that the brain case did not really change. How absurd! Such a notion is intellectually akin to the pseudo-science of phrenology, which advocated that bumps on the skull reflected mental traits. It's what was happening *inside* the brain that caused the prehistoric cultural revolution.

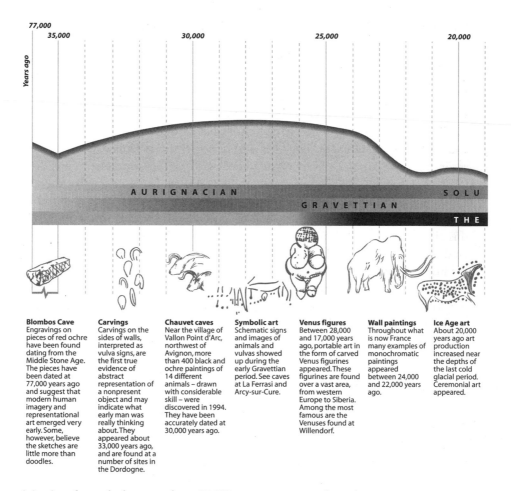

Blombos Cave
Engravings on pieces of red ochre have been found dating from the Middle Stone Age. The pieces have been dated at 77,000 years ago and suggest that modern human imagery and representational art emerged very early. Some, however, believe the sketches are little more than doodles.

Carvings
Carvings on the sides of walls, interpreted as vulva signs, are the first true evidence of abstract representation of a nonpresent object and may indicate what early man was really thinking about. They appeared about 33,000 years ago, and are found at a number of sites in the Dordogne.

Chauvet caves
Near the village of Vallon Point d'Arc, northwest of Avignon, more than 400 black and ochre paintings of 14 different animals – drawn with considerable skill – were discovered in 1994. They have been accurately dated at 30,000 years ago.

Symbolic art
Schematic signs and images of animals and vulvas showed up during the early Gravettian period. See caves at La Ferrasi and Arcy-sur-Cure.

Venus figures
Between 28,000 and 17,000 years ago, portable art in the form of carved Venus figurines appeared. These figurines are found over a vast area, from western Europe to Siberia. Among the most famous are the Venuses found at Willendorf.

Wall paintings
Throughout what is now France many examples of monochromatic paintings appeared between 24,000 and 22,000 years ago.

Ice Age art
About 20,000 years ago art production increased near the depths of the last cold glacial period. Ceremonial art appeared.

2.9 Art through the ages: from 77,000 years ago to modern times.

Of course, we cannot measure these changes directly, but, from what we know about the way the brain works today, we can make some intelligent inferences regarding brain changes that likely took place. Some are considered next.

The Cognitive Blueprint

Like an ever-brachiating network growing exponentially, the human brain became by far the most complicated entity known to man. With more profusely arborized neurons working in parallel synchrony, the computational powers of the human

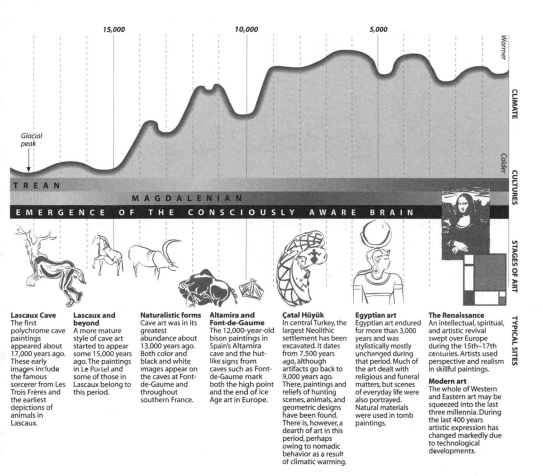

15,000 10,000 5,000

Warmer

CLIMATE

Glacial peak

Colder

CULTURES

T R E A N

M A G D A L E N I A N

E M E R G E N C E O F T H E C O N S C I O U S L Y A W A R E B R A I N

STAGES OF ART

TYPICAL SITES

Lascaux Cave
The first polychrome cave paintings appeared about 17,000 years ago. These early images include the famous sorcerer from Les Trois Frères and the earliest depictions of animals in Lascaux.

Lascaux and beyond
A more mature style of cave art started to appear some 15,000 years ago. The paintings in Le Portel and some of those in Lascaux belong to this period.

Naturalistic forms
Cave art was in its greatest abundance about 13,000 years ago. Both color and black and white images appear on the caves at Font-de-Gaume and throughout southern France.

Altamira and Font-de-Gaume
The 12,000-year-old bison paintings in Spain's Altamira cave and the hut-like signs from caves such as Font-de-Gaume mark both the high point and the end of Ice Age art in Europe.

Çatal Hüyük
In central Turkey, the largest Neolithic settlement has been excavated. It dates from 7,500 years ago, although artifacts go back to 9,000 years ago. There, paintings and reliefs of hunting scenes, animals, and geometric designs have been found. There is, however, a dearth of art in this period, perhaps owing to nomadic behavior as a result of climatic warming.

Egyptian art
Egyptian art endured for more than 3,000 years and was stylistically mostly unchanged during that period. Much of the art dealt with religious and funeral matters, but scenes of everyday life were also portrayed. Natural materials were used in tomb paintings.

The Renaissance
An intellectual, spiritual, and artistic revival swept over Europe during the 15th–17th centuries. Artists used perspective and realism in skillful paintings.

Modern art
The whole of Western and Eastern art may be squeezed into the last three millennia. During the last 400 years artistic expression has changed markedly due to technological developments.

mind attained levels unseen before on earth (and may have become the most complicated entity in the universe). Current brains suggest wild arborization in which the number of neural connections almost seems to grow out of control and allows us felicitous contemporaneous humans to understand and change the world through abstract imagery, tools, and language.

From the physical evidence uncovered, we can piece together a picture of how people lived and make prudent deductions as to what type of brain was necessary for such actions. At a fundamental level, a brain that could image nonpresent objects and render likenesses of those objects was a necessary ingredient for the production of cave art and sculptures. That type of brain would require a complicated

2.10 The Vogelherd horse, made of ivory about 32,000 years ago.

nervous system capable of perceiving, storing, and processing vast amounts of information. It would required the capacity to image the world and act symbolically. It would require more efficient neurons and greater enlargement, especially of the frontal lobes.

Size Limitations

The enlargement of the brain (and brain case) was nearing a maximum, given the restrictions of the birth canal and later difficulties with locomotion and vertical stability. Bigger heads are obstetrically problematic as well as cumbersome for moving about. The solution to this dilemma was to increase the invagination of the brain, with more and deeper folds being created in the cortex. In addition, elaborate changes likely occurred in the way nerve cells communicated within neural networks which involved synaptic changes at the dendritic level, with cells from one neuron becoming able to connect to many other cells in a massively parallel network. The capacity for higher-order thinking involved in learning, imagery, and art production was made possible through these alterations in brain physiology.

Neurological Changes

Basic neurological changes provided the platform upon which actions and learning denied to previous generations could be built. It is suggested that these changes were partly brought about by dietary changes (see below) and had profound psychological consequences, including the increased capacity to learn from experience and the production of art. They also fostered human AWAREness, which evolved unevenly.

Impulses from the sensory receptors are transmuted by the fully conscious brain in the context of past knowledge and future intentions by means of an intricate network of associative processes. Such an evolutionary quirk that used the brain as an adaptive instrument led humans in one direction: a direction that endowed us with the competence to produce and enjoy art. In addition, it provided humans with a form of intelligence that went far beyond enhancing the chances for biological survival.

A fortuitous companion in the evolution of (advanced) intelligence is that we modern humans use intellect not only to imagine what might be behind the next bush but to envision how electrons work, how DNA constructs organic beings, and how neurons communicate. Intellect, which saved many an ancestor from getting killed, may not turn out to be the ultimate survival technique. The application of "intelligently" produced weapons of mass destruction, for example, may kill us all off. Or our inability to take care of a global neighborhood might also have catastrophic effects. Our distant cousins, on the other hand, followed a course of evolution that equipped them with sometimes elaborate means of nonintellectual coping with the uncompromising forces of the physical world.

The relative indifference to the environment springs, I believe, from deep within human nature. The human brain evidently evolved to commit itself emotionally only to a small piece of geography, a limited band of kinsmen, and two or three generations into the future . . . [because] it is a hardwired part of our Paleolithic heritage. For hundreds of millennia, those who worked for short-term gain within a small circle of relatives and friends lived longer and left more offspring.

—E. O. Wilson

ORGANIZATIONAL CHANGES

These profound changes could only have been brought about by changes in the organization of brain structures and processing networks. Mere size and number of neurons were not sufficient to bring about the changes in human culture, language, and technology. The modern brain, which developed from the Paleolithic up to today, is comprised of numerous specialized modules whose processing efficacy is tremendously capacitated by the way information is processed. However, it is important to recognize that the origin of the brain has a far more ancient history, acquiring a basic schematic millions of years ago.

The cerebral blueprint designed very early in the history of humankind served as a prototype for subsequent structural compositions and mental operations. Specifically, brains were organized in such a way that massive parallel processing was

possible, thus increasing the understanding of what the world was, in actuality, and, more importantly for conscious AWAREness, what the world *could be,* in imaginable ways. The computational power of massive parallel processing was an order of magnitude greater than simpler processing schemes. It was possible to process many different thoughts simultaneously while attending to an ongoing cavalcade of sequentially appearing sensory events.

UNCONSCIOUS THOUGHTS

Our conscious AWAREness engages only a tiny fraction of the psychological activity that may be found just below the level of conscious thoughts. The human brain is aglow with untold millions of neural circuits flashing their electrochemical messages from one module to another. These excited spatiotemporal patterns allow access to information just below the level of consciousness. If there were one reason why human consciousness and intelligence are unique, it would be the distinctive ability to process many thoughts simultaneously, most of them unconsciously. While other primates and other mammals may have similar processing modalities, none come close to the expansive cognitive capacity exhibited by humans. (The further consequences of human intellect as an adaptive mechanism over millennia are unknown: it is possible that cockroaches and many other critters will still be crawling around long after humans have outsmarted themselves.)

This new "wise man" envisioned a world that was created wholly in his brain, could cogitate more deeply, and, in general, could understand the world more completely. The relationship between cause and effect (being hit on the head with a stone and feeling pain) could be expressed in symbolic ways (thinking about being hit and how it might feel). Such revolutionary new ways of thinking were wrought by billions and billions of neurons and a neurological circuitry crackling out ingenious solutions to problems that dealt with survival but could be applied to creating art and building a technological society. Several things brought about this intellectual revolution, which are considered next.

Environmental and Dietary Changes

BRAIN: THE GIFT OF THE PLANET

If art is the gift of the brain, then to really understand art we need to understand the brain—a route that will take us far afield from looking at a Manet (figure 2.11) with your friend while visiting the Musée d'Orsay on the Rive Gauche on a fine

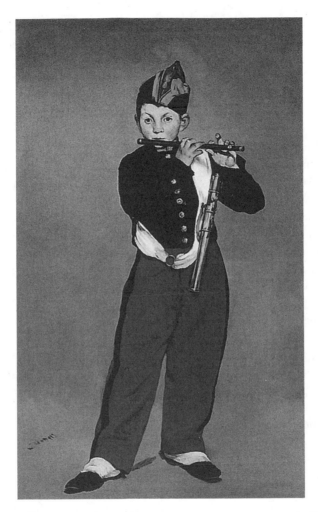

2.11 Edouard Manet, *The Fifer* (1866). Musée d'Orsay, Paris. A small boy dressed
smartly in a military uniform piping a shrill tune, yet it took a lot of fish oil to see
and hear him.

spring day in Paris. We all recognize this picture as a small boy decked out in fine military garb proudly tooting away on a shrill fife. We all "see" this lad, but we also "hear" him and, in the most human reaction of all, we try to understand what this is all about. All art is effortlessly parsed by humans into modules of thought, yet no other being even comes close to this type of cognitive analysis. "Elementary," Sherlock Holmes might have deduced. Yet the many complicated steps involved in arriving at that conclusion are anything but elementary. Here we will probe the most fundamental chemistry of organic creatures and discover how this relates to the evolution of the brain—the brain that understands Manet at the Orsay.

In the African crucible of human creation, God reached down into the mud and from it created a man and a woman. Every one of us is, in a very real way, a child of the earth. Even though much of our knowledge of the process of evolution is based on fragments of information and inferential logic, it is possible to make some very precise scientific conclusions about the human past and, more importantly for our understanding of art, see how those conclusions are related to understanding Manet.

SOMETHING FISHY FROM THE BEGINNING

Life on earth for the first 2.5 billion years consisted of blue-green algae drifting around in proto-oceans. Then, about 600 to 500 million years ago, something wondrous happened. Over time, algae reacted to sunlight—photosynthesized—to produce proteins, carbohydrates, and lipids which were rich in fatty acids (called docosahexaenoic acid or DHA). The basic forms of life (phyla) known today appeared. But the real importance of reducing billions of years of evolution to a few lines is to establish that all complex organisms evolved in an Omega3- or DHA-rich environment (see Crawford, Cunnane, and Harbige 1993). During ensuing cataclysmic climatic and geological changes in which large land masses appeared, DHA was still readily available in fishes and shellfish found in lakes, streams, and seas. For our discussion of the evolution of the brain (and hence of imagery and art), DHA is the most important fatty acid used in photoreceptor and synaptic actions.

Returning to figure 2.2 we note that, about 200,000 years ago, there was a palpable increase in cranial size. To give some perspective on this astonishing cerebral enhancement, consider the fossil evidence of the *Australopithecus* whose cranial capacity remained at about 500 cm^3 for over 3 million years. The genus *Homo* cranial capacity *doubled* from *Homo erectus* to *Homo sapiens* in 1 million years. The expansion, according to Crawford et al. (1999, 2001), may not be explained by expected Darwinian progression toward modern intelligence but by the rich source

of DHA from the lacustrine and marine food chain that was being used by early hominids. To which I might add, the overall dietary changes experienced by early humans. The ingestion of seafoods (abundant in Omega3) by people who lived near lakes and rivers is correlated with expanded brain capacity. The inference is drawn that they are causally related. Of course, changes in brain size and functionality were caused by a multitude of factors such as climatic changes, genetic accidents, and dietary changes including (but not limited to) eating fish from the sea. The idea that the ingestion of seafoods is related to cortical development is supported by current organic studies in which DHA has been shown to be a nutritional component and is important in vascular development, a prerequisite for cortical development.

"THE BRAIN MUST COME FIRST"

Further evidence for the importance of a seafood diet (to provide what nutritionists call long-chain polyunsaturated fatty acids) for brain development may be found in the complex migratory colonization of Australia, and later Tasmania and New Guinea, from the Wallacean Islands. To mount such an operation required an advanced brain. These early peoples' overland pathway followed along the coast, an anthropological observation of considerable interest. And one can easily imagine people combing the seashore and streams for readily obtainable small crustaceans, and other animals from the marine food chain, rich in Omega3.

Crawford et al. (1999) astutely comment on the importance of these concurrent events: "We consider this association not accidental nor coincidental, but a

reflection of the dramatic influence of brain specific nutrition on the evolutionary process. We do not accept the postulate that *H. sapiens a priori* evolved a large, complex brain, then began to hunt in order to maintain it—*the brain must come first*" (p. 5). And, in order for the brain (whose gift was art) to come first, there had to be a proper diet abundant in docosahexaenoic acid. (Perhaps the old adage about fish being "brain food" is true.)

Intellectual changes were necessary not only for developing all the skills necessary to build seagoing vessels, but for humans to become consciously AWARE, in the full sense of the term. Knowledge of the organic and biochemical reasons for the expansion of the brain helps us understand how modern humans had the necessary cerebral machinery to image and produce art—an endowment akin to imagining and building boats. There is one final factor in the formula that makes the type of computational processing of visual information, language, and abstract representations of reality possible: how the brain works vis-à-vis its evolutionary history.

Brains and Adaptation

Of the many bits of Darwinism, the supposition that living beings have been around for a very long period—far, far longer than the six millennia suggested by a literal reading of the Old Testament—is sometimes overshadowed by other parts of the theory. Yet, when we look at the fossil evidence of cranial capacity, and, more importantly, at the cerebral cortex inside, we see that brain development has undergone remarkable change over the past two million years and really spectacular changes in the past half million years. (See figure 2.2.) Of all human features, the brain has changed the most.

A key marker in the evolution of the human species is the production and understanding of art. No other creature has this capacity. One way to understand art is to look into the brain for reasons. Human brains are bigger, in general, and more complex, by far, than other mammalian brains. The "purpose" of this brain was to serve the biological needs of adaptation to the planet and reproduction, which is not a bad assignment. It was not to go to the Louvre on Sunday afternoon and look at the Mona Lisa. However, art is the unexpected result of this remarkable evolutionary tale. The features of the human brain that make art (and many other capacities) possible are in its composition and functionality. The modern brain is composed of a number of rather specialized modules, each of which has evolved through natural selection to cope with specific problems. These adaptative-coping mechanisms evolved as humans struggled to survive during the Pleistocene—a period when the style of daily life was hunting and gathering.

Modules, Problem Solving, and Art

Modules are "content-rich," meaning that they provide sets of rules whereby one might solve a problem and the knowledge necessary for such a solution. This knowledge reflects the real world—the world that existed during the Pleistocene—and is part of the hard-wired brain we come into the world with. A neonate may form eye contact with her mother very soon after birth and with little conditioning to influence such innate performance. While many innate modules are engaged in our understanding art (the perception of form, colors, movement, for example), there are other learned attributes we bring to art (such as knowledge about the historical/philosophical context of an art object).

Several theorists have eloquently characterized the functionality of modular intellect in terms of specialized cognitive faculties (e.g., Gardner 1993). The mind might be conceptualized as a Swiss Army knife (Cosmides and Tooby 1992, 1994) that has "blades" for specialized functions, or as a "clearing house" (Karmiloff-Smith 1992) for processing information. Such metaphors may help us grasp the way a modular brain works, but I would argue that such accounts fall short, as they do not engage conscious AWAREness. While good neuroscientific evidence exists that validates the idea that the mind consists of a number of interactive modules, it is suggested here that the solutions and knowledge needed to solve problems are meaningful in terms of consciousness, as well as in terms of unconscious determinants of behavior. Thus, when we view a painting, we may organize the piece in terms of any number of Gestalt principles of closure or common fate that bear directly on how we understand the object. There are, simultaneously, a number of unconscious primes that likewise activate thoughts and actions. The brain has enormous processing routes that may be triggered by the sight of a picture.

Seeing Art

Seeing art is initiated when an eye views objects, an eye that was designed to see forms, movement, colors, and faces over a million years ago. Understanding art happens after sensed stimuli are processed by mental modules that originally evolved to understand interactions between ourselves and objects and other people. As the fingernail did not evolve to open a Swiss Army knife, so too the brain did not evolve to understand Picasso. The fact that fingernails and brains can do more than pick berries or react to danger speaks volumes for the type of adaptive ape we all are.

It is sometimes easy to overlook how uncommon brains are. We are, after all, surrounded by whole kingdoms of brainless things, from plants to lifeless inorganic

worlds which, insofar as any scientific evidence is concerned, are devoid of intelligent beings—SETI investigations notwithstanding. Furthermore, our planet spun lifelessly for millions of years before simple life forms coalesced, and only during the thinnest sliver of life has intelligence appeared.

VISION, BRAINS, AND ART

While questions of cosmic intelligence go unanswered, at least for now, we finish this chapter with some general ideas about the nature of human vision and brains, especially as related to art.

The visual system, by which we perceive much of art, evolved for the same reasons as the brain evolved, and the two work harmoniously to enhance survival and reproduction—not to find beauty in a Bach fugue or Raphael painting. Their purpose was to solve mundane problems such as finding food, distinguishing objects from their backgrounds, recognizing kinfolk, making judgments about people's motives, selecting sexual partners, using language, making tools, and hundreds of other things. The fact that we use our eye and brain in the current world to understand the profound meanings of paintings may all be traced to and comprehended in terms of who we are and how we got here.

Our eyes and brain evolved for a particular function—adaptation. In order to attain this, the external world had to be represented to the internal world accurately. (See chapter 1.) If judging the trajectory and speed of a spear headed toward one's chest is inconsistent with the physical reality of either trajectory or speed, the unlucky mortal would not likely survive long enough to breed his dysfunctional cognitive trait. Visual perception is useful to early man trying to bring down a wily antelope, or dodge a falling rock, or read the expression on a woman's face as being receptive, only if such perceptions are consistent with the external realities, and woe to the hapless man whose perceptions fail. He is liable to end up hungry, wounded, and disillusioned. Fortuitously, evolution corrects such incongruous discrepancies.

VERIDICAL PERCEPTION

What we see is what is in the "real" world—philosophic arguments on the issue being temporarily suspended. This is called *veridical perception* or the idea that one's perception is consistent with the actual reality in the external world. However, we know that when two people view the same piece of art there may be two broadly different interpretations. How can this be, given the reliability of veridical perception through the ages? The answer has baffled philosophers and psychologists for

some time, yet the answer, it seems, is straightforward if the question is cast in an evolutionary psychology mode. We will revisit this topic in chapter 6.

EXPERIENCE, MEMORIES, AND ADAPTATION

Our perceptual-cognitive system, which developed over hundreds of thousands of years, evolved for the purpose of representing the terrestrial world to the brain so that reasonable actions might be performed. The brain, however, records these experiences in memory and records many more throughout the course of a lifetime. The brain is particularly adept at storing past memories, which provides a plentiful repository for understanding new information. Each time you see a baroque painting, you do not see it with a naive eye and brain, but based on your knowledge of baroque art, of seventeenth-century Western culture, of art history in general, and of visual event as an inclusive category.

As individual experiences are accumulated and interact, a type of personal schema emerges. We all have them. Your personal schema may prompt you to see "the eternal struggle between a man and his Creator" or "the desire to raise a healthy family" or "the need to find order in the universe and one's daily life." Seeing the world through the tinted glasses of a schema always distorts perception. But we will discuss that part of the story in the final chapter. For now, consider how these matters bear on adaptation.

Brains evolved because they performed computations that regulated a person's internal processes and overt behavior, which were related to adaptability. Within a person's lifetime the brain records instances and knowledge of past actions and their consequences. Those neural patterns and modules of problem-solving that were successful were passed on, while unsuccessful mutations of cerebral mechanisms died out.

The Evolution of the Brain

Of all the unsolved mysteries of the history of the universe, none is more enigmatic than the evolution of the human brain. The fact that organic life emerged from the inert planet is, in the minds of many, a miracle of (truly) biblical proportions. The earth, the only life planet of which we have any knowledge, spun lifeless for over a billion years before the first glimmer of blue-green algae appeared; it was three billion years (3,000,000,000 years) later that shellfish and sea corals emerged, and it took another 350 million years for mammals to evolve. Another 345 million years would pass before the first humans walked the earth, and only 125,000 years ago

did a semiconsciously AWARE man begin to ask questions that showed some cognizance of something beyond himself. Art, the clearest marker of the emergence of the consciously evolved brain, is only about 60,000 years old.

EVOLUTION AND DIVERSITY

Edward O. Wilson in *The Diversity of Life* (1992) bemoans the fact that we have only a rough approximation of the number of species on our own earth. There may be 10 million species or 100 million. And the number of species that has graced the earth from its beginning may be as high as 500 million.

Consider how these diverse living beings survived and reproduced. Insects, which enjoy the largest number of living species (750,000), have been around for about 340 million years. Some humble living things, such as the marginally AWARE cockroach, have survived for 320 million years (and may well continue) because they do not mind eating garbage, wallowing in dung, and, perhaps most worrisome, because they can tolerate many times the amount of radiation that would kill off people and other fleshy mammals. Never mind that they look ugly to us. (And in making such an aesthetic judgment is contained the basis on which most humans form their opinions of "good" and "bad" art.) Insects and flowering plants, which comprise the greatest number of creatures on earth, use a type of well-balanced symbiosis.

Insects suck nectar from flowers and befoul themselves with pollen, which is unAWAREly used to germinate a neighboring plant. It seems to me that this type of opportunistic symbiosis is a lesson humans could learn from. Other creatures have survived because they run faster, fly higher, swim deeper, have sharper teeth, mimic others, hide better, see, hear, taste, or smell more acutely, or are simply terribly repugnant to eat or be around. There are few suave warthogs, except to other warthogs. But of all survival techniques, the one that seems to be most popular is redundancy. Almost every living thing produces many times more seeds than can be expected to survive—in some cases by an order of magnitude in the millions. There is an exquisite balance between production and survival that has maintained a delicate equilibrium in the natural order of species. Only within the last few centuries has man been able to invent means to keep alive people who, by natural selection, would die off.

AWARE BRAINS ARE SPECIAL

The most curious method of adaptation is one found among only a handful of species: the computational brain ensconced in the skull of consciously AWARE be-

ings. Science has overlooked how unusual brain power is in outfoxing predators, perhaps because we humans are so accustomed to doing so, on the savanna or in the board room. Only a minute number of creatures evolved this unusual mechanism to cope with the vicissitudes of environmental change. Because it is the rarest of survival techniques, found among the smallest number of species whose evolution was contingent on very narrowly defined environmental conditions, it is possible that this method of survival *may* be unique to earthlings. Even more fascinating is how cortical development, designed for the limited purpose of survival and procreation, was able to contemplate weighty topics such as "Who am I, where did I come from, and where am I going?"

Some Dogs Can't Hunt

Some brains can't understand while others can. And that was the miracle that happened in a jagged fashion when modern man was granted a computational brain 60,000 years ago . . . with some sapient shards of AWAREness arriving as early as 120,000 years ago, and cerebral architectures forming the blueprint for the modern brain millions of years before. That we modern humans evolved a magnificent brain capable of seeing outside of itself is only part of the story. From what we know of the epistemological history of gathering information about the world and its inhabitants, it is highly likely that our present brains are capable of understanding only a particle of universal truths—and what we do "know" is markedly distorted by our limited sensory-cognitive systems.

Human brains, like some dogs, can't hunt beyond those borders set by physiologically and psychologically determined limits. We cannot know what we cannot know. We even have difficulty asking questions to which we couldn't understand answers!

Contemplate the history of knowledge, say over the past three millennia, and consider the tremendous progress in knowledge. Now, project that vector of progress into the next three millennia. Then the next 60,000 years—the approximate time fully AWARE humans have been around. Cast in these modest time frames, modern man's depth of ignorance of universal knowledge is, in fact, unfathomable. We "fully" AWARE beings, with our capacious computational brain and billions upon billions of interactive neurons, might really be in the same mental league as the witless unAWARE cockroach if we consider what fraction of universal knowledge we grasp. It is difficult enough for humans to understand things as rudimentary as neurotransmission, the beginning of the universe, the rings of Saturn, geological layers, or infantile autism, let alone what happened before the Big Bang, what gravity is, and what is beyond the universe.

The intricate sequence of neurocognitive developments, which lead to conscious AWAREness in modern man, may be reconstructed logically from empirical evidence, some of which has been presented in this chapter. From our story of tools, language, and art, all supported by a brain capable of thinking outside of itself, it is intellectually tempting to presume that we cerebrally superior animals are divinely endowed with a manifest destiny that compels us to seek purpose and understanding in the universe. Such teleological speculation is unsupported by archaeological and neurological evidence. The queer course of evolution was driven by capricious winds, and, as metaphorically difficult as it is to conceptualize "life," it is beyond the creative talent of man to find the truth—if there is a truth—about the purpose of existence.

Cognizant creatures reacted to the winds of change by using their brains and imagination to change the environment. Through the gift of imagery, humans could not only see things as they appeared but also, much more importantly, as they might be. Vision, intellect, adaptation, memory for past actions, mixed with the instinct to survive, were the ingredients that produced art, clothes, language, tools, chariots, and computers, as well as every other thing cobbled together by a mind that guided the hand of man.

3 Art and Vision

*If the Creator were to bestow a new set of senses upon us, or slightly remodel
the present ones, leaving all the rest of nature unchanged, we should never
doubt we were in another world, and so in strict reality we should be, just as
if all the world besides our senses were changed.*

—John Muir

During the past few years remarkable progress has been made in perception and
neurocognition, those scientific areas involved in sensation, perception, knowl-
edge, and thinking. Among the most exciting developments—especially for those
of us interested in the visual arts—are discoveries made by cognitive scientists re-
garding human vision that tell us how we "see" and "understand." Of the five senses
with which we behold the physical world—vision, audition, taste, touch, smell—
vision is the faculty that is most directly related to the perception of art: it truly is
"the big window."

Visual AWAREness

Our perceptual apparatus—eyes, ears, gustatory and olfactory sensors, and sense of
touch—all evolved to *sample* physical energy which abounds in the universe. The
most prominent energy on earth, since its forma-
tion more than 5 billion years ago, is solar energy. *Nature is the wellspring of all art.*
The segment of this energy we see is called light,
yet many other kinds of energy surround us that go undetected. Less than half of
the light from the sun is within the visual spectrum of humans.

 We terrestrial mammals have basked in sidereal sunlight since before the very
beginning of measured time. Eyes evolved to catch a bit of the electromagnetic en-
ergy that so abundantly bathes the earth. Likewise, the other senses evolved to cap-

ture different classes of energy: all of which gave a wider impression of the earth and the things therein. This expanded view of environmental forces was an initial step in expanding human AWAREness, as discussed in chapter 1. In order for animals to become more consciously aware of the world, a sensory system that captures essential information from a broad cross section of environmental stimuli was required. While we *Homo sapiens* rely mostly on vision, all senses are important for survival. In other animals the same five senses emerged, but the relative importance of each sensory modality varies. As an example of how some senses are more important than others, consider the case of dogs, in which a heightened sense of smell is more sensitive than vision, while in birds just the opposite is true. At the sensory level, dogs are more aware of olfactory cues and birds are more sensitive to visual signals than are humans. Whether they are more cognitively conscious of these signals is doubtful, however. In order to ascribe higher-order meaning to these signals, a more complicated brain is necessary—a brain capable of forming abstract representations. Birds (and dogs) may be trained to respond to complex visual and auditory stimuli, but *understanding* abstract concepts (such as calculus, the origin of the universe, the meaning of a metaphor) is a trait that requires a level of comprehension beyond their cerebral capacity.

There is a celebrated case in which the famous behaviorist B. F. Skinner, during World War II, concocted a scheme whereby pigeons were to be placed in an explosive missile. The pigeons could direct the missile to an enemy target by pecking at three disks hooked up to the missile's guidance system. These kamikaze birds never saw live combat; apart from humane considerations, there were those who thought some hapless birds might unthinkingly turn the missile back on Allied targets, in spite of the fact that experimental results clearly indicated that operantly reinforced birds could make reliable, and rather complicated, operant responses. In any case, not a single bird indicated a deeper understanding of the nationalistic principles involved. Nor was there a single instance of draft card burning or conscientious objection. While birds may be conscious of many things, they seem not to grasp the deeper meaning of their mission.

The same level of cognitive consciousness is true of your dog, who, when called by name, may bound across the room with reckless abandon, scattering flowerpots, small chairs, and lamps, but, sadly, doesn't have the foggiest notion of the *meaning* of a simple conversation. Or my friend's dog, Haggis, who is simple by elementary school standards, though sensitive and reactive to emotional dissonance in the house. Arguments of human superiority are out of place here. I am talking about differences, not supremacy. Pigeons, dogs, and Neanderthals do what they do very well (fly, run, sense strife, survive).

Homo sapiens do some things differently, such as use a complex brain to attempt to understand cosmic problems. The human brain that has evolved to this point is capable of processing a number of thoughts simultaneously. This helps us to think deeply about issues and allows us, coincidentally, to glimpse the eternal forces that spun the earth and heavens in the first place. In that, we think like no other earthly being. Because of the extraordinary circumstances surrounding the evolution of conscious AWAREness, our intellectual endowment may even be cosmically unique.

TECHNOLOGICAL AWAREness

The evolution of the eye and other sensory devices, in conjunction with a multiprocessing brain, was designed to optimize a species's performance. Such observations have been made throughout the animal kingdom (Goldsmith 1990; Land and Fernald 1992). In every case, the perceptual-cognitive systems are designed to represent signals of the external world to the brain. However, as well as they depict images, they also distort the external world by amplifying some signals (as in the case of contour enhancement), by limiting other signals (as in the case of responding to a limited range of electromagnetic stimuli), and by deceiving our perception (as in the case of illusions).

As serviceable as these sensory devices are in keeping us and other creatures out of trouble, they are capable of detecting only a tiny fraction of the available energy in the cosmos. It was not until the emergence of a technological world—say about 1610[1] (plus or minus 400 years!)—that man's perception expanded beyond the prosaic equipment that had evolved over millennia to see ripe berries, moving predators, and a friendly face. Since that time we have been able to see the invisible, hear the inaudible, and in many ways amplify, diminish, or modify signals so that they are brought into the range of natural sensory detection. These devices, which are very important to technological AWAREness, have had equally profound psychological impact in that they have extended human consciousness and brought forward fantastically new heights of human AWAREness. The significance of the technological revolution, which may well be in its initial stages, on psychology is as important as the emergence of the newly consciously AWARE human some 60 millennia ago. Of course, a more or less consciously AWARE brain was required in order to invent techniques that enhanced, widened, and deepened the ken of our senses.

As we approach the topic of the psychology of art as a visual experience, we do so with a technical knowledge base concerning physical energy and the mech-

anisms of vision not available to the legions of artists and art scholars in the past. Photonic energy, as seen in reflected light off a painting, and its transduced form, as seen in human sensory-neurological signals initiated by light, are both physical processes. Art and physics share a common electrochemical bond, as mentioned in chapter 1. Understanding the basic properties of how the eye processes visual signals and how the brain interprets the signals is fundamental to the psychology of art and consciousness.

By considering the evolution and purpose of the human visual system, we gain important perspective on those things that are (and were) important for us to sense for survival. From this more broadly defined vantage point, we can develop a theory of aesthetics that considers the principles of visual science and the evolution of the eye and brain. This descriptive evaluation of art begins with the eye of the beholder, not in the sense that there are no universal standards but, quite the contrary, that the collective eye of the beholder is the only means people have of seeing art in the first place. Through millennia, our visual system has grown to respond to a narrow range of stimuli while at the same time our brain has also developed cerebral modules and routines that interpret and evaluate these signals along aesthetic lines. The considerable influence of culture is woven into these evaluations, but the point here is that all art is first of all perceived by early sensory receptors that are universally shared by all members of the species, *then* subjected to aesthetic appraisal.

Seeing with Brain and Eye: The Dynamic Properties of Vision

When we see an object—it could be a painting, such as the gentle scene of a mother and her child depicted in Mary Cassatt's *The Bath* (figure 3.1)—our understanding of it is based on a stream of neural activity initiated by light reflected from a surface combined with our existing knowledge. We are AWARE of the content because physical changes take place in our eye and brain. We interpret these signals in the light of our knowledge of how mothers care for their daughters. This light, which is purely physical in nature, reaches the retina of the eye, where it is converted (or *transduced*) into neural activity and passed along to the brain. The physical characteristics of light follow regular and lawful rules. So, too, the laws of neurotransmission are regular and lawful, with few structural differences among people.

To become fully AWARE of art involves the observer's cognitive background, which gives such experiences meaning. Thus, your recall of information (about mothers and daughters) and your emotional reaction to *The Bath* might be far differ-

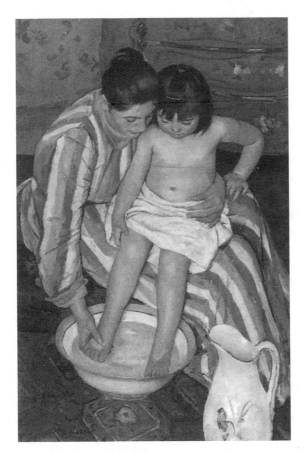

3.1 Mary Cassatt, *The Bath* (1891). The Art Institute of Chicago. The softness of light reflects the tenderness of the moment captured by the artist.

ent from mine; and your reaction to another picture is likely to be entirely different from your reaction to *The Bath*. Each of us "sees" the world in profoundly different ways because of the vast diversity in the way we humans develop individual mental structures of the world, which are expressed in our conscious AWAREness.

INTERPRETATION OF VISION

Lest this claim become too exaggerated, it should be noted that there are broad areas of common experience among people that ensure a degree of intellectual

equivalence. Your conscious AWAREness is something like that of most bus drivers, college professors, and artists. It is the reason we can form cooperative societies. When views differ radically (views of how mothers relate to children, for example), they may be the cause of personal strife. An important conclusion we can draw from this simple example is that *seeing is accomplished through* both *the visual stimulation of the eye and the interpretation of sensory signals by the brain.*

Light reflected off objects does not fall on the eyes of mindless creatures; each of us has a thinking brain that we use, more or less effectively, to comprehend what the eye senses. We are endowed with an immense capacity for thought and cognition, applied so routinely to the world around us that much of our everyday behavior may seem a simple matter of stimulus and response. We now know that the sensory-cerebral machinery involved in the execution of "simple" tasks, such as stopping an automobile when we see a red light, involves a number of very complicated neuromuscular reactions.

Our common ability to "see and understand" allows us to read and comprehend the great literature of the world, to formulate elaborate botanical taxonomies, to classify types of artists, to perceive and understand the motion of planets, to enjoy and grasp the inner meaning of baseball, Beethoven, ballet, or bungee jumping, to make sense out of everyday conversation, and to otherwise move around in a three-dimensional world without getting killed. We will have much more to say about the dual nature of seeing, but for now it is valuable to recognize that seeing is initiated by sensory objects and the interpretation of sensory stimuli by the brain.

THE PHYSICAL SIDE OF VISION

In this chapter we will concentrate on the physical nature of visual objects and then consider the physiology of the eye and brain involved in processing this information. These topics are related to the sensory part of the dual theory of visual perception. Later we will consider the interpretive-cognitive aspects of the problem.

To "see" the world, and hence to see art, requires first of all physical energy: without the swing of electromagnetic energy there is nothing to sense, nothing to see, nothing to understand.

Seeing is an enormously complex phenomenon that is difficult to grasp in its entirety. However, by considering the individual components of seeing—the physical properties of light, the structure and function of the eye, the neurotransmission of visual signals to the brain—we can begin to sort out and understand the steps involved.

Nighthawks: **An Example of Information Processing**

The forlorn figures in Edward Hopper's *Nighthawks* instantly evoke a feeling of loneliness and desolation in many observers. Perhaps the scene created by this American artist even reminds you of a melancholy episode in your life. Certainly, children of the American Depression view this scene in light of their experience, while people reared in happier times might see a cozy refuge from the bleak street. (Not all reactions to this painting are the same.) These impressions are the consequence of a series of processing stages in each of which information is enriched, or in some way transformed, and passed on to a subsequent stage for further processing.

In the first stage, reflected light from the painting passes through the lens of the eye, is inverted, and is focused on the retina. Several electrochemical functions take place in the first stage, in which light energy (photons) is converted (transduced) to neural impulses. These impulses are routed to the visual cortex by means of the optic nerve. There the second stage of processing takes place, in which visual stimuli are "analyzed" according to primitive features, such as vertical and horizontal elements, angles, and curves. These primitive features are "recognized" and "classified" and dispatched to other parts of the brain by means of a massively parallel network for processing, some parts of which deal with colors, others location, and others faces. It is during this final stage, in which signals are scattered to distant parts of the brain, that associations are made between this painting and the viewer's vast personal knowledge of self and the world. Consideration of these three stages will guide the discussion of art throughout this book.

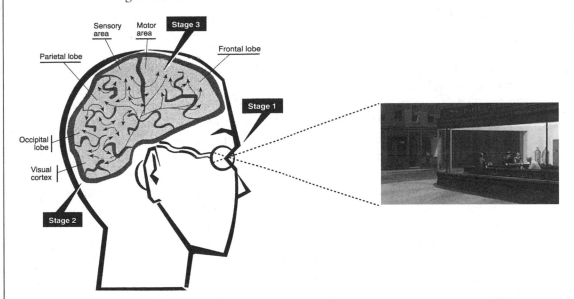

3.2 Stages of information processing in viewing art. Edward Hopper, *Nighthawks* **(1942). The Art Institute of Chicago.**

INFORMATION PROCESSING THEORY

The analytic operation of identifying the principal components of perception-cognition is particularly suitable to the study of vision, because the process seems to follow the flow of information from the presence of light energy, to the detection of that energy by the eye, to the transmission of the signal to the visual cortex in the brain, to the cognitive interpretation of signals throughout the brain. This flow of information (physical energy → eye → visual cortex → associative cortex) is compatible with a major theoretical paradigm in cognitive psychology called the *information processing paradigm*.

The information processing (INFOPRO) paradigm (or model) proposes that information is processed through a series of stages, each of which performs unique operations. Each stage registers information from a preceding stage, processes it, and then passes it along to another stage. This is sometimes casually called a "conveyer belt" model. While the INFOPRO paradigm is a suitable model for understanding the various components and sequences involved in perception and cognition, we should be mindful of the interactive qualities of the components. Thus, processing of information in the brain, for example, is subjected to highly interactive operations that blend incoming sensations with past memories. These operations are only beginning to be sorted out by modern imaging technology and other, conventional cognitive studies. It appears that the unique processing done in each "stage" is seamlessly integrated with other systems.

The perception of visual art follows the orderly sequence of processing stages expressed by the INFOPRO model. In the first stage, reflected light energy (emanating from a painting, for example) passes through the pupil in the eye and falls on the retina, permeated with photosensitive neurons that line the interior of the eyeball; here, initial optical processing occurs. These retinal receptors work with other neurons—some processes are activated and others inhibited; lines, edges, contours, contrasts, and colors are initially processed, and so on—in an intriguing amalgamation of neurochemical actions. These initial processes operate automatically, without conscious control, and are generally the same for all members of any given species. On the other hand, where we focus our attention is a subjectively determined matter. Light energy is transformed to neural energy and passed along to the primary visual cortex (PVC) in the occipital region for processing and then routing to other centers.

To many, the activities performed by the brain are even more fascinating than the optical processes. Here, basic information is received from the eye and organ-

ized into meaningful patterns. It is in the brain that multitudinous connections are made between incoming signals and numerous neural units that give meaning to the visual object detected by the eye. Following the initial processing by the PVC, two interactive "streams" or routes are initiated: one, called the *what pathway,* and the other, the *where pathway,* specialize in determining what an object is and where it is located. This characterization is a bit simplified, as many other interactive streams take place simultaneously. *Higher-order processing* is also engaged. It is during this stage that vast knowledge about the world in general, and about art specifically, is applied to the sensory information; the object is interpreted. These brainy matters will be fully explored in the next chapter.

Using the INFOPRO model here, we will begin with an analysis of the first part of the process, the perception of light. While the common impression is that the universe is filled with light, my view is that we are more like the figure (whom I call Zil) in Peter Max's painting *Traveling in Light,* shown in plate 1. Here, Zil, like all of us, hurtles through a pitch-black universe wrapped only in a cocoon of dazzling light. We see colors with photosynthetic eyes designed to see terrestrial objects—sweet berries, moving game, fresh water, and the like. I use this image as a metaphor for the phenomenology of sensation. It is only because Zil has eyes and a brain with which to see and understand that he can see colors and light. For billions of years only the darkness prevailed, till sensory receptors allowed it to be experienced as a noisy kaleidoscope of earthly sensations. These wonderful windows to the world allowed us to see the invisible things of this world and beyond. In the new technological world we have invented with an AWARE brain, it is even possible for Zil to penetrate the darkness beyond the cocoon.

> *And the earth was without form, and void; and darkness was upon the face of the deep. . . . And God said, Let there be light; and there was light. And God saw the light, that it was good.*
>
> Genesis 1:2–4

LET THERE BE LIGHT

Imagine the world before there was life to give it light—only a turbulent orb spinning in a wash of electrical forces. The earth, like the rest of the universe, is totally blind. Yet, to us, the earth and cosmos are brilliantly illuminated. Light needs life to be seen. Gradually, early life captured energy from the sun, such as the blue-green algae that broke down water and carbon dioxide and provided oxygen for the atmosphere, well over a billion and a half years ago. Did light appear then? Or did

the light of the world appear first to the common trilobites whose relentless mucking through slimy mud pits over 500 million years ago caused them to sprout a specialized sensing instrument some call an "eye"? Or perhaps light did not flash on the earth until the first lobe-finned fishes, the first sharks or first amphibians, or the first dinosaurs allowed a peek at the celestial. Certainly, the eye of mammals and man discovered light. Understanding—really understanding—light and all it illuminates, however, requires conscious AWAREness; an awareness van Gogh taught us to see when he painted *The Starry Night*. (See plate 2.)

We are allowed a view of light and the impressive colors of the rainbow because our eye and brain evolved to respond to those rays. Our eyes sense no more. Nature reveals the narrow range of sensory colors in the rainbow (see plate 3) as electromagnetic energy passing through water droplets is prismatically scattered. You may wonder why she shows us only the colors of the visual spectrum. Actually, the field of energy is far more capacious than the span from red to violet that we see. Nature is showing us just what the eye can see. Somewhere over the rainbow, countless other rays, both shorter and longer than the eye can detect, stealthily fall unseen to the earth—and for good reasons. Ultraviolet (UV) light is harmful to the eye. Fortunately, our stratospheric ozone layer absorbs most of the light below 300 nanometers (nm), and of those rays (both UV and infrared) that do reach our planet most are well tolerated.[2]

The Eye

Without light there would be no art, but without an eye to register the light there would still be no art. So the next piece in the puzzle is the structure and function of the eye.

It may come as a surprise to learn that human eyes are not the most complex optical systems in the world. They are complex and sophisticated, but other creatures have more complex optical structures. The eyes of simple arthropods (such as insects), for example, contain many lenses and receptors, while we have but one lens with numerous receptors. In general, more simple-brained creatures have more complex optical sensors while more complex-brained creatures have simpler optical sensors. Offsetting the relatively simple lens of the human eye is a fantastically complicated brain that permits us to "see" far more than

Painting is, first of all, optical. That's where the material of our art is: in what our eyes think. Nature, when we respect her, always tells us what she means.

—Paul Cézanne

3.3 The fossil eye of a species of trilobite. This is the earliest known fossil remains of an eye. Each of the circular facets is a corneal lens similar to the structure of modern insect eyes. Some trilobites could see 360 degrees. (From Gregory 1978.)

we sense. The earliest known visual sensing device has been remarkably preserved in the fossil remains of trilobites, which inhabited this earth over 500 million years ago. These marine arthropods, ancient relatives of crabs and shrimp, lived mostly in the murky waters of ocean bottoms. Figure 3.3 shows an example.

BASIC ANATOMY

The basic anatomy of the human eye is shown in figure 3.5. Light enters the eye through the pupil, the opening in the eye that is surrounded by the colored iris. On the surface of the eye is the cornea, and behind the iris is the lens. Contrary to the popular view, the lens does not bend the light, at least not very much; it is the fluid (aqueous humor) in the cornea that bends incoming light. The lens does serve an important role in accommodation, the process that allows us to focus on near things

The Evolution of the "Big Window"

The human eye is the most important sensory instrument for detecting information. The "big window" is open to a wide range of visual information, from the sight of a setting sun to the words on this page. Human eyes are also prominent social instruments, signaling interest, as is well known among amorous couples. The evolution of this most remarkable sensory channel did not occur overnight, or even during the period of prehistoric man, but required hundreds of millions of years before reaching its present stage of development. Long before the first humans scratched out an existence on the African plains, their distant forebears had highly developed eyes and brains that saw and comprehended the sights of the world.

The very earliest "eyes" were scarcely more than a cluster of photosensitive cells that were connected to locomotive devices. Thus, the detection of light (or heat) might activate an appendage that would move the creature toward (or away from) the stimulus. Eventually these photosensitive cells became more densely clustered and situated in an indentation on the body surface. The opening to the indentation was closed with a transparent membrane. These components later developed into what we now know as the retina and the lens. Figure 3.4 shows

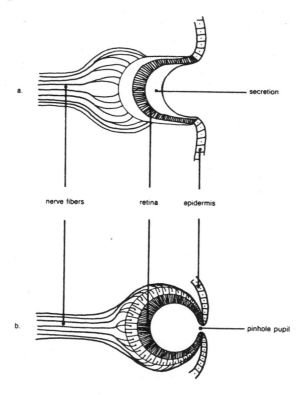

3.4 **The eye pit of the limpet (above) and the pinhole eye of the nautilus (below). (From Holland and Quinn 1987.)**

January 2000

Sunday	Monday	Tuesday	Wednesday	Thursday	Friday	Saturday
					1	**2** Amphibians
3	**4** Reptiles, Insects	**5**	**6**	**7**	**8**	**9**
10	**11** Dinosaurs, Mammals	**12**	**13**	**14**	**15**	**16**
17	**18** Prosimians	**19**	**20**	**21**	**22**	**23**
24	**25**	**26** Monkeys emerge	**27**	**28** Apes emerge	**29**	**30**
31 Australo-pithecus	9:00 p.m. Humanoids, 11:59 p.m. Recorded history					

the eye pit in the limpet, a shellfish similar to a scallop, and the "pinhole" eye of the nautilus, a shelled mollusk related to the octopus and squid.

The first multicelled organisms with their rudimentary "eyes" emerged during the Proterozoic Era (1.5 billion to 600 million years ago). Sometime during the Paleozoic Era (600 million to 220 million years ago) something like a "real" eye and central nervous system materialized. Only within the past three million years have a humanoid eye and brain graced the earth.

All too often we act as if our eyes and brains were invented during the twentieth century, or perhaps during the Renaissance, to see and understand art. Wrong! Eyes, primitive and unknowing instruments that they were, emerged hundreds of millions of years ago, and their purpose was not to see Rembrandt, van Gogh, or Picasso paintings, but to see and comprehend light, movement, and contours. It is that old-fashioned eye and brain that we use to see and understand the universe.

To place the evolution of the eye (and brain) in context, consider only the past 248 million years of organic evolution. This spans the Mesozoic and Cenozoic eras and includes the period in which complex eyes appeared. During this period, insects, dinosaurs, giant reptiles, sabertoothed cats, grazing mammals, and primates (including your mother and father) emerged. Each had eyes and a brain of some sort. Now, depict this period as one 31-day month (we will use January 2000). Each day in this immensely long month is equal to eight million years.

During the first week of this month amphibians, reptiles, and insects were abundant, all of which had well-developed eyes. (Primitive eyes had emerged during the previous month.) On about January 10 mammals evolved, during the Triassic period. During the next period (Jurassic), which ended after the second week, huge dinosaurs walked the earth and birds evolved. Only on the last day, January 31 in the early afternoon, did a humanlike form appear; within the last 10 minutes of the month falls the entire history of visual arts, and about 4 minutes before midnight humans recorded their impressions on the caves in Lascaux, France. At the beginning of the last minute of the last day the pyramids of ancient Egypt were still 1,000 years away, and the entire history of Western art is crammed into the last 30 seconds. Most of the twentieth century, with its revolutionary scientific and artistic change, is allocated only one second in this scheme.

The human eye, the instrument we call the "big window" that gives us so much information about our world and is the source of our knowledge about art, emerged relatively recently.

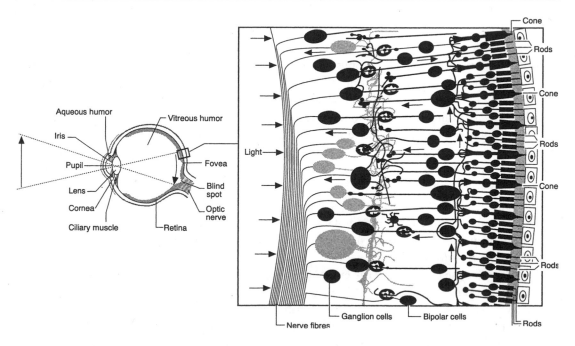

3.5 Diagram of a human eye and detail of the retina showing the rods and cones.

Plate 1 Peter Max, *Traveling in Light* (1971), private collection. Here, Zil sees light and the colors of the rainbow as he hurtles through an opaque universe, much like we earth creatures who are sensitive only to the narrow band of electromagnetic energy in the visual spectrum.

Plate 2 Vincent van Gogh, *The Starry Night* (1889), The Museum of Modern Art, New York. Teaching the world to see light, colors, the moon and stars.

3

4 ELECTROMAGNETIC SPECTRUM

10^{-14} meters 10^6 meters

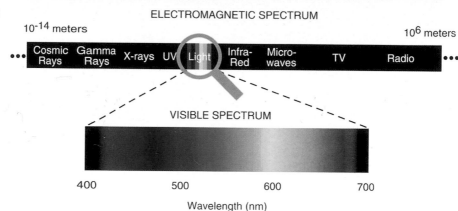

Plate 3 *Mountain Rainbow* (2001). Water particles have a prismatic effect on sunlight. Many different wavelengths are created by this action, but only those in our visual spectrum are sensed. Photo by R. Solso.

Plate 4 The electromagnetic spectrum. The only light human eyes evolved to see is the visual spectrum, which is in the range of about 380 to 780 nanometers, of which 400 to 700 nm are shown here. (From Palmer 1999.)

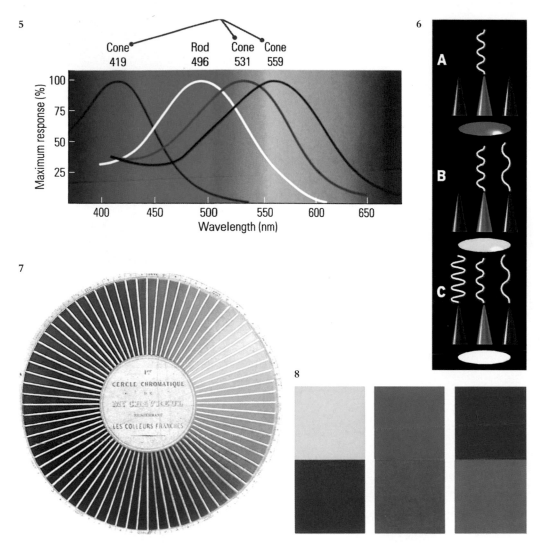

Plate 5 The relative sensitivities of three types of cones, called "blue," "green," and "red," and of rods.

Plate 6 Types of cones and how additional hues are sensed. There are three types of color-sensitive cones in the human eye, called blue, green, and red cones. In A, only the green cone is significantly stimulated, with a maximum sensitivity to wavelengths in the 530-nanometer range. In B, green and red cones combine to produce a sensation of yellow. In C, green, blue, and red cones are stimulated to produce white.

Plate 7 Chevreul's color wheel. Bibliothèque Nationale, Paris.

Plate 8 Three pairs of complementary colors by which maximum color contrast may be obtained. Complementary colors are colors whose mixture in the right proportions produces white (in the case of light) or gray (in the case of pigment): in the above example, red and green are complementary colors.

9

10

Plate 9 Enguerrand Quarton, *The Coronation of the Virgin* (1453–1454), Musée de l'Hospice, Villeneuve-lès-Avignon, France. This altarpiece shows the early use of primary colors: yellow (gold), blue, and red.

Plate 10 Claude Monet, *Impression: Sunrise* (1872). Musée Marmottan, Paris.

and far things as we choose. The mass of the eye is filled with a dense fluid called the vitreous humor, a jellylike matter that helps maintain the shape of the eyeball. The vitreous humor is mostly transparent except for floaters, which most people observe as they grow older. Floaters are thought to be caused by residual parts of red blood cells that seep into the humor and clump together in strings. To see an example of these floaters, gaze at a light surface for a few seconds. If you don't see any floaters you must be very fortunate or very young.

RETINA

The retina is the most interesting part of the eye for students of the psychology of art. The word *retina* is derived from the Latin *rete* or "net"; it is so named because, if you look at the back of the eye (the retina), a network of blood vessels is visible. Behind these blood vessels is the part of the retina that, because of its importance in perception, some scholars call an outgrowth of the brain: a thin sheet of nerve cells no thicker than a page of this book. The basic purpose of the retina is to absorb light rays and transform them to the electrochemical signals that comprise the language of the brain.

Three different types of cells found in the retina are important in passing visual sensations to the brain (see figure 3.6): (1) receptor cells (rods and cones), which are sensitive to electromagnetic energy; (2) bipolar cells, which receive information from the receptor cells and pass it along to the next level; (3) ganglion cells, which organize the information from the bipolar cells and pass it along to the lateral geniculate nucleus, then to the optic cortex in the brain. In addition to the "vertical" processing of signals from eye to brain, visual information is also processed in a "horizontal" fashion across the retina through two other types of cells: horizontal cells and amacrine cells. Horizontal cells allow sensations from receptor cells (rods and cones) to be passed along to other receptor cells. Horizontal cells are also connected to bipolar cells; thus, a limited network of communication is possible among the receptor cells in the retina and the bipolar cells. Amacrine cells connect ganglion cells with each other and thus allow communication among ganglia. Amacrine cells are also connected to each other.

RODS AND CONES

When viewed through a microscope, two distinct types of light receptor cells can be seen in the retina. They are the rods (so named for their polelike appearance) and the cones (so named because they are generally broader than rods and have a

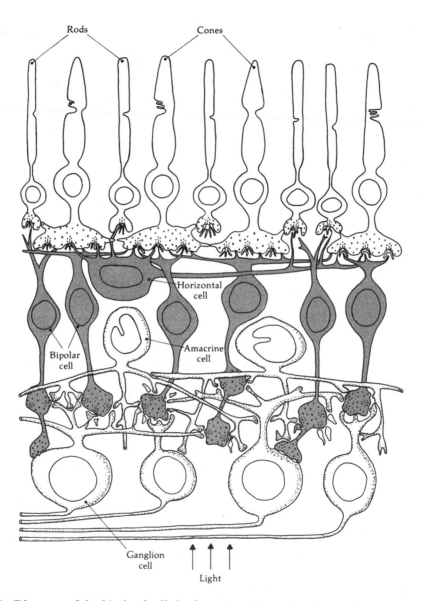

3.6 Diagram of the kinds of cells in the retina. (From Dowling and Boycott 1966.)

conical tip). A schematic cross section of the retina is shown at right in figure 3.5. Light enters the eye from the outside, passes through the pupil, and then must penetrate several layers of tiny blood vessels and supporting nerve cells (ganglion and bipolar cells) before reaching the rods and cones. It is almost as if we "see" inside out, with the receptors located on the rear periphery of the eyeball and supporting cells, blood vessels, and nerve fibers on the inside.

It might be said that by moving from the center of the human retina to its periphery we travel back in evolutionary time; from the most highly organized structure to a primitive eye, which does little more than detect movements of shadows. The very edge of the human retina . . . gives primitive unconscious vision; and directs the highly developed foveal region to where it is likely to be needed for its high acuity.

Rods work under conditions of low light intensity, such as at dusk or at night when you try to make your way to the bathroom without turning on the light. They specialize in producing vision in varying shades of gray. Cones specialize in producing the full range of color vision and are active under well-illuminated conditions, such as in broad daylight. The fovea (see below) contains numerous cones, which are present throughout the retina and allow us to see colors out to the far periphery; rods are mostly absent from the fovea but are plentiful in the periphery of the retina. For this reason, visual acuity under dim illumination, such as dusk, is actually better a few degrees off center

—Richard L. Gregory

than directly on center. (The next time you are in a dimly lit environment, try to view an object by looking a few degrees to one side.) Astronomers, sailors, hunters, and Boy Scouts have known this for a long time.

Fovea

Opposite the pupil (close to the optic nerve) is a small indented area about 2 mm in diameter called the fovea or *macula lutea* (yellow spot). Rods and cones are distributed throughout the retina, but they are unevenly concentrated. Rods are generally distributed throughout the retina except for the central fovea, which is densely packed with cones. Overall, there are far more rods than cones. Each eye has about 125 million rods and 6–7 million cones. Together, there are about a quarter of a billion rods and cones in your eyes, and they are bunched together in an area about the size of an American silver dollar. Of course, they are very small.

Figure 3.7 shows the distribution of cones in the retina and its relation to visual acuity. Foveal vision, in which an image is focused on the very sensitive

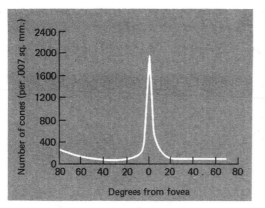 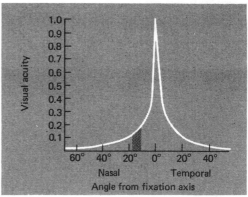

3.7 Distribution of cones and of visual acuity in the retina. The shaded area is the "blind spot" (point of attachment of the optic nerve). (From Solso 1991.)

fovea, encompasses a visual angle of only about 1 or 2 degrees. It is within that very limited range that vision is sharpest. Indeed, visual acuity for images that fall even a few degrees outside of foveal vision is very poor. The human fovea is minuscule in size, yet some estimates suggest that as many as 50,000 cones are crowded in that small area. It is immense in importance. The fovea occupies a space about the size of a pinhead, and yet, because of the vast number of cones crowded in this space, we see more of the outer world with the fovea than with any other structure. (Medieval theologians who contemplated "How many angels can dance on the head of a pin?" had no idea that the principal visual mechanism was that size.)

VISUAL FIELD

The limits of our visual field are shown in figure 3.8. Humans can detect some visual cues from a field of more than 180° horizontally (about 90° to the right and 90° to the left) and 130° vertically (about 65° up and 65° down). Sharp vision is restricted to a much smaller region. As mentioned, foveal vision subtends a very small angle of view, while impressions in the parafovea (the region surrounding the fovea) are somewhat less distinct. Even impressions up to 30° from the center are discernible, but are much less clear than central impressions. Even though stimuli in peripheral vision are poorly resolved, a considerable amount of information is processed. For example, movement of objects in the periphery significantly en-

3.8 Visual field showing the limits of monocular and binocular vision. Vertical and horizontal axes in the diagram correspond to vertical and horizontal angles of vision; the angle is measured from the perpendicular straight ahead of the eye. The lack of vertical symmetry in the binocular field is due to occlusions by the nose.

hances our ability to detect them—likely a hangover from our evolutionary past in which the detection of moving objects was important for survival.

The parameters of the visual field can be conceptualized as a "cone" of vision, as illustrated in figure 3.9, which shows a three-dimensional view of the confines of vision. The uneven clarity within the visual field is illustrated in figure 3.10, in which central items are sharp and clear and peripheral objects less clear. Because sharp vision is restricted to a narrow band of available stimuli, we view objects, such as paintings, with eyes that are constantly refocusing on different regions. A consequence of this eye movement is that we do not see a painting all at once, as is commonly thought, but by forming an impression based on a large number of individual eye fixations that examine details falling within foveal vision and input from the periphery.

To better appreciate how narrow foveal vision is, try this simple experiment. Close one eye and extend your arm with the thumb pointed upward. Now look at some object across the room. The area covered by the thumb is roughly equal to the angle subtended by foveal vision. It is within that small slice of the entire visual

3.9 Cone of vision showing foveal, parafoveal, near peripheral, and peripheral vision. (Here the angles measure the field of vision from one side to the other.)

field that visual perception is sharpest. While doing this, contemplate how fuzzy are the impressions only a few degrees from foveal vision.

Beautiful Colors

Plate 4 shows the segment of the electromagnetic spectrum visible to humans. Note that this is a small band of the total range of energy, as if we were standing behind a theatrical curtain only slightly opened. We are perceptually insensitive to the teeming energies outside of that range. But things that we can see are displayed to us in a delightful range of beautiful colors. (Unabashed romanticism! We just learned that

**3.10 What the eyes see. Notice that the face and nearby objects are clearly per-
ceived, while peripheral objects are fuzzy.**

seeing colors closed an evolutionary circuit with nature. But "seeing" is much more
than detecting electromagnetic waves of differing frequencies in order to adapt more
successfully.)

Other waves of the electromagnetic spectrum range from gamma rays and X
rays, which are tiny, to AM radio waves and the waves of microwave transmission,
which are very broad. It is within the narrow slit of the visible spectrum that all
visual experiences are compressed: from the shimmer of a swimming fish, to the
morning sun, to the yellow signpost on the interstate highway, to the sight of Lake
Tahoe's blue-green waters, to Rembrandt's subtle use of reds, browns, and golds to
create an air of deep emotion. They are all there, between 380 and 780 nm. This is
all we can sense; it is the only light to which we give life.

The relative sensitivity of the rods and cones to different wavelengths is shown
in plate 5. The sensitivity of rods is greatest at about 500 nm and drops off sharply
from there. The visual information detected by rods is not of color but of the in-
tensity of black/gray/white stimuli. Cones are most sensitive to colors in the 550
nm range, colors seen as yellow-green. Colors farther away from the maximum
sensitivity of rods and cones require greater intensity to be detected—an important

consideration for the artist who wishes to create a certain atmosphere through the use of colors and intensities.

The light waves are rarely "pure"; they are usually altered by the atmosphere. Moisture in the atmosphere, for example, diffuses or disperses light and causes a hazy image. In clear daylight, the atmosphere scatters the short (blue) wavelengths, creating the sensation of a blue sky, while during early morning and evening the long (red) wavelengths are emphasized, inducing a sense of dramatic sunrises and sunsets. This distortion of light is recognized by photographers who capture the "feeling" associated with different visual spectacles, and by artists who skillfully incorporate "mood colors" in their palettes to evoke certain emotions in their audiences.

Somewhere over the Rainbow: Trichromacy

We see all the blazing colors prismatically diffused across our visual field because of three types of cones in the retina. Each cone is assigned a portion of the visual spectrum to respond to. The effect of blending these sensations is called *trichromacy*. Refer to plate 6. Here the three types of cones are shown, each of which contains a different photosensitive pigment. The cones differ in the sense that the wavelengths of light they absorb most efficiently are in the neighborhood of what we call violet (419 nm), green (531 nm), and yellow-green (559 nm), which are also referred to as short, medium, and long spectral sensitivities. Color sensations can be combined to produce all of the many nuances of hues we experience.

The ~380–780 Puzzle

We humans can see electromagnetic wavelengths that fall between approximately 380 nm (deep violet) and 780 nm (red). There are individual differences within these parameters; some people can perceive wavelengths as low as 360 nm and others as high as 800 nm (De Grandis 1986). Other creatures can detect much shorter or longer wavelengths. Some insects, bees for example, can perceive ultraviolet rays that are invisible to humans. Pit vipers have sensory organs that allow them to detect long-wavelength signals so that they can stealthily track their unsuspecting prey. Undoubtedly, these infrared signals are of far greater importance to a pit viper than to average human citizens and figure more in its survival scheme. Modern warriors, on the other hand, have invented a whole arsenal of sensing tools that make visible warm-bodied creatures lurking in the darkest of corners. Technolog-

ical inventions, such as infrared optical instruments, are changing our conscious awareness of the world.

Heavy Thoughts on a Light Topic

The evolution of the eye and conscious brain proceeded in an earthly garden lavishly bathed in light from the "eye of heaven," as the sun is sometimes poetically called. Why fate decreed that we humans should get turned on to 380–780 nm, and not 340–800 nm or 350–360 nm or be totally oblivious to all light (and perhaps develop ultrasensitive hearing), is seemingly one of nature's little secrets—at least that is what our unAWARE prescientific ancestors might have concluded. The hypothesis advanced here is that "fate" had little to do with the outcome. Our dauntless ancestors evolved color vision in the 380–780 nm range as a consequence of natural selection. The very short answer to the 380–780 question is: *earthly things within that electromagnetic range are important (if not necessary) for us to see, so we use those cues to make prudent behavioral decisions related to personal and species survival.* At the same time fruits, flowers, and aposematic warnings coevolved to use the visual range because the eye could see in that range. The same general principle applies to other types of visual stimuli, such as the perception of forms, contours, motion, and faces, as well as to other types of sensory stimuli, such as the perception of olfactory, gustatory, cutaneous, and auditory stimuli. All are "windows" to the *terrestrial* world—a world we know best and, parenthetically, a reason we have so much difficulty in understanding cosmic issues such as what was there before the "beginning," what time is, and what is beyond the heavens. Some dogs can't hunt outside their own yard.

Art imitates nature. By virtue of creative action, a work of art takes on a living quality. Thus, the work will appear fruitful and endowed with that same internal energy and vibrant beauty that can be seen in works of nature.

—Henri Matisse

Primates, Fruits, and Evolution of Color Vision

These observations make a very nice link between survival and physical evolution of light-sensing instruments. Being able to distinguish between poisonous and nonpoisonous sweet berries on the basis of subtle color distinctions surely had the felicitous effect of helping our forefathers live long enough to reproduce and genetically transmit color vision in the 380–780 nm range—the same range we use

to see stop signs, technicolor films, and Rembrandts. We have yet to hear from the other cousins who failed to develop such visual acumen (presumably because they didn't collect enough edible fruits and get lucky).

Recent studies of the evolution of trichromatic color sensitivities by Old World (catarrhine) monkeys and dichromatic color sensitivities among New World (platyrrhine) monkeys vis-à-vis fruit coloration confirms such a coevolution hypothesis. A few more empirical logs and a few less speculative chinks for the espoused hypothesis about visual evolution and natural selection are supplied by researchers from several universities, including the universities of Hong Kong and Cambridge.

The evolution of colored fruits . . . was a process parallel to the evolution of the color sense in the animals to be attracted. . . . This relationship became beneficial to both partners, which profited from it: the animals in getting food, the plants in perpetuating themselves.

—Stephen Polyak

Specifically, several researchers have found that trichromatic color vision of primates with retinal photopigments in the 430 nm, 535 nm, and 562 nm range (similar to human trichromatic color absorptions) is closely attuned to the detection of red-green colors associated with the long-range detection of ripe fruits or young leaves (which frequently turn red in the tropics), thus supporting a coevolution hypothesis. The primates' eyes evolved red-green sensitivities in order to see ripe fruit—and the fruit coevolved red-colored produce that can be readily seen by these primates.

Dominy and Lucas (2001) and a small army of students extended these observations. They went to Kibale National Park in Uganda in search of clues to the ecological importance of trichromatic vision in primates. In a dedicated study requiring 1,170 hours of observation, they found that the color discrimination was finely tuned to the red-greenness of the leaves rich in protein and low in toughness (we should be so lucky when we order a steak). New World primates exhibit somewhat different color perception, with all males being dichromates but about two-thirds of the females being trichromates. (See Regan et al. 2000 for a complete review.) The conclusion of many of these studies, taken collectively, is that a carefully balanced symbiotic system has evolved that meets the nutritional needs of primates and the need for plants to have their seeds distributed, the evolution of primate color vision capabilities being based on *local* complementary environmental factors. It is highly likely that we humans coevolved a visual system designed along the same lines—to find food (and other necessities), to react to local environmental stimuli, and to interact comparably with the needs of other organisms. There are numerous other examples of coevolution of visual systems in the animal kingdom, especially among insects and flowering plants.

We create art from an image deep within our hereditary mind, which evolved over hundreds of thousands (if not millions) of years for the purpose of distinguishing objects, discriminating between essential colors, reading faces, and paying attention to moving animals and spears. *That* milieu, much, much more than the academy, was the wellspring of all art. We see beautiful colors and judge an art object as being balanced aesthetically with an eye whose developmental history saw none of these simulated objects. The human mind grew up on the Serengeti plains millions of years ago, trudged northward to what is now the Near East, spread through Europe and Asia and America capturing game and fish, picking nuts and berries, forming kinships, and having sex and making love. No one then even heard of van Gogh but, in a very genuine sense, van Gogh shows us clearly what was in the primitive mind. Art shows us what every human from Adam to the newest baby has locked up in his eternal view of the world.

From the Eye to the Brain

After a visual signal passes through the pupil and is absorbed by the rods and cones, it is collected and passed along the large optic nerve on its way to the brain. However, its routing to the brain is complicated. As shown in figure 3.11, the optic nerves come together at a center called the optic chiasm. Here a complicated distribution takes place. Half of the fibers from each eye cross over at the optic chiasm and are passed on to the visual cortex on the side of the brain opposite their source, and half of the fibers terminate in the visual cortex on the same side. This crossover effect is consistent with other brain-body functions and is called contralaterality. Motor functions, for example, are processed contralaterally. A patient with a stroke affecting the left hemisphere of the brain may have paralysis on the right side of his or her body. Even though visual contralaterality is not so simple, it is important for art students to be familiar with its basic aspects.

Refer to figure 3.11 and trace the pathway of the dotted image presented in the right visual field. Reflected light from this object, which is placed to the right of the observer, enters each pupil and is absorbed by retinal cells situated on the left side of each eye. Messages detected in that area of the eye are passed on to the optic chiasm, then to the lateral geniculate nucleus (LGN) of the *left* visual cortex, even though they were shown on the *right* side of the field of vision. Similar routing is shown for the gray object in the diagram, which is presented in the left visual field and processed in the right hemisphere of the brain.

Located at the very back of the cerebral cortex, the primary visual cortex (PVC) receives input from the eye through the LGN—for our purposes, a relay

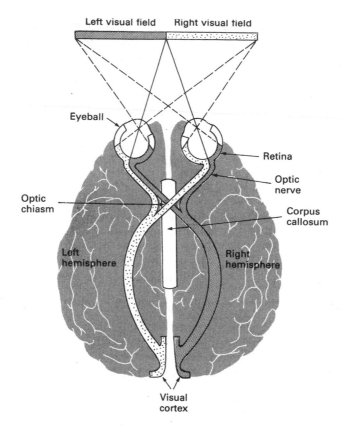

3.11 Schematic drawing of the neural pathways between the retinas of the right and left cerebral hemispheres. Note that some of the nerve fibers from each eye cross over to the opposite hemisphere at the optic chiasm and some terminate on the same side.

station located in each hemisphere. The LGN is part of the thalamus, which is the gateway to the cortex for all senses but smell. The thalamus is important because it is primarily implicated in attention. The PVC is a part of the brain also called the striate cortex, or area 17, or V1. It is very important in vision and in the perception of art, as it is here that early perception and routing of signals takes place.

Fortunately, we know quite a lot about this part of the brain due to seminal experiments conducted by Hubel and Wiesel (1963, 1965) during the mid-twentieth century. In their classic experiment, a tiny electrode was inserted into the visual cortex of a cat and was designed to record minute electrical activity of single cells as they might be activated by a visual signal. Then, in the cat's visual field, a

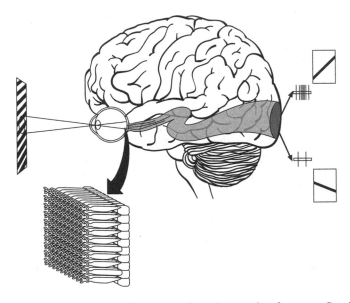

3.12 The visual pathways from the eye to the primary visual cortex. Cortical activity is represented by the short vertical lines near the back of the brain, with the upper location showing much activity and the lower one no activity. Specialized cells attuned to a specific visual target fire rapidly, as shown in the upper recording, while other cells designed to respond to visual stimuli of other orientations are inactive.

series of stimuli were presented by means of light slits—a vertical line, a diagonal line, a moving diagonal line, and so on. The essential finding was that specific parts of the cat's brain responded to specific types of stimuli but were unresponsive to most other types of stimuli. Since that time, studies with human subjects have shown that we too have cells in the PVC that react to specific stimuli, as shown in figure 3.12.

Thus, it appears that the first line of cortical action in response to a visual stimulus is carried out by dedicated cells that are specifically tied to this type of stimulus. From that initial reaction, an entire flood of cortical streams follows. But that part of the story is covered in the next chapter.

The Visual System and the Perception of Art

Our human eye and brain evolved in the macrocosm of our earthly community. Nothing was artificial or contrived in the beginning. Gradually, simple tools for

slaughtering and butchering meat and grinding plant foods emerged, followed by more finely fashioned hand axes, clothes, shelters. Eventually symbolic scratches on stone objects and wall paintings were produced by an emerging AWARE person. The beginnings were not only the inventing of the necessary—although that was the primary feature—but the making of the artificial. Nature was transformed, and manufactured objects became essential to the lives of *Homo sapiens.*

The natural colors of the rainbow were perceived by partially AWARE people. It was much later that these chromatic wonders were aesthetically combined in the making of beautiful designs that adorned bodies and decorated the walls of caves. We still use the elementary criteria of aesthetics that evolved over millennia to judge the qualities of balance, harmony, and color agreement in today's world of fashionable clothes, detergent boxes, and art, although present standards have many more intellectualized footnotes.

With human perceptual AWAREness of light and colors, man attempted to reconstruct natural sensations with hand-made reproductions. Humans were beginning to be aware that terrestrial stimuli could be imitated and that we, consciously inspired beings, could create a world close to the mind's desire. How did art evolve over the years to capitalize on the painterly products at hand as well as the nature of the polychromatic eye?

COLOR SCIENCE COMES TO ART

The French chemist Michel-Eugène Chevreul (1786–1889) worked for the Gobelins weaving factory as director of dyeing—a topic he avoided for over a century, one might be tempted to say, since he lived to be 103 years of age. He excelled at coloring woolen yarn before it was woven into fabrics. To the surprise of some, the brightness of colors in the final product differed from the brightness of the dyes and of the individual strands. Some colors became less intense when woven with others and, to the eye, lost some of their vibrancy. Chevreul arranged colors in a wheel (see plate 7) in which 72 hues may be derived from 12 focal colors. This organization of hues was then graduated in terms of 20 degrees from brightness (white in the center of the wheel) to darkness (at the periphery), to make spaces for a total of 1,440 dyes. In this circle of hues, complementary colors may be found opposite each other. In the 1830s, Chevreul began to discover "laws" of juxtaposed complementary colors that attracted the attention of artists and scholars. The principal idea of simultaneous or reciprocal contrast is that the perceived difference between two colors may be found in their complementaries (see plate 8).

3.13 Horace Vernet, *Michel-Eugène Chevreul* **(c. 1850). The eminent French chemist developed the law of contrasts for colors.**

There are physiological factors that support his ideas. If you stare at a color, say red, and then look away to a neutral surface, you "see" its complementary. This is known as chromatic adaptation or an afterimage. As in the case of seeing a light area next to a darker area, the edge between two complementaries seems more distinctive because of the inhibitory effect. In color contrast, maximum contrast occurs when complementary colors are next to each other. This proved to be a breakthrough in chromatic science, and artists have been using the technique ever since.

There is an interaction between perceived brightness and color. "Deeper" colors, for example saturated blues, violets, and reds, appear less bright than greens and yellows, even though their physical intensity may be equal (figure 3.14). For centuries, artists have explored the subtleties of color effects, using colors of different luminosities to produce different psychological effects.

In addition to their different sensations of brightness, different colors have different psychological effects on us: bright colors tend to cheer; dark to depress.

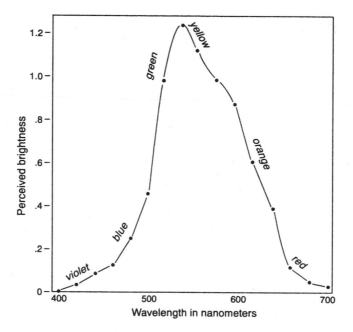

3.14 Perceived brightness of different colors with the same amplitude (intensity).

Even our mood (and the attitude of people who see us) may be affected by the color of clothing we wear. No less important is the impact colors have on the mood of a painting, which reflects the larger influence of colors in our everyday life.

THE USE OF COLORS IN ART

The first step in creating art that mimicked the real world was taken in the mind. The second step required finding material with which to draw forms and colors. The early caves at Chauvet and Lascaux were decorated with material found in nature nearby. Ochre, an oxide of iron, gave a rich, red color which, it is believed, symbolized life. Charcoal, a carbon product from wood or bone, produced a pure black color that symbolized death. Initially, the two powerful symbolic forces—life and death—were memorialized by conscious beings in artistic expression. The cave walls were finished in white calcite crystals. Some yellow ochre was also used.

The early Egyptians had a more complete coloring box. In addition to the white, black, red, and yellow mentioned above, they ground mineral malachite, a

green copper carbonate mineral, to make green (which represented the Nile); lapis lazuli, a beautiful blue stone found in the Sinai and in Afghanistan; and sulphur, which made a bright yellow hue. All of this was supplemented with plant colors. It was possible to combine these materials to get almost any color desired. These ancient colors are so vivid today because they are mostly composed of stable minerals that do not fade or deteriorate with age. Many are even impervious to light exposure. In spite of the number of colors that could be produced, the Egyptians chose to use only a handful (mostly in the "earth" shades) and were equally rigid in the way people and objects were represented.

During the Greek and Roman periods, many artists used the four elements of ancient physics as a theoretical basis for color use. For earth, gray was used; for air, blue; for fire, red; and for water, green. A new type of parochialism dominated by ecclesiastical business swept through Europe in the fourth and fifth centuries with the spread of Christianity which culminated, not coincidentally, with the beginning of the Renaissance. Here opulent colors and materials were used in religious paintings with astonishing grandeur and beauty partly to impress the illiterate masses with the power and glory of the Church. As an example of such art, examine plate 9, a painting by the early French artist Enguerrand Quarton.

The colors used in this work are sensational, and expensive! Notice that three colors predominate: vermilion red, lapis and azurite blue, and gold and yellow—a divine melding of celestial colors. Although the material sources of these colors drip with worldly decadence, they are used here to depict the holy coronation of the Virgin Mary, the mother of God, as Queen in Heaven. Here the artist (and his patron) spared no expense, using ultramarine blue extracted from lapis lazuli imported from Afghanistan, deeply saturated red, and shining gold. Apparently the painter thought that we would take our trichromatic eye to heaven.

Quarton knew little about the psychology of colors and less about the physiology of the eye, yet he used vivid primary colors juxtaposed skillfully to produce a striking picture. The painting contains red, blue, and yellow (gold), each of which complements the use of the other. Each color is very close to what is called a focal color, which is defined as the color most clearly identified with a specific hue. The viewer had no question that the colors used are central, unambiguous ones that are understandable in their simplicity. The colors also take on meanings which, throughout the Renaissance, symbolize various features of Christian beliefs. Gold, the most precious of materials, was used to highlight the Virgin and accentuate the robes of God the Father and God the Son, who are indistinguishable. The brilliant, vermilion cloaks are made even more intense, trimmed with pure white and lapis

blue. The host of saints and angels in Heaven in the upper part of the painting are also resplendently attired, as contrasted with the much more muted colors of earth and hell shown in the lower quarter of the painting.

Viewing *The Coronation of the Virgin* in modern times, it is easy to lose sight of the fact that in the fifteenth century this painting would have been illuminated by candlelight. Think of how striking the colors, especially the gold, would be as they caught the flicker of soft light from a nearby flame.

With new materials and techniques, artists from the Renaissance to the baroque, rococo, romantic, and classical ages used nearly every combination of colors and forms imaginable. Yet there was something new under the sun that exploded on the art scene during the mid part of the nineteenth century. The movement was called impressionism and showed an unusual sensitivity to how colors could create a feeling. Advanced partly by new materials (it was possible to carry paints outside in tin tubes), partly by advances in physics and chemistry (Maxwell, Helmholtz, and Chevreul were working on the physiological basis of color mixing), and partly because of a revolutionary cast of characters (Cézanne, Degas, Monet, to name only a few), the impressionists broke the yoke of conventional salon art that dominated the art scene in the early 1800s. Able to take their easels outside, they painted all sorts of natural things in natural light, not so much as the academy prescribed they should appear but as the artist consciously sensed their impressions. The light of colors was showered on portable canvases rendering poppy fields, river scenes, villages, horses, and outdoor parties. A tree on the canvas of an impressionist could be painted green, but then, if it was a distant tree, it might appear blue.

"Impressionistic" was initially a derisive term. Henry James, the famed author and brother of William James, wrote: "None of the members show signs of possessing first-rate talent, and indeed the 'Impressionist' doctrine strikes me as incompatible . . . with first-rate talent." (New York Tribune, May 1876.)

This new breed of painters paid particular attention to the effect one color had on another and, fascinated by the recent developments in color theory (namely Chevreul), they experimented with numerous combinations. Though they were initially often ridiculed, some critics praised the impressionists' work: "From one flash of intuition to another, they have succeeded in breaking up solar light into its rays, its elements, and reconstructing it as unity by the general harmony of the iridescence they spread on their canvases. . . . The most astute physicist could find no fault with their analysis of color." (Edmond Duranty, quoted in Katz and Dars

1997.) An example of their use of color is seen in Monet's elegant work *Impression: Sunrise* shown in plate 10.

Monet has captured the impression of this setting and presented a psychological view of motion and color. Unlike many of the formal studio-bound artists of the nineteenth century, Monet captures the effects of natural light and early morning atmosphere. The orange-red sun is made brighter by its juxtaposition with the hazy blue background which is carried into its reflection on the river. The central figures in the boat are clearly shown, while more distant objects along the shore are indistinct. The use of color by the impressionists changed art from representation to impressionism; from form to feeling; and from cortex to heart. These liberating ideas were carried to the next century on the wings of color. Art was never the same.

4 Art and the Brain

The brain is an enchanted loom, where millions of flashing shuttles weave a dissolving pattern, always a meaningful pattern though never an abiding one.

—*Sir Charles Sherrington*

There is much more to the psychology of art than understanding light, the eye, and the evolution of conscious AWAREness. The next part of the puzzle is, to some, the most fascinating of all. It is the human brain, without which there would certainly be no art, no consciousness, no emotions, and not even light.

While artists have honed their skill over centuries, scientists have investigated the anatomy and functioning of the brain for just over a hundred years. Evolutionary psychology, which deals with the origin of the adaptable brain, has an even shorter history. In spite of the relatively recent emergence of all types of brain sciences, scientific progress has been nothing short of astonishing. So profoundly informative are the latest discoveries in brain sciences that some have considered building a unified theory of the brain that encompasses all of its functions, including the appreciation of art. While the neurosciences were making real progress in understanding the brain, art critics, sociologists, and historians paid little heed to these discoveries. Neuroscientists were likewise uninterested in art, at least as a subject of scientific inquiry.

Art and science were conceptualized so differently that not enough common ground was available for a good debate over their differences and similarities. Art, one might assert, deals with the extended mind and is ethereal, aesthetic, and holistic; any attempt to analyze it would surely destroy it. Conversely, science deals with the real, the tangible, those things that can be measured and experimented with and are divisible. Yet, as we saw in the first chapter, art and science (specifically the science of the brain) may share a large common ground in the physical world. Inexorably, we are beginning to understand that ideas from each discipline help to explain the other.

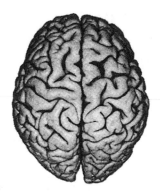

The Evolution of the Consciously AWARE Brain

We begin our story of the evolution of the conscious brain so that we might better understand art—a kind of alpha and omega approach in that a sensory-cognitive system is necessary for the detection and understanding of art. Between α and Ω consequential neurological events took place. From the origin of life to the first single-celled animals, to the first brachiopods, trilobites, corals, and ray-finned bony fishes, to the first amphibians, dinosaurs, primates, to modern man, neurological changes unfolded in fits and starts. For a scientist, the many bioecological wanderings to follow during the evolution of a brain are difficult to fathom. Even more astonishing is the fact that such an instrument, with its biological fragilities, costly maintenance, and incomprehensible complexity, evolved at all.

In the previous chapter we traced the evolution of the sensory system, especially the eye, in our search for a basis for understanding the psychology of art. Here we will look at the evolution of the brain with a similar purpose.

Something like the first brain evolved half a billion years ago. It took another 250 million years for it to evolve beyond simple reactive processes. The first humanlike brain appeared only about 4 or 5 million years ago, and modern brains emerged between 200,000 and 60,000 years ago (and likely

Mind and world . . . have evolved together, and in consequence are something of a mutual fit.

—William James

continue to change). Some of the components of AWAREness may be found in brains of millions of years ago, but it was not until about 60,000 to 30,000 years ago that consciousness reached the state that continues today. Life is not contingent on a neurological system, let alone a brain. Even rarer is a computational brain capable

of thought and artistic appreciation. It is on these last 5 million years that we will concentrate our discussion.

A nagging question is again raised by the observation that the modern brain arrived so late on the planetary scene. Life arrived early; complex life forms developed over 500 million years ago; and even more intricate systems tens of millions of years ago. Why did it take so long to develop a conscious brain? And for what purpose did such a brain evolve in the first place? Does such an observation suggest that "intelligent" life on this planet is rare, and might we generalize to other planetary systems? The study of the evolution of the conscious brain spins cosmic questions that may be only partly answerable. But finding the questions is an important step.

The Genesis of the Adaptive Brain

The human brain (and body) changed as an adaptive response to climatic changes on a very long timescale. In many ways art history is also a response to environmental changes both physical and social. At each significant environmental change, adapting creatures responded with neurological and physical changes.

Among the most apparent of these global changes was an event that happened 8 million years ago, when the rich forests in eastern Africa were replaced by more sparsely tree-covered and grassy regions as a consequence of a massive tectonic shift. Organisms of this region that did not adapt to the new conditions would have died off. In particular, the new environment demanded that apes spend more time moving between food sources and between trees, which required a more upright stance. Presumably, natural selection favored those among the more able primates who could move swiftly and see farther over those who continued to lope along scraping their knuckles along the tall grasses.

Serendipitously, a more perpendicular stance also meant that body temperature was reduced. As we shall see shortly, big brains require super-cooling machinery to function. Without the quirky, geotectonic cataclysm that affected the earth's crust and climate, we might have been content to lounge about in humid rain forests munching on nuts and berries, collecting rainwater, and basking in a rare sunny day rather than sampling Brie and sipping Chardonnay while looking at an exhibition of the latest avant-garde paintings. As fate decreed, our hairy ancestors who survived beyond the Great Rift Valley in the dry eastern African plains did so partly because they had big brains.

Once there, there are several reasons why the brain and body evolved further by mutations and natural selection:

• *Cognition.* To adapt to the environment required mental adaptation. Brute strength and simple responses were insufficient to ward off predators and find food. The diets now available, rich in sucrose, in turn enabled the brain to grow. The newly created environment required primates to forage for fruits, not simply gobble grass or vegetation within easy access.

Searching for fruits is a complicated activity, as not all trees bear fruit and not all fruit is edible. In addition, as we saw in a previous chapter, fine visual discriminations were necessary to choose between nutritious and nonnutritious, or even poisonous, foods. This biological necessity, caused by an environmental shift, required an AWARE brain capable of color vision and discrimination, spatial skills, hand-eye coordination, memory, learning foraging skills from parents and others, navigation, and, later, tool making. In addition, success in these matters frequently required social interaction and cooperation. All of this required greater cognitive skills, larger, more complex brains, and an increased AWAREness.

• *Cerebral growth and brain cooling.* A different physiology helped the brain to be cooled more effectively, thus facilitating greater cerebral growth. This hypothesis, sometimes called the "radiator hypothesis," was suggested by Falk (1990), a neuropsychologist inspired by his auto mechanic, who told him that in order to have a bigger engine one needs a larger radiator.

The brain is a hot organ requiring massive cooling. Our brain makes up less than 2 percent of the entire body, yet it burns up to 25 percent of the body's oxygen and 70 percent of its glucose. Without the means to cool the brain by increased blood supply, rapid cerebral evolution would not have been possible. This is but one of numerous physiological changes that were necessary for brain growth. Cerebral physiology and adaptive cognition coevolved symbiotically, leading to more complex, conscious AWAREness.

These early, critical stages of cerebral evolution emphasize two characteristics of the human brain important for students of the psychology of art: (1) the brain evolved cognitive mechanisms of prodigious complexity to survive in a changing environment, and (2) the allocation of cerebral space was so pivotal to survival that many other physiological functions were necessarily altered to accommodate the growth of the brain—for example, the development of an intricate vascular system for cooling the brain.

Both the cognitive and the physiological functions changed the way humans conceptualized the world. We could now think beyond simple stimulus-response reactions to the environment. In addition, change in our physique aided further adaptation. By standing more upright, we could use our hands for tool making. These

major changes in the protohuman brain and body determined the creature we became: it gave us Sunday afternoons at the Art Institute, the means to paint Mona Lisa and fabricate *The Thinker,* and (most of all) the vision to see beyond the rainbow.

Endowed with an attentive eye with which to see and a wondrous brain with which to think, the mind's basic evolutionary direction for the next 8 million years was more or less set. This vector of cognitive adaptation was like an intellectual arrow shot into the Upper Miocene air, flying on course through the Pleistocene and continuing to soar to an unimaginable apogee in recent times. All the time, human consciousness as expressed through art was gaining AWAREness.

As discussed in some detail in chapter 2, profound changes took place about 60,000 to 30,000 years ago in art, religion, language, and AWAREness. Behind all of these behavioral-cultural changes were changes in the way the brain did its business. What were the immediate causative antecedents to the intellectual big bang that gave us art as well as later developments in agriculture, civilization, and our technological world? It is simply foolish to state with authority that one or two or even many climatic, neurological, nutritional, and cultural factors were responsible. Some things are lost forever. We can focus our attention with some certainty, however, on probable causes and make intelligent inferences about which combination of events contributed to the palpable changes that shaped our lives. Here, three causes are noted: changes in the brain (both its size and its circuitry), changes in the diet, and changes in social structure. All three factors, and likely some that are unknown, work together.

THREE QUESTIONABLE ASSUMPTIONS

Before we tackle the problem of how cerebral size and well-connected neurons made us the way we are, there are some widely accepted assumptions about the

evolution of the computational brain that need to be clarified. First is the idea that evolution has inexorably produced a "better," more adaptive entity when it constructed an AWARE human being; second, that human brains were engineered in perfect synchrony with the environment; third, that guiding these developments is some grand purpose.

1. *A superior brain leads to better adaptation.* Humans have more and better-wired neurons than any other animal on earth. But this has not necessarily made us more adaptive, if adaptation is defined narrowly in terms of survival. Cockroaches have lived for 320 million years, some insects many times longer, and even the hulking Neanderthal lived about 200,000 years—over five times longer than our great ancestors who mixed animal fat and minerals to decorate caves. Conscious AWAREness has contributed to the survival of our species. Yet this quirky intellectual mechanism is terribly fragile, and its efficacy has yet to be proven over the long haul.

A computational brain may be useful when it comes to imagining and making needles, baskets, and warm clothing but counterproductive when it comes to neurosis, psychosis, and autism, not to mention when it is used to create weapons or microbes designed to eradicate life. We came dangerously close to blowing ourselves off the planet in the twentieth century, and some doomsayers predict that with self-imposed environmental hazards—both ecological and cultural—we will not see the end of this century. Our invention of malevolent devices without antidotes is a serious concern in today's world.

2. *The brain and body are perfectly attuned to the world.* The notion that our brain and body work in perfect synchrony with the world is so foolish that refuting it is like preaching to the converted. Evolution is not engineering but the consequence of a chance reaction to a changing planet. It isn't that the rules of cause and effect go haywire in evolution; it is that the evolution of species is capriciously tied to inexplicable events. The dinosaurs got wiped out by an errant meteor, and mankind changed forever as a result of massive shifts in the tectonic plates. To think that such cataclysmic events evolved perfect beings is either the height of absurdity or of egocentricity. The evolution of any life form on this planet is a curious if not quixotic incident. One could imagine our planet mindlessly spinning in its orbit content with stable rocks that need neither food, specialized air, clean water, nor love, affection, sex, and rock 'n' roll. After all, every planetary system that we know of is of that genre.

If life itself is something of an accident of nature, and a very feeble one at that, then intelligent life is even more of an enigma, in the sense that survival

systems based on situational problem-solving ability may have the seeds of total self-destruction built into them. Cognition, once thought by the psychological evolutionists to be the supreme means of coping, may actually be the ultimate doomsday device that will kill off our species and perhaps all others like us (except the invincible, ugly, and only marginally AWARE cockroach). In the event that other planetary systems did evolve life and monkeyed around with intelligence as a survival mechanism, the intrinsic seeds of destruction may have killed it off before it was sufficiently mature to e-mail us. Zil may ultimately return the cosmos to darkness.[1]

3. *Because of the improbability of conscious development, the whole thing was planned.* The suggestion that behind all of life is some benevolent, divine, teleologically motivated creator is fraught with paradoxes, ambiguities, and reliance on faith and religious beliefs rather than logic and data. Yet with the highly improbable (and seemingly accidental) evolution of conscious AWAREness, it is tempting to think that some force must have overseen its development.

Furthermore, the evolution of life, and especially intelligent life, is such a weird happenstance that it may not be replicated anywhere in the universe, despite the "theory of large numbers" which posits that anything can happen if you have enough chances. Even under optimal evolutionary conditions afforded by our hospitable world, intelligent life did not evolve until very late. Of course, a null hypothesis is always difficult to prove, and I remain hopeful that we will see life from both sides someday. But this alternate view needs to be verified. Intelligent life is precious, and it may be more precious than generally thought.

These issues deepen the mystery of life, art, and possibly our singular position in the universe. While it is easy, as well as tempting, to fall down on the side that proclaims that some universal force planned it all, the empirical evidence suggests that the eccentric forces of nature shaped our destiny. We have wandered off the main course of the psychology of art to present these assumptions, which are often taken as facts. In considering a comprehensive theory of the psychology of art and the evolution of the conscious brain, these assumptions had to be addressed. Now we can return to the matter of brain size and those well-connected neurons.

The Cognitive Big Bang and the Emergence of Art

It is possible to reconstruct the cerebral and social events that may have contributed to the "cognitive big bang" using a type of reverse engineering. By examining fossil, behavioral, and artifactual evidence, we can come to some well-reasoned conclusions without resorting to too much intellectual horse-pucky.

SIZE MATTERS

Brain size is correlated with intellectual performance (see previous chapters). Such observations hold for humanoids as well as other species. In bats and dolphins there is a relatively large inferior colliculus used for the echolocation of food and obstacles. In many fish the optic lobes are disproportionately large and are used for visual identification of prey and predators. And in humans, parts of the cerebral cortex involved in language processing are relatively outsized to support speaking and communication. Many distinguished anthropologists, including Charles Darwin (1871), argued that the differences between humans and other "higher" animals was a matter of degree rather than kind. Of course, Darwin did not have the vantage point gained from over a century of human neurological research.

Size matters, but it is far from the only neurological factor that separates humans from other forms of life.

WELL-CONNECTED NEURONS

While big brains may have assisted in the successful adaptation to the world, that alone could not have bestowed on humankind art, astronomy, agriculture, and the potential to see ourselves as others see us. It is suggested that those powers were made possible through well-connected neurons that coalesced into cognitive modules. These cerebral circuits increased the capacity for abstract, symbolic, and artistic thought.

O wad some Power the giftie gie us
To see oursels as ithers see us!

To paraphrase Robert Burns, the great Scottish poet, O would some power give us the gift to see what neurological connections have made us.

—*Robert Burns*

Our exploration of the brain, thus far, has not yielded definitive answers as to what neuroconnections set us apart from all other earthly creatures. We do, however, have both neurological and behavioral evidence that points to plausible answers to this central question. A critical mass of cortical neurons of various types is essential to understanding terrestrial intelligence.

There are more synaptic connections in the human brain than there are stars in our galaxy.

The human brain evolved over millions of years for adaptive purposes. One important component of adaptation was the facility to image and respond to things not present. One did not need, for example, to feel the sting of an angry snake in

order to avoid angry snakes or need to have one's head knocked off by a flying rock to see the connection between a flying rock and losing one's pate. This capacity for anticipating actions and imaging things not immediately sensed was made possible through the formation of various types of specialized cognitive modules and the circuitry necessary for connecting these modules.

In addition, the well-connected brain allows for ideas and thoughts to be considered at different sites simultaneously because of massive parallel processing. It is suspected that parallel processing appeared early in humanoid evolution but that only in recent times—say about 120,000 years ago—did this form of mental operation take place on a massive level. Being able to process two or more things at the same time added tremendous richness to the cognitive life of human beings. *Thoughts became multidimensional.* The subtle meaning of everyday events—the hunt, the cooking, the gathering of berries—was understood with greater complexity. Perhaps even humor and double entendres appeared.

Recent studies of the priming effect show convincingly that a simple stimulus (e.g., a red square) sets off profuse unconscious associations. Our appreciation of art is largely set in motion by these aroused associations. (See the discussion below of parallel processing as currently applied to art.)

The exact means by which the brain carries out these functions is not clearly understood by neurobiologists, but it is possible to know where to look. Higher-order mental functions of the type mentioned above are likely to be mediated by distributed systems throughout the cortex, extending to other regions. This is accomplished by our modern brain, and the brain of our not too distant relatives, by three actions:

• The internal organization of synaptic circuits.

• The external organization of connections to other regions, which may include cortical and subcortical regions. (This is analogous to commerce that might take place within a state and between states.)

• Extensive parallel processing, which enables multiple processing of information.

The likely site for such multifarious cerebral actions is in the pre- and post-synaptic structures of neurons. Cortical synapses deal with connections among neurons. (For further details see Shepard 1994.) An increased capacity in the number of neurons that might be activated presumably increases the range of modules implicated. The activation and integration of more specialized processing tools may lead to higher-order processing of information and thoughts about things present

and, more importantly, about things that may be imaged. Ultimately, this makes it possible to think abstractly, linguistically, and artistically.

Change in Diet

In order for the brain to organize new and more versatile neural networks of the kind just described, it had to be sustained by nutrients that would increase cerebral blood flow or otherwise provide physiological support for brain development. As we learned in chapter 2, a diet rich in docosahexaenoic acid (DHA) and meat supports cellular brain development by increasing vascular blood flow. Also, as has been documented, fish and crustacean foods are rich in Omega3, which contains DHA. The fossil records indicate that early man lived near streams and oceans where he had ready access to fish and aquatic arthropods. It is therefore reasonable to surmise that these nutrients, important building blocks for brains, were abundantly ingested by the people who were about to become more fully consciously AWARE.

Greater imaginative capacity brought about by dietary changes resulted in developing better shelter, clothes, foods, and the like. Clever people could image and create these things. Enhanced living circumstances, in turn, would lead to a more healthy body and brain, a more comfortable social environment, and more time for leisure—more time for daydreaming and abstract expressions. It is not coincidental that the first vestiges of wall drawings, amulets, and stone decorations appear about this time.

Learning, Socialization, and Imitation

With a more efficient brain, learning, memory, and cognition of a higher order were possible. Early people were finding that it was possible to recall important information and solve problems.

With migratory campaigns being organized, partly as a reaction to climatic changes, people began to coalesce into groups in which they found strength through cooperative actions. Living in a larger group provided ample opportunity to express opinions, make new tools, dwellings, and clothes, and in general exchange ideas. New innovations, expanded language, symbolic representations, body decorations, religious practices, and even incipient government and justice spread in such a milieu. The revolutionary changes that took place during the late Pleistocene were not caused by any single event (and those who dogmatically promote a single-cause argument are ignorant of the complexity of cause-and-effect relationship in science and society) but, as with most significant changes in the evolu-

tion of the species, by a chance meeting of several different forces, some of which are unknowable.

What Brains Do

Physically, the brain is unimpressive: a gray-pink substance about the size of two clenched fists, weighing about one and a half kilograms, deeply furrowed, and divided into two seemingly identical halves.

The anatomy and major lobes of the human brain are shown in figure 4.1. The two halves are called the right and left cerebral hemispheres. The hemispheres are covered with the cerebral cortex, a thin, gray, moist matter richly equipped with the tiny neurons that carry vital information. A diagram of the network of cortical neurons is shown in figure 4.2.

The human brain has more than 100 billion (that is, 100,000,000,000) neurons, each capable of receiving messages from and passing on messages to sometimes thousands of other neurons through its many branched-end fibers. Even a "simple" cognitive act, such as viewing a solitary colored square, involves billions of neurons. The brain is alive with electrochemical messages, which dart through millions of intricate connections—choosing some pathways while rejecting others. Through the most elaborate system known to man, percepts are combined with other impressions, encoded for future use, and stored in neural network archives.

Despite their complexity, we have a fairly comprehensive view of what brains do. Our brain, whose workings baffled our forefathers, is now giving up some of its secrets under the steadfast investigation of a group of scientists who, armed with new instruments, have told us much of what brains do and how they do it. While we have

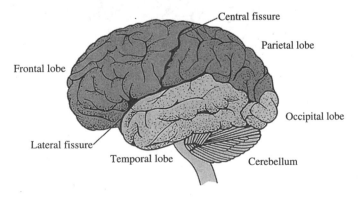

4.1 Anatomy and principal lobes of the brain.

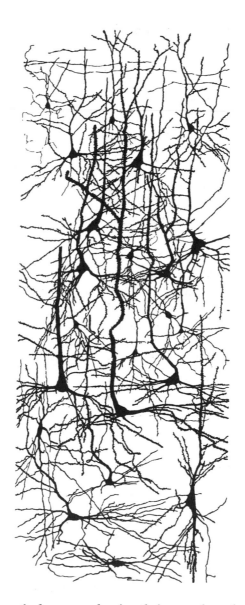

4.2 A diagram of cortical neurons showing their many branches.

not arrived at total understanding of the brain, it is clear that the paradigm used to study the brain and its functions has been framed during the twentieth century.

The brain is the nucleus of the emotions; it gives life feeling; it is the center of thinking, it provides associations for rational thought; it is the locus of visual perception; it enables us to see, feel, and understand art; it is the seat of conscious AWAREness; it gives us cognizance of the terrestrial world and the heavens beyond. Without a brain, the world would be void, dark, and meaningless.

Contact with the environment is made through the five sensory windows to the world, of which vision is central to the production and appreciation of most art. While the neurocircuitry of the cerebral cortex is less well defined than, say, the sequence of information processing from the eye to the brain, an astonishing amount of data has been produced about these complicated navigational routes in the brain largely as a result of recent MRI, PET, and evoked potential brain observations.

Let's take a tour on one of these rivers of the brain as it responds to an object viewed by the eyes—as that image wends its way through the many branching tributaries of the cortex seeking a match with natural visual primitives and then searching for higher-order cognitive-emotional meanings that allow us to understand the object. We begin our tour with a general (and recent) theory of how neurological messages travel through the cortex in an ever-branching system which generates enormous computational potential via parallel processing. Later we will recount the subroutines and streams used in cortical processing, and then apply those ideas to how your brain (and Raphael's) might process a classic piece of art.

PARALLEL PROCESSING

Recent studies have shown that although there are centers associated with specific functions, the working of the brain is accomplished through the simultaneous activation of many areas, a process that has been labeled massive parallelism. The concept is central to revolutionary new ideas in neurocognition called parallel distributed processing (PDP).

This theory posits that the brain functions by distributing impulses throughout large portions of itself in a parallel fashion rather than in a series of steps. Neurons pass messages on simultaneously to numerous other neurons, which pass messages on to other neurons. At a more fundamental level, learning and memory formations are based on synapto-dendritic connections between neurons. This ever-branching network grows more complex within a very brief time. The most important aspect of neural processing is that these multiplicative functions occur in parallel—thus creating a system of analysis that engages countless millions of

processing units simultaneously. The computational power of such a massively parallel processing organ using billions of neurons is simply staggering.

PDP research helps explain one of the most fundamental questions about visual perception, including the perception of art: How is it that we are able to recognize and classify visual events in such a brief time? If the brain were "wired" serially, with one neuron passing information on to only one other, then the amount of time required to make sense out of an object would be many minutes—if such an operation were even possible. But if information were distributed over many neurons operating in parallel, the number of processing units would increase geometrically over time.

This concept can be placed in perspective by looking at some recent experimental work in cognitive psychology. In a typical experiment, a person might be asked to discriminate between two visual objects, say a painting by Vincent van Gogh and one by Leonardo da Vinci. (See plate 11: on one side is a detail from Leonardo's *Virgin of the Rocks* in the National Gallery, London, on the other, a van Gogh self-portrait in the Musée d'Orsay, Paris.) Take a moment to look at these two portraits and then make a judgment about which was done by van Gogh. How did you arrive at your evaluation? What were the salient features you used in making your decision? What other factors entered into your reaction? Now think about how many more discriminations you are capable of. There are countless thousands. You know van Gogh from da Vinci, you know Rockwell from Pollock, Egyptian art from prehistoric, Picasso from Kline, and so on. If visual recognition (as well as your decision-making process) required the sequential slogging through a single pathway for recognition, you would still be working on the van Gogh-da Vinci problem. You have a lightning-fast cognitive computer not because of the speed of neurotransmission, but because neurons are firing all over the place. The brain processes many sides of a stimulus simultaneously.

In a typical laboratory experiment where the behavioral effects of multiple processing are displayed, a person might be confronted with a discrimination problem, such as the van Gogh-da Vinci problem, and then asked to press a reaction time key. Experiments of this sort tell us that recognition-response time for a highly familiar object is about 600 to 800 milliseconds, or less than one second. Because such experiments typically involve motor responses, which require additional time to execute, it is safe to infer that "pure" cerebral processing of visual recognition takes considerably less time. The time required for impulses to pass from one neuron to another is, in terms of electrical circuitry, ponderous—many millions of times slower than the time required for a computer impulse to spin through its program. Yet the human brain with its sluggish machinery is able to make complex judgments

far faster and more intelligently than the quickest computers, because brain processing engages a huge number of units that operate simultaneously. For some time, computer scientists have attempted to fabricate parallel computers that simulate human processing. While results have been impressive, they have failed even to come close to approximating the huge computational powers of the human brain.

COGNITIVE EVIDENCE FOR DIVERSE PROCESSING

A cognitive experiment I conducted with my colleague Bruce Short some years ago sheds some light on how capacious parallel processing is (see Solso and Short 1979). In our experiment, college students were shown a color square, such as red, and then immediately afterward the same color square, the name of the color (RED), or an associate of the color (BLOOD). The task was to decide as fast as possible if the second item was related to the original red square. As shown in figure 4.3, the initial reaction times to make a decision ranged from 600 to over 800 milliseconds (from about a half second to nearly one second). We tested two other conditions, delaying the presentation of the second stimulus by 500 milliseconds and 1500 milliseconds. In these conditions the reaction times were much faster for all three groups (the color square, the word, and the associate). When the delay of the second stimulus was up to a second and a half later, the reaction time for associate group (BLOOD) was nearly equal to that for the other groups. This little experiment tells us a great deal about the many associations that develop in our brain in a matter of only a second or two. Keep in mind that the people who participated in this task did not have prior knowledge about what they were to see. The word BLOOD is only one of many associates that could have been presented, such as FIRE, HOT, ANGER, and presumably, had those words been used, the increased availability of each would have been primed by the color red. The point is that people react to visual stimuli (and other stimuli as well) with innumerable implicit associates, which attests to the richness of experience as well as the depth of cognition we all enjoy. Consider how fertile human reactions are to viewing visual masterpieces such as the portraits by da Vinci and van Gogh.

CEREBRAL CARTOGRAPHY: PLACES AND HIDDEN RIVERS OF THE MIND

Franz Josef Gall (1758–1828) and Johann Spurzheim (1776–1832) were early nineteenth-century phrenologists who advocated the idea that our brain was compartmentalized and that complex psychological functions—such as color, form, self-esteem, hope, and in some later maps even republicanism—were geographically

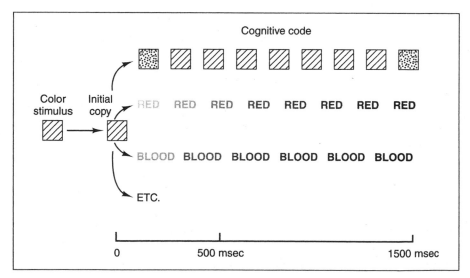

4.3 Above: reaction times of various match conditions as a function of priming interval: C–A = color to associate; C–W = color to word; and C–C = color to color. Below: the development of color codes. (From Solso and Short 1979.)

4.4 In the early nineteenth century, phrenologists maintained that brain functions were localized and could be identified by reading the bumps on the skull. Here more than forty intellectual and behavioral traits are identified.

located (see figure 4.4), and that by reading the bumps on your head your relation to these functions could be ascertained. The concept of localized functions is not totally unreasonable, but the bit of the theory that particularly galled anatomists of the day was the idea that soft gray matter could exert such a force on the cranium, the hardened, calcified brain case, as to make a bump appear on the outer surface of the skull. Offended by this pseudoscience, some physiologists set out to disprove the concept of compartmentalization of the brain and replace it with a "mass action" idea, which suggested that the brain worked as a holistic entity. Both camps had part of the truth.

The brain does have dedicated areas in which specialized processes are carried out. The occipital lobe concentrates on visual information, such as the processing of lines. But each part works in partnership with others. Thus, intersecting lines may be processed initially in the visual cortex, but understanding that the lines make an X or a cross and the implications of either of those symbols takes place in a different region, such as the prefrontal cortex. The history of neurocognition can largely be followed in terms of the scientifically controlled discovery of increasingly specialized functionality, interrupted by some ironic quirks of wartime injuries.

During the Russo-Japanese War of 1905, rifles with higher muzzle velocity and small bullet size were used, with the result that shots could drill clean through a skull leaving a sharply defined wound. A surgeon's scalpel could be no cleaner. With increased survivability of soldiers, it was possible to match the site of an injury with the person's subsequent cognitive performance; thanks to the careful observations of the ophthalmologist Tatsuji Inouye, a type of topological map of the primary visual cortex was produced. Inouye found that a disproportionate amount of the visual cortex was dedicated to processing information from the central part of the retina (where sight is most clear) rather than from the periphery (where sight is fuzzy). These findings are not surprising to us and have a very important role in how we look at paintings. We do not gather all of the information in a picture all at once but through a series of "snapshots" in which our sharp foveal vision is focused on one part of the scene and then darts off to another where more information is gathered, before the process is repeated. More on that topic later.

By the twentieth century, neuroanatomists were beginning to record the electrical activities of selected areas of the brain. So minute were their instruments that they were able to record the activity of single cells. Here they found dozens of localized cortical fiefdoms each controlling its own territory. And sometimes within a local region there were subregions, each contributing unique operations. In the visual world of man's close cousin the monkey, for example, at least 34 different venues were discovered. Some areas process forms, some color, and some orientation. Human brains are much the same—at least on this level of processing.

One important study by Tootell, Silverman, Switkes, and DeValois (1982) showed dramatically the organization of simple visual information in the striate cortex in monkeys (figure 4.5). Here we can clearly see that the visual stimulus is physically copied on the striate cortex. And, consistent with the results obtained from the Japanese soldiers who had part of their cortexes unceremoniously removed by high-velocity bullets, greater area is given to foveal stimuli (note the left portion of *B*) than to peripheral stimuli. The lines between the outer and middle circle are large in the stimulus but only moderate in the reflected brain areas.

What Leads to Where? Streams of Vision

As important as the geographic specialization of the brain is, an even more engaging part of the story is how the brain integrates information from its specific modules. In this case we are confronted with the most haywired cross-circuitry one might imagine, which involves a search for "what leads to where." Neurologists call these circuits "streams," and the two whose course is true and deep (and of great-

4.5 The retinotopic organization of the striate cortex in macaque monkeys. *A* **is the visual stimulus presented to the animal.** *B* **shows the activity of the striate cortex in response to the pattern in** *A*. **Note that there is an expansion of the foveal portion of the visual stimulus. (From Tootell et al. 1982.)**

est interest to students of the psychology of art) are the ventral and dorsal streams. Both deal with the processing of visual information, such as a painting. These streams are sometimes called the "what" and "where" streams, as their purpose seems to be to answer the question of what an object is and where it is. But this is an oversimplification, as there are many cross circuits that link streams—as if there are main rivers but also essential channels that go between them. In figure 4.6 the two main streams and interactions are shown.

Visual information, such as the viewing of a painting, is processed in a variety of loci. First the signal is sensed by the eye and passed along to the visual cortex, which divides into the "what" and "where" routes. These observations have been greatly supported by animal studies as well as imaging techniques such as magnetic resonance imaging (MRI) and positron emission tomography (PET) with humans.

The areas of the cortex implicated in color perception and motion perception have been investigated by Zeki (1993) using PET scans and generally complementary experiments done on nonhuman subjects, such as monkeys, that have relied on single-cell observations. Using PET and MRI technology it is possible to observe which part of the brain is activated by certain stimuli, such as a face, a moving object, a line, or a color, and thus complete one more part of the jigsaw puzzle of the brain.

4.6 The ascending or dorsal stream and the descending or ventral stream. In the primary visual cortex (far back of the brain) geometric forms are initially detected. The dorsal stream is called the "where" pathway, as it is implicated in identifying the location of an object such as depth (indicated by railroad tracks), direction (curve sign), and location (compass). The ventral stream is called the "what" pathway, as it is implicated in the identification of form (angle), colors (spectrum), and faces. Schematic locations in this figure are approximate. Of special interest is the vast number of interactions between processing centers and other parts of the brain.

The experimental paradigm and results are shown in plate 12. In the color part of the experiment, shown on the left side of the plate, subjects were shown an array of gray rectangles of varying shades (a control condition for shading) or colored rectangles (the experimental condition), sometimes called Mondrian displays after the Dutch painter Piet Mondrian famed for his use of minimal rectangular forms. (Zeki's forms are quite unlike Mondrian's, but the term has stuck.) In this part of the experiment, the blood flow activity measured by PET scans associated with the gray condition was subtracted from the activity associated with the color condition to yield the brain scan shown in *A*. In the motion part of the experiment, a random pattern of black and white squares was either stationary (the control condition) or moving (the experimental condition). Here too the control data was subtracted from the experimental data to produce the results shown in *B*. A third measure was made in which both stimuli were displayed (*C*). Highest levels of activation are shown in white, next in red, and then in yellow. In the color display condition (*A*) the activity was medial, or more toward the center of each hemisphere in an area of the brain called "human V4," an area associated with color

perception; in the motion display condition (*B*) the activity was more lateral, or toward the sides of the hemisphere in an area called "human V5," an area associated with motion perception. In the condition in which both moving and color stimuli were presented, there was an increase in activity in the primary visual cortex as expected. This area is the initial area in which visual stimuli are processed.

Finding corresponding parts of the brain implicated in the processing of simple geometric colors was an important demonstration of how abstract forms are processed, but how does the brain manage realistic visual experiences? In our everyday world and in the world of art, we experience a wide range of shapes, colors, and forms. Indeed, the brain and eye evolved for just that purpose, so that we might distinguish between ripe red fruits and unripe green fruits, for example. Our visual apparatus and inborn cerebral circuits easily adapt to the processing of cars, clothing, buildings, and other modern articles. Zeki and Marini (1998) conducted just such an experiment and found that the parts of the brain involved were somewhat similar to those for the Mondrian figures, with some important differences. (See figure 4.7.) The V4 area was involved, as might be expected, but other areas lying just in front of the V4 complex were activated. This area extended down into the temporal lobe, and an area known as the hippocampus, which is strongly associated

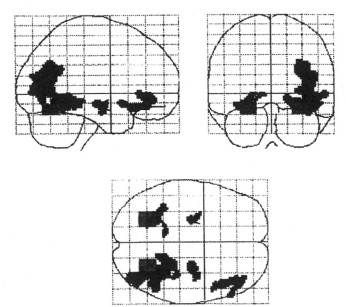

4.7 Brain activity when people view colored objects. This condition shows more general cerebral involvement than when viewing abstract colored rectangles. (See plate 12.) (From Zeki and Marini 1998.)

with memory consolidation, was also activated. This connection is specifically made through the front part of the cingulum, which is typically called the anterior cingulate—a critical structure because it is essential for the hippocampal binding and consolidation of long-term memory.

Drawing conclusions about the brains of artists and art critics based on these studies is scientifically a bit risky, but a few tentative observations are offered. Abstract art as done by Mondrian, Nicholson, Malevich, Kline, Rothko, and others who use bold lines and simple geometric designs seems to engage more rudimentary cerebral sites, while artists who portrayed more realistic scenes, such as Leonardo, Courbet, Boucher, Ingres, and Rockwell, might appeal to more expansive sites.

This observation does not imply that abstract art is simple, as it is likely that it engages higher-order parts of the cortex (such as the frontal regions) for processing that supplies greater imagination and interpretation from the observer. Alas, such observations await empirical data for confirmation. Realistic art, on the other hand, seems to engage parts of the brain that seek associations in one's memory systems, which may be distributed widely. Initial studies in these areas have only given us a hint to the validity of this hypothesis but promise to provide more concrete answers in the future. These studies are the initial steps seeking confirmation of the types of brain structures involved in viewing different types of art.

CARVING NATURE AT THE JOINTS

From its very beginning up to today, science has been devoted to inventing taxonomies (which may in fact be only cognitive illusions). Art critics as well as artists and observers of art also carve up what they see (or create) into categories. While the boundaries may be even more rigid in the art world than in the science world, the means of analysis is, by and large, less prescribed. The scientific method is scrupulously applied to the investigation of brain activity, while deciding how a specific work is to be classified is sometimes open to some subjectivity. Scientists are fond of calling the latter "variance." The taxonomy of art has been based on several factors, among which historical times and/or geographic regions are most frequently used (Byzantine, Renaissance, baroque, romantic, modern, postmodern).

Modern cognitive neuroscience now offers another way of conceptualizing art, namely on the basis of natural neurological processing in the viewing and comprehension of art. Although this suggestion is in its embryonic state, enough solid empirical information is available for artists and scientists to begin to think about carving *art* at the joints. Specifically, this approach would be based on "natural" boundaries of visual-cognitive divisions. These taxonomies would follow along the

lines by which the brain parses pictorial information. Already, less formal but nevertheless reliable parameters have been specified that separate fine arts from each other. Visual art lodges in the occipital lobe; literature in the left hemisphere; metered poetry in both hemispheres; music in the auditory cortex; and ballet has a large motor component that likely involves the motor cortex. Within visual art, the results discussed above (although in need of confirmation by additional experiments) tell us that the processing of realistic objects takes place in different regions of the brain than the processing of "abstract" objects. It is plausible to extend this argument to surrealist forms of art which, I would hypothesize, perform out of another cerebral theater.

Carving art from the inside of the brain creates a much different organizational pattern and one that, on first impression, may appear grotesque. Here faces, forms, colors might be the superordinates, with, for example, Rembrandt's faces grouped with ancient Egyptian faces and Warhol's faces. Strange bedfellows, but if we are to rely on what we know about the way the brain processes these things, facial categories make as much sense as geohistorical ones. While such a taxonomy may appeal to those who are daft over science, reductionism, and empiricism, the method has serious limitations based on incomplete knowledge of the processing streams beyond the initial stages. And integration of information from one's personal history is still an enigma.

Our technical discussion of measuring different areas of the brain activated when human subjects view color objects, realistic pictures, and moving objects adds further credibility to the hypothesis that the viewing of angles, colors, moving objects, perspective, and faces (a topic we will deal with in the next chapter) each have specific physiological analogs. These hard-nosed scientific experiments have relevance in understanding how people view art; in the next section they are applied to a classic piece.

"Raphael's Brain"

For this tutorial in cerebral streaming, I have selected a well-known piece by the extraordinary Renaissance painter Raphael, whose portraits are still among the most exquisitely created of any age. My analysis is meant to illustrate a general scheme for how human brains process and interpret art (and other sensory events).

The aspiring young artist arrived in Florence, a bustling city dominated by the Medicis, the Pope, Michelangelo, and Leonardo (probably in that order), in 1504. Raphael was but 21 years old and had begun to emulate the styles of his creative heroes. One can especially see the influence of Leonardo (*The Last Supper*, painted in Milan) in Raphael's use of geometric regularities and even in his utilization of

pyramidal structures. But Raphael added his own immaculate precision to his works, as depicted in *Madonna of the Meadow* (plate 13). There are several features of this painting that make it a desirable candidate for analysis.

FROM THE EYE TO THE BRAIN

Visual processing of information from the receptors is hierarchical, moving from the eye to the neurons of the primary visual cortex and then to many other cerebral neighborhoods, including various associative regions in which numerous connections are made with other neurons which interrelate modules. At each level, the processing becomes more entangled with higher-order functions, so that in a very brief time we interpret the visual signals into meaningful thoughts. For familiar objects, each of these "perceptual units," by which is meant the recognition of an object as belonging to a class of objects (e.g., the recognition that the woman in *Madonna of the Meadow* is Mary), requires only a very brief time. Of course, many factors influence the amount of time required for the brain to spin out an answer to the questions of who and where. Simple identification of a painting may take only a fraction of a second, but more complex and complete analysis takes many times longer. Estimates of simple recognition may serve as a good index of how rapidly (or slowly, depending on your perspective) something "out there" gets recognized "in here." Once a perceptual unit is set in flux, it continues to spread its activation, followed immediately by the detection of another stimulus which begins the process afresh. This sequence of perception-cognition continues as, metaphorically speaking, a picture is painted in the head. We reconstruct visual impressions, adding knowledge, interpretation, and even bias to what we see and what it means.

VISUAL PRIMITIVES

The term *visual primitives* refers to elementary components of visual stimuli that are detected and processed by those parts of the cerebral architecture in more or less predetermined ways. These processes are built in—those with which we are born. They are commonly called "hard-wired" structures as they are part of our genetic makeup and mature naturally, being altered little by learning and environmental influence. Furthermore, these structures are (generally) geographically stable. As an example, the site for the processing of a vertical line is similar among different people.

All nature's structuring, associating, and patterning must be based on triangles, because there is no structural validity otherwise. This is nature's basic structure, and it is modelable.

—Buckminster Fuller

In the painting *Madonna of the Meadow* the Madonna and the Christ child are balanced by the young St. John on the left. Mary's right leg traverses her body, and her ivory foot forms the point of an equilateral triangle with the apex defined by her left eye. Mary, Jesus, and St. John are placed in an Umbrian landscape which further frames the figures from the background. The "mind's eye" seeks visual stability in environmental forms. The figures herein are parsed into familiar forms such as a triangle, ovals (seen in the three faces), and cues of directionality and depth (seen in the direction of the Madonna's eye and the contrast between the foreground figures and the background). The faces are clearly and beautifully shown. Raphael used red, blue, and yellow to enhance the delicately composed ivory faces. The initial cerebral analysis of shapes, colors, and faces is performed by areas that begin at the back of the brain in the primary visual cortex and then extend to the temporal lobes in the lower middle part of the brain and at the same time activate specialized regions such as the limbic system, frontal lobes, and other areas. The initial stages of processing are fairly well localized in the brain and have been successfully tracked in recent imaging studies and animal models.

COGNITIVE MEANING

The second level of analysis deals with the cognitive meaning of *Madonna of the Meadow*. An interpretation of this piece might engage a person's long-term memory for the symbolic meaning of the triangle as an important Christian icon representing the Holy Trinity—the Father, the Son, and Holy Ghost. The scene also holds key events in the life of Christ. His birth is suggested by Mary, his death by the cross (a paradoxical symbol, as it is implied that death on the cross was foreseen at an early stage). The presence of infants in this painting may stir feelings of emotionality and nurturance in some viewers, while others may find emotional solace in the serene features of Mary. Many more highly individualistic interpretations are awakened by this masterpiece from the Renaissance. (See Solso 2002 for a more complete description.)

Trying to track the tangle of meandering streams aroused by these complex thoughts engaging long-term memory, creative thoughts, and emotional centers is beyond our present state of neurological technology. Indeed, such a search may be scientifically misdirected. While brain-processing primitives seem to be more or less geographically localized, higher-order associates are likely distributed in many different sites. *Thoughts* about this painting are difficult to localize because they are the result of the integrated brain drawing on different modules for analysis and integration. We may, however, make some informed hypotheses as to which sites contribute to the overall understanding of art, with this cautionary note: higher-order

cognition is the result of subtle contributions and interactions that engage billions of neurons located throughout the brain, whose collective electro-chemical-psychological actions are not known at this time.

A great deal *is* known about the processing streams as we look at a painting, and that is the next part of our story. What eye and brain functions are activated when one sees this picture? The moment reflected light from it reaches the retina, a series of spontaneous sensory-cognitive functions are energized that recognize and give meaning to the experience. As soon as the eye has focused on a part of the artwork, it darts off to another region and then to another. Almost immediately, colors, contours, and figures are organized into sensory signals that are swiftly dispatched to the region of the brain called the visual cortex, located in the very back of the head. There, further featural analysis takes place that activates many other regions throughout the cerebral cortex. One route, or stream, takes a downward course where the signal is analyzed for angles and colors while another stream goes upward where an object's location or motion is situated. In these routing paths, there is massive interconnection with other regions; in general, the cerebral action takes information from a painting and analyzes it into components while at the same time engaging higher-order processing areas of the brain that make us aware of the significance of the piece.

One of the many regions that might be minimally activated by this anfractuous circuit is the motor cortex, a center for muscle actions located in the cortical surface of the brain. There impulses are sent out that mobilize the muscles controlling the eyes, causing the eye to move to another section of the painting. The entire process of focusing the eyes on one part and then moving on to another is repeated dozens of times in the interval required to read this discussion. Each of these impressions is transmitted to an ever-branching network of cerebral synapses and combined with previously stored information to give thoughtful interpretation of the painting.

In many of the examples used in this chapter, we have shown the human face. Faces have dominated art, especially Western art. Is there anything special about human faces? We will learn more in the next chapter.

5 About Face

The human face is the organic seat of beauty. . . . It is the register of value in development, a record of Experience, whose legitimate office is to perfect the life, a legible language, to those who will study it, of the majestic mistress, the soul.

—*Eliza Farnham*

A few years ago an article in a prestigious journal in psychology theorized "Why Faces Are and Are Not Special" (Diamond and Carey 1986); another article later examined "What Is 'Special' about Face Perception" (Farah, Wilson, Drain, and Tanaka 1998). Both papers presented convincing arguments about the distinctive psychological characteristics (and not so distinctive characteristics) of faces. One studied facial recognition by experts; the other was based on brain processes. While cognitive psychologists attempt to find the neurological substrates of facial processing, artists have known for centuries that faces are special. From prehistoric amulets to postmodern images, faces have been in the forefront of art, and now of cognitive neuroscience.

In the previous chapter, we learned there were two main visual processing streams (with many complicated interactions between them): the ascending dorsal stream to locate *where* an object is and the descending ventral stream that tells us *what* an object is. It is in the "what" stream that we find specific brain structures dedicated to the processing of upright, normal faces—faces that have a pivotal role in evolution, in everyday life, and in art.

The study of faces is an important part of anthropological studies. An early attempt to classify faces—a type of counterpart to the pseudoscience of cranial phrenology popular during the eighteenth and nineteenth centuries—was made by Johann Lavater (1741–1801) in his *Von der Physiognomik*, 1772, in which he compared the facial expressions of humans with animals. Over the years many

A Potpourri of Faces (see plate 14)

Some of the finest examples of early Roman Hellenistic art are found in Egypt as mummy masks. The mask of this very attractive and noble Roman woman was completed in about 170 A.D. Characteristic of the very skillful portraits of the time were the slightly exaggerated eyes, the fair complexion, and subtle use of cosmetics and jewelry. Her simple, direct expression evokes a calm feeling. (British Museum, London.)

Little is known of the eighteenth-century Japanese artist Toshusai Sharaku, whose portraits of Kabuki actors express emotions dramatically. Here the posturing actor is silhouetted by the dark mica background which accentuates his stark ivory face. The face here depicts an important moment in a play, when the principal character draws his sword to avenge his father's murder. Look at the face again with this information. (The Art Institute of Chicago.)

The haunting face in Edvard Munch's *The Scream* (1893) has terrified viewers for over a century. In these few simple lines Munch has captured terror in a skull-like figure—the type of terror one might experience in a nightmare. (Nasjonalgalleriet, Oslo.)

On May Day of 1991 in Moscow, Russia, I happened on this veteran of World War II resplendently displaying the medals he won during the "Great Patriotic War." His face is devoid of hardship and even appears calm and kindly, belying the human suffering he must have seen. While experience etches its mark on the human face, the face still exhibits the indomitable spirit of its owner.

One of the most famous faces in history is that of Nefertiti from ancient Egypt. This elegant bust was sculpted in 1360 B.C. and is unequaled in refinement. This piece was likely an idealized model based on Nefertiti or one of her daughters. It has been used as a standard of beauty for centuries.

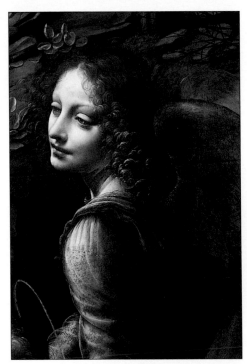

Plate 11 Van Gogh and da Vinci. Which of these paintings was done by Vincent van Gogh? Make your decision as rapidly as possible. See page 120 for an explanation.

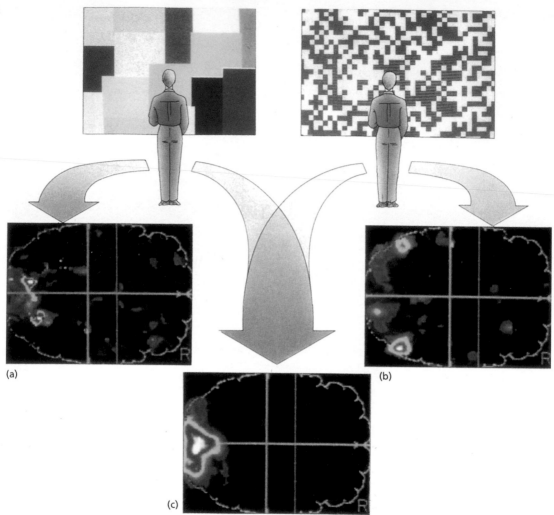

(a)

(b)

(c)

Plate 12 The regions of the human brain showing increased blood flow as measured by PET when viewing certain objects. People looking at colored rectangles, so-called "Mondrian" figures, showed brain responses in the rear central part of the brain (A). People looking at moving black and white squares showed more distant brain response (B). Seeing both colors and moving features caused general activity in the rear of the brain in the visual cortex (C). These results help in the localization of function for visual events, including art. (From Zeki 1993.)

13

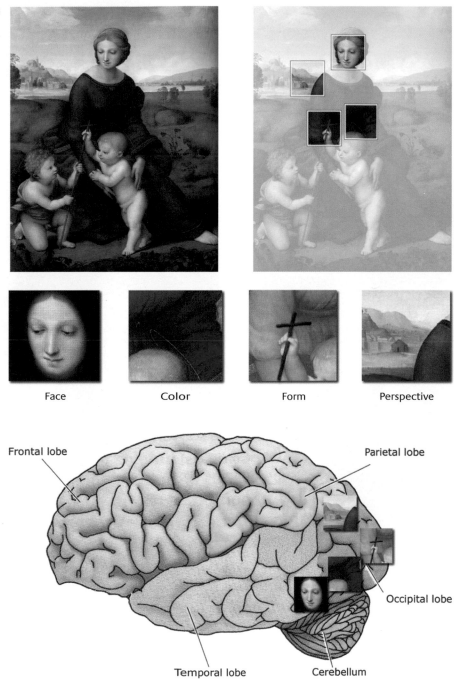

Face Color Form Perspective

Frontal lobe

Parietal lobe

Occipital lobe

Temporal lobe Cerebellum

Plate 13 Raphael's Brain. © Anne Solso. Raphael, *Madonna of the Meadow* (1506).

14

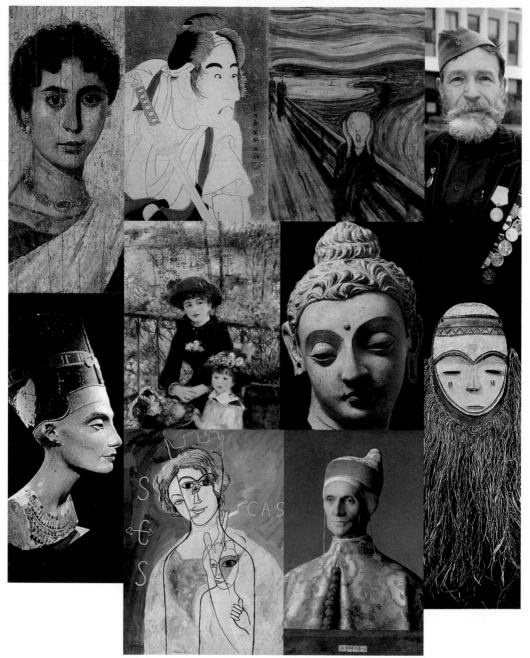

Plate 14 A potpourri of faces. See pages 134–135 for their identifications.

Auguste Renoir painted young girls whose simple innocence and loveliness appeal to the viewer. Men and women wish to see their daughters in these lovely girls, and young men envision a woman they wish to spend their life with. Part of the charm of the faces and surrounding scene in this double portrait is in their softness and the impression they create in the viewer. The style is impressionist. (The Art Institute of Chicago.)

Far from the Greek and Roman tradition in which gods and heroic figures were shown in idealized forms, Indian art also depicted gods beautifully. This rendition of the Buddha exudes quiescence and tranquillity. (Calcutta Museum.)

This ceremonial mask from Africa is an unmistakable human icon even though it is highly symbolic. The face evokes mysticism associated with cultural heroes, ancestors, divinities, and spirits. The face nevertheless holds a clouded beauty in its symmetry, simplicity, and style. (G. Mandel, Milan.)

Francis Picabia produced this gouache on paper in 1928 after having moved through impressionism, cubism (in which a face is depicted from different angles simultaneously), and dadaism (which rejected traditional art and produced "sheer nonsense"). His innovative style here shows three superimposed views of a woman's face. The laws of perception, in which a foreground object occludes a background object, are suspended, giving the piece an ethereal quality. The seemingly transparent faces compel us to look at them more deeply with the mind's eye. (Private collection, France.)

Giovanni Bellini, an artist of the Italian Renaissance, was commissioned to portray the Doge Leonardo Loredan, a stern-faced Venetian aristocrat. The piece is known for its exquisite rendering of the Doge's cape and headdress, but the face is one of a harsh and uncompromising official. (National Gallery, London.)

quick-buck con artists have capitalized on the gullibility of the public on this matter, while racists, both in the eighteenth century and in modern times, have found grist for their narrow views in these physiognomy systems. Lavater's work went through many editions, and it still attracts followers. It was not until Charles Darwin published *The Expression of the Emotions in Man and Animals* in 1872, which was originally conceived as part of his classic book *The Descent of Man,* published a year earlier, that facial expressions were cast in the larger scheme of legit-imate science. Modern anthropological studies of the face were established in this work. Darwin reasoned that facial expressions were originally functional: frowning shaded the eyes, turning down the mouth rejected bitter foods, opening the eyes wide enhanced vision, and the like. Furthermore, emotions such as fear, aggression, and love were also displayed by one's face as emotional posturing, all of which were related to survival.

> *A noble forehead, a miracle of purity, the love of order, I might say, the love of light. Such the nose, such is all.*
>
> —*Johann Lavater*

All people have faces and most animals do, too—putting aside the anomalous jellyfish, most clams, and the celestial starfish. Why, in the crooked path of evolution, did the face emerge? While speculation about the emergence of a face and its purpose may be more fanciful than a description of Gulliver's travels, some logical inferences are ventured.

Starting with the human face, we observe that faces are packed with forward-oriented sensing tools—our eyes, nose, tongue, and ears—and therefore serve useful purposes in directing our body, perceiving important things in the world, and ingesting food. Very early creatures—those slithering worms from the dawn of earthly life—may have shown the first faces to the world. Worms (as well as most organisms) needed to sense where they were going. By placing the mouth up front, an indecorous little face was born. Also, such a configuration proved to be handy

for scooping up delectable (worm) snacks along the way. The trilobite, who we learned in chapter 2 sprouted rudimentary eyes, showed a kind of forward–directed face suitable for finding and ingesting food. From what we know of the muck through which trilobites made their way, the view was not very interesting. But then, it is hard for a human to judge what is interesting to a trilobite or, for that matter, to any other being. More complex creatures, such as fishes and vertebrates, evolved complex faces whose superstructures were the bony cases that kept their precious, if not lilliputian, brains from harm's way.

Land-based creatures grew faces that were exemplars of an archetypally de-signed face, a sketch and photograph of which are shown in figure 5.1. It consists of a forehead, two eyes, a nose, a mouth, and chin. (Look in the mirror and you will find an excellent example.) Almost all animals, from loyal dogs to feathered canaries, great gorillas, formally dressed penguins, curious salamanders, menacing Gaboon vipers, leaping kangaroos, to your weird-looking Uncle Cyrus and even nocturnal spiders from Australia and inquisitive chimpanzees from Africa (see figure 5.2), adhere to the same formula for facial composition. None, for example, has a mouth over the eyes and nose; none has only one eye in the back of the head; none has a nose that is inverted (which would be a really poor design flaw on rainy days!).

5.1 A "standard" type of human face (left). Tom Cruise, American movie star (right): a "standard" face but much more.

5.2 The face of the nocturnal large-eyed net-casting spider from Australia (left); the face of a chimpanzee from Africa (right).

Why was the hand of nature so uniform in giving us all the same type of face? A simple answer is that the arrangement optimized survival: the eyes, for example, located high on the face occupy a commanding view of the world excellent for sighting food, avoiding low-hanging branches, and directing locomotion; the nose is well designed by being turned downward (avoiding the rain gutter problem mentioned above) and strategically positioned just above the mouth, thus serving as a last-ditch guard against eating spoiled, stinking foods. And the mouth is pragmatically situated to ingest food that has been perused by the nose and eyes just above it.

E. H. Gombrich Comments on a Face by Goya

"He also looks at his sitters with a different eye. . . . Goya seems to have known no pity. He made their features reveal all their vanity and ugliness, their greed and emptiness. No Court Painter before or after has ever left such a record of his patrons." (Gombrich 1989, p. 385)

5.3 Francisco de Goya, *King Ferdinand VII of Spain* (1814), detail. Museo del Prado, Madrid.

Describing the architecture of the face is like looking at a blueprint of a beautiful building: it gives information about structural properties but fails to express the richness of detail personified by the real object. Contrast the sketch and the photograph in figure 5.1, for example. A face is much more than an arrangement of features (and recent studies into the brain's cortex involved in facial analysis have found that primates process faces holistically). Not only is a face the first thing noticed about a person, but also it tells more about an individual than any other physical attribute. No wonder they have become a popular theme of artists, anthropologists, and cognitive neuroscientists; faces embody important aesthetic, evolutionary, and cerebral elements.

Faces Are Special in Art

Clearly, faces *are* special: each period of art, from prehistoric carved-stone "Venus" amulets to ancient and Ptolemaic Egypt, the early and late Renaissance, classicism, impressionism, cubism, through to postmodernism, has featured the portrait as a central theme of artistic expression. And "classic" faces from Nefertiti to Mona Lisa to Marilyn Monroe have been the cynosure of the hoi polloi as well as the aristocracy for ages. A series of faces may be seen in plate 14. Take a moment to look at this collage as well as other portraits shown throughout this book (e.g., plate 11). Note that as you study each face your perception is not limited to simply looking at facial features; each face sets off a flood of questions and hypotheses. Who is this person? What is he or she thinking? What is he or she feeling? What experiences are etched on this face? Is the person kind? Stubborn? Cruel? Happy? Deceptive? Honest? How does the world view this person? How does the face fit into the psychology of art? In each instance there is a side of humanity that cuts to the core of the person behind the mask of facial expression. Even when an artist presents a face in an impressionist, abstract, or cubist style, as in the case of Picasso's *Weeping Woman* (see figure 5.4), internal states of personality burst through; one senses the terrible anguish of the woman. Or, in a case of photographic realism like Dorothea Lange's *Migrant Mother, California,* which dates from the same period, a life story of anxiety, hope, and love emerges from an unmasked face. Faces touch us. These faces deserve your careful attention. Study them. As we shall see shortly, they touch us in an area of the brain dedicated to their perception and analysis. As our eyes are our openings to the world, our face is the quintessential embodiment of who we are.

The importance of faces in art is overwhelming: the majority of illustrations in standard art books are human portraits; faces dominate our popular media, including film and TV; portrait-drawing courses are standard offerings in universi-

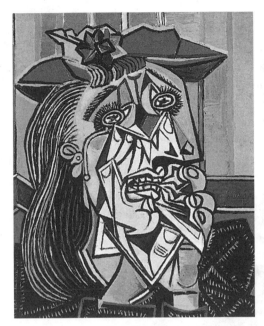 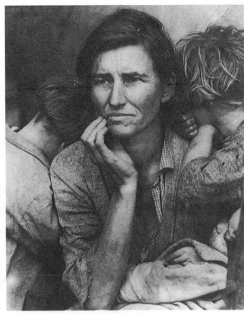

5.4 The portrayal of a face in an abstract or cubist style, as in the case of *Weeping Woman* **(1937) by Pablo Picasso, sends an emotion-laden, profound message to the brain. The photographic image by Dorothea Lange,** *Migrant Mother, California* **(1936), of a concerned mother deep in the Great Depression holding her dependent children, also evokes powerful emotional reactions. Faces, whether abstract representations or concrete images, excite the brain of the observer.**

ties and art schools; and art galleries, including some that specialize in portraits (e.g., the National Portrait Gallery in London), are filled with faces. Equally obvious is the importance of facial identification as we conduct our daily lives. It distinguishes the familiar from the unfamiliar, friend from foe, the truthful from the deceptive, and the powerful from the meek—among dozens of other distinctions.

Domain Specificity and Faces

Evidence for the importance of faces in the neurological circuitry of the species has only emerged during the past few years and has confirmed the obvious—faces *are* neurologically special. Understanding the psychology of art is to a large extent dependent on understanding the basic neurological roots of perception and cognition. The human face is a perfect place to focus our attention as it is not only the

"Man Now Realizes That He Is an Accident"

The English artist Francis Bacon (1909–1992) is associated with the expressionist tradition, but his works contain realistic features. Few artists have been able to convey unnerving anguish in their paintings as has Bacon. One device for which he is known is distorting the human face to the point that it becomes distressing to the viewer. In the example shown here the man's face is all a blur. It is difficult to view this painting without an emotional response. These human reactions are widespread and suggest that facial perception stimulates the limbic system (tied to emotional responses) as well as visual recognition centers.

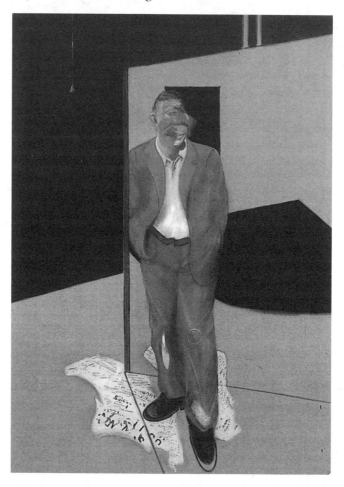

5.5 Francis Bacon, *Study of a Man Talking* (1981). The Hess Collection, Napa, CA.

main theme in art but also has unique and clearly delineated neurological features. In addition, the study of the human face represents a microcosm of the computational brain.

How the brain processes facial information is central to the question of how the brain works in general. Two contrasting hypotheses are popular among cognitive neurotheorists:

• One position contends that the brain is composed of domain-specific modules (we encountered the "Swiss Army knife" idea in chapter 2), each of which (more or less) carries out an explicit function. Clearly, such functions can be seen in the part of the brain dedicated to sensory and motor functions. Also, parts of the primary visual cortex are consigned to featural identification.

• An alternate view is one that suggests that the brain, although somewhat segmented by neurological modules, processes information by means of domain-general mechanisms, which may process different types of information. This view suggests that the brain's modules may be far more versatile in dealing with the myriad of different signals that arrive in a great flood for simulation processing.

"Facial Cells"

While some modules in the brain seem to process diverse types of information, there is a domain-specific and localized part of the human cerebral cortex that is dedicated to facial processing. As with so many early discoveries in neural science, findings in neuropathology led the way to the idea that there was a "facial module" in the brain. A particularly curious condition, called prosopagnosia, or facial blindness, leaves patients who otherwise have normal vision with the inability to recognize familiar faces. Early postmortem examinations of these patients (which have been confirmed by modern imaging technology and electrical evoked potentials) localized an area of the brain tied to facial perception. Prosopagnosics exhibited defects in an area in and around the human temporal lobes and hippocampus (see plate 13). More specific areas of the brain have been identified as related to facial perception, notably the fusiform and inferotemporal gyri. More on this topic later.

The condition is spectacular in its manifestation. People with the disorder cannot recognize very familiar faces, such as those of their business associates, friends, and—in one of the most celebrated cases documented by Oliver Sacks in *The Man Who Mistook His Wife for a Hat*—even their spouse. In this case the patient was able to recognize his wife only if she wore a familiar hat. Of course, what he was seeing was the hat, not his wife's face. Object recognition in these cases is often unaffected.

As is the situation with many neuropathological afflictions, the site of disorder is rarely well circumscribed. The inability to recognize faces may be caused by a number of conditions such as lesions, strokes, head trauma, encephalitis, and even poisoning, all of which tend to be somewhat unspecific in their loci. Other areas outside the fusiform gyrus, for example, may be affected by disease or trauma, which complicates the cause-and-effect relationship between affliction and facial perception. Nevertheless, studies of a large number of patients using imaging techniques (see Farah 1990), animal studies (Kendrick and Baldwin 1987), and recent human studies (Allison et al. 1994; Haxby et al. 1994; Haxby et al. 1999; and Kanwisher, McDermott, and Chun 1997) confirm the localization of facial processing in the brain.

PET, MRI, AND ERP DATA

While studies of facial processing exhibited by pathological types and animal experiments generally pointed in the direction of dedicated "facial cells" in the brain, in order to verify the idea that faces were anatomically special there needed to be confirmation with normal, healthy people. Fortunately radiological science provided techniques that allowed curious people to peer inside the human brain while it was processing specialized information, such as looking at a face.

Among the most widely used of these are PET (positron emission tomography), MRI (magnetic resonance imaging), and ERP (event-related potentials). All these techniques have been used to study the perception of visual stimuli, including art, faces, and geometric figures. Here follows a brief overview of what is being measured in the brain, so that the implications of the technique for art might be better understood.

• PET scans use radioactive particles injected into the bloodstream to measure cerebral blood flow by means of external peripheral sensors. Unlike ordinary X-rays, in which the body is subjected to high-energy rays, PET scan images are made from positrons that are injected into the bloodstream. Short-lived radioisotopes of carbon, nitrogen, oxygen, or fluorine are carried to the brain by glucose. As the brain metabolizes the glucose in proportion to its needs, the radioactive material is read by a series of detectors, which a computer then transforms into a picture of the brain's activity.

• MRI scans are done by surrounding the body with a very powerful electromagnet that orients the nuclei of hydrogen atoms. The aligned atoms are then bombarded with radio waves, causing the atoms to emit radio signals which are read in

terms of their density and chemical environment. In a simplified version, MRI measures blood density (or rCBF, regional cerebral blood flow), which is an indication of the brain metabolizing oxygen. In fMRI (functional MRI) technology, blood flow is measured as neural activity changes are imposed.

• Event-related potentials (ERP) is another technique used to understand the local parts of the brain. This is a type of specialized electroencephalogram—a technique that records electrical activity of the brain by external electrodes—in which the signal is detected in response to a sensory stimulus. If one were interested in the effect of a sound on the auditory cortex, for example, electrodes could be positioned in that area and a sound presented to a patient.

The logic behind some of these technologies is that cortical activity in specific areas of the brain requires greater volumes of blood in these areas. Therefore, if one traces the regions that show increased blood flow, one can identify precise areas of the brain that are currently active. These measurements are then correlated with external events, such as looking at a picture, listening to an auditory signal, thinking, remembering, and so on, to gain a detailed impression of the relationship between environmental stimuli and corresponding cortical activity. In effect, a type of cortical map of external events can be drawn.

THE FUSIFORM GYRUS

Several pivotal studies localized an area in the brain implicated in facial processing. The intention of these studies was to shed light on specialized brain functioning, not to tell us the way art is perceived. Did the brain consist of modules (Swiss Army knife model) or not? In addition, neuroscientists were fascinated with the idea that there were processing "streams" (as we learned in the last chapter) and that the visual system harbored a multitude of complicated, interactive neural circuits. One stream decomposes visual signals into elementary lines and angles and then processes the signal at a higher level, such as colors and faces, while another stream is dedicated to locating an object in space.

The gyri in the brain are the ridges of a hilly cortical topography, with valleys (or sulci) separating the higher ridges. The fusiform gyrus is one of these outcroppings located in the regions called the occipital and occipitotemporal cortex, on the underside of the brain near the back. That area "lights up" in most people when they look at faces, and that little hill is a leading candidate for the location of the "facial cells."

VISUAL PROCESSING STREAMS—WHERE AND WHAT

The discovery that the fusiform gyrus was implicated in facial recognition was the result of a few important experiments conducted in several different laboratories, including the National Institute of Mental Health, Harvard University, and MIT, among others. One such experiment by Haxby et al. (1994) was particularly comprehensive as it used both new PET data and historical findings, and measured facial matching (which has been shown to be located in the descending, ventral stream) and location matching (which has been shown to be located in the ascending, dorsal stream). The experiment was conducted on healthy participants who were asked to match a face with one of two other faces, as shown in figure 5.6. Another condition in the experiment asked the subjects to match the position of the double line and thus measure the location of an object.

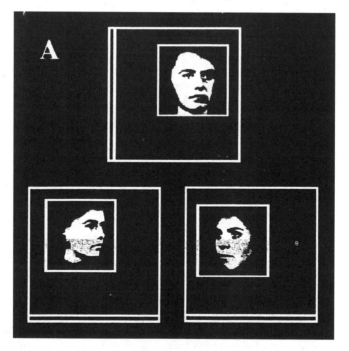

5.6 Facial matching task used by Haxby et al. Healthy participants were asked to match the top face with one of the lower faces while having a brain scan. The results showed increased activity in the facial fusiform gyrus (FFG), supporting the idea that human brains have specific-purpose neural cells dedicated to face processing. (From Haxby et al. 1994.)

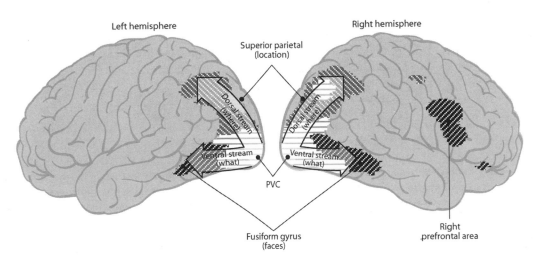

5.7 **The areas of the brain that showed increased rCBF (regional cerebral blood flow) when young healthy men were asked to match faces, match locations, and match both faces and locations. The dark hatching on the bottom parts of the figures shows the area most active in facial matching. This area is in the fusiform gyrus in the occipitotemporal cortex. The area indicated by the light hatching is in the dorsal occipital, superior parietal, and intraparietal sulcus cortex. In this dorsal stream the location of an object is activated. In the area indicated by horizontal lines in the primary visual cortex, both face and location activation are shown. (Data from Haxby et al. 1994.)**

The measurement of rCBF was done by PET scans (see above). Each person in this task was given an intravenous injection of $H_2{}^{15}O$ (water with a radioactive isotope of oxygen). The half-life of the radioactive material in these experiments is very short, thus the scanning was completed within about a 4-minute period. The areas of the brain that showed significant increase in rCBF during the face-matching, the location-matching, and the face- and location-matching tasks are shown in figure 5.7.

The region of the brain clearly implicated in face matching is in the fusiform gyrus or the FFA (facial fusiform area) and seems also to engage parts of the occipital cortex. Matching of locations was associated with increased blood flow in the dorsal occipital, superior parietal, and intraparietal sulcus cortex.

These important initial findings have been confirmed and refined by many other experiments using a variety of imaging techniques. Of particular interest to students of art and brain mechanisms are an article by Tong et al. (2000) and

5.8 Some of the figures used in Tong et al. Both faces and upright cartoons showed maximum activity in the FFA, but inverted cartoons and objects showed considerably less activity. (From Tong et al. 2000.)

summary by Nancy Kanwisher (2001). In the Tong et al. research paper, a number of different faces and objects were shown to people undergoing MRI scans (see above). Using a different methodology than that employed by Haxby et al., these researchers obtained very similar results, corroborating the finding that the FFA is implicated in facial processing. In addition they extended the range of the study to include not only human faces but cat and cartoon faces (see figure 5.8), both of which showed considerable activity in the FFA. They found less activity for schematic faces, inverted cartoons, eyes alone, and objects. While learning and experience affect the way we process specific faces—e.g., we have learned to recognize Tom Cruise, George Bush, and our psychology professor—the FFA appears to be optimally tuned to recognize a broad category of faces.

REAL ESTATE VALUE AND FACES IN THE CEREBRUM

It would be hard to overestimate the value of cerebral space. Each part of the brain is the result of millions of years of selective pruning, random mutations, and growth, just as the neural circuitry of each part of the brain is the result of lifetime learning and memory formation. It is highly unlikely that nonessential circuits seized any territory—at least for the long run. Cerebral space is exquisitely precious, especially in humans who rely on intellect for survival.

Why, you might ask, with cortical resources so scarce, is a portion of the brain dedicated to the perception of faces? Is it to see Raphael's Madonna? Van Gogh's Doctor Gachet? Warhol's Marilyn? Max's Zil? Rembrandt's self? Tom Cruise? This is not the "reason" human brains evolved an FFA, any more than the auditory cortex evolved to hear Palestrina, Beethoven, Kiss, Puccini, or a police siren. Rather

the reverse: these sounds were created to have a stimulating effect on the auditory system, as art was created to stimulate the visual system.

The perception of the human face evolved so we could see things *important* to us—important in the sense that seeing them might help us live longer and better. And a moment's thought will confirm the importance of facial perception in the social sense. Human interactions are mediated by facial cues. Knowing that faces are important, we can better appreciate the artistry involved in creating a likeness of a face, as shown in the color montage of plate 14.

There is a much bigger lesson to be squeezed out of this exercise in neuropsychology than simply discovering brain areas that are related to facial processing. That more global, artistic lesson is that our sense of harmony, beauty, aesthetics, and even dissonance—indeed, our entire understanding of art—is rooted in our neurophysiology, which formed cognitive structures for less elegant processing demands over many millions of years. While it would be brutishly uncouth to suggest that intellectual adaptation in a changing environment could be summarized as "hunt, kill, eat, have sex," such a characterization does embody many of the important features of visual processing, including the facial and featural representations—the very essence of art from the time man became conscious until now.

The basic primitives of our deeper comprehension of art, including visual representations of faces, lie ever ready to respond to the myriad incoming eclectic stimuli that strut across our perceptual landscape in an uninterrupted parade. While reflection, cognition, and interpretation of art are all enhanced through our memory for past experiences and subjective logic, it is the intrinsic structure of the brain that provides the canvas on which perceptions are painted. Nature has parsimoniously supplied us with an internal neuromachinery from which we can best view the parade within the confines of space and processing capacity, and the potential to learn through experience what these things mean. Art and science contribute to this magnificent process, each providing its own view of what the world is, each telling its truth about a single reality.

What the Portrait Artist's Brain "Sees"

"Your brain and the brain of Leonardo da Vinci are the same, structurally, when viewing a face." While that statement may be true in the sense that the architecture and general schema of your brain are the same as Leonardo's, the specific functional characteristics are (likely) different. Without wiring your central nervous system to his, his view of life and your view of life can only be estimated. An individual's life experiences are stored in long-term memory cells. These cells provide an analytic

filter through which sensory impressions are given meaning. Because individual perceptual-cognitive experiences differ for each of us, specific interpretations of art are subjective. An individual's view of the parade takes place from that singular, phenomenological platform. Experience shapes the view of art; neurology determines the domain of art.

The Artist's Brain

From the laboratories of Haxby, Kanwisher, Tong, Ungerleider, and others, spectacular brain images have been made of ordinary folks as they look at faces. Faces are special—both from a social and a neurocognitive viewpoint. However, the puzzle suggested at the beginning of this section still remains: when viewing a face, does a skilled portrait painter process that information differently from a layperson? Did Leonardo's brain metabolize hemoglobin in different regions than a nonartist's brain as he looked at and painted Mona Lisa? (Regrettably, Leo did not live long enough for an fMRI scan.) There are many exceptionally talented living portrait artists, one of whom, Humphrey Ocean of London, was willing to subject his brain to scientific scrutiny in a project called "The Artist's Brain."[1] The idea was to look at the brain of a working artist as he looked at and drew a face, and contrast these data with that for a control subject who was a nonartist.

In order to test the feasibility of examining the brain of an artist as he drew a portrait, I modified an MRI machine so that a small portrait and notepad could be attached to the inner surface of the machine and copied while I underwent a cranial scan. (See Birmingham 1998, which shows Solso's brain scan while drawing a face.) The procedure in fMRI technology of this type is to have the participant generate contrasting types of brain scan information so that the main effects of the experiment may be shown in comparison with other data. In this case, we were interested in which parts of the cerebral cortex were implicated when one attends to and draws a face. A comparable visual-motor task was devised in which geometric forms were made. In the experimental procedure, the participant was asked to draw a series of faces, but also a series of geometric figures, while undergoing a scan. The information gathered from the geometric drawing condition was subtracted from that of the facial drawing condition, leaving the "pure" facial processing data. Even though there were some technical problems to overcome—for example, in scanning the brain with contrasting conditions, the skull must be held absolutely stationary—we found it entirely possible to collect good data from a participant actively drawing a face in the MRI machine.

OCEAN'S BRAIN ON PORTRAITS

The National Portrait Gallery in London named Humphrey Ocean as one of the foremost portrait artists of the twentieth century. He has exhibited his paintings of faces (notably of Paul McCartney) at the National Portrait Gallery, the Royal Opera House, Wolfson College (Cambridge), and many other galleries and private collections. He has been the recipient of numerous awards and solo exhibitions. He specializes in portraits and has spent about four hours a day in the drawing of faces over the past 20 years.

Ocean was invited to Stanford University to John Gabrieli's MRI laboratory to participate in an experiment similar to the pilot study done on Solso. As Ocean eased his robust frame into the MRI machine, we began the process of outfitting him with a bite bar to keep his head steady during the drawing process. Then he began drawing faces alternating with drawing figures, as the throbbing MRI machine aligned the dipoles of hydrogen atoms in his brain and response radio signals recorded the volume of blood flows to specific areas. A sample of his drawings appears in figure 5.9.

In addition to gathering the results of Ocean's brain activity as measured by blood flow results, we collected data on a matched control subject who, except for being a nonartist, had a similar background to Ocean's. The results of this double subtraction method (faces vs. geometric figures; Ocean vs. control subject) are shown in plate 15.

Here, for the first time (see Solso 2000 and 2001 for details), we showed the brain activity of a professional portrait painter as he drew faces. Our results were most rewarding, as there was a visible increase in blood flow in the region previously identified as the "facial" area, i.e., the facial fusiform area (FFA). Somewhat surprisingly, the degree of activation in the FFA seemed greater for the nonartist than for Ocean; on reflection, such a finding was understandable in terms of the efficiency with which a practiced artist processes facial information. While a novice might have to study the specific features of a face in order to render a drawing of it, the expert would gather pertinent information in a moment's glance and then allocate further attention to "deeper" cognitive-perceptual matters. Findings from other areas of cognitive psychology support such an idea, as in the case of chess masters who require only a momentary look at a chess setup drawn from classic games to be able to reconstruct accurately the entire board, while novices require considerably more time to do so. (See Chase and Simon 1973.) It may be that Ocean, like other proficient professionals, developed a type of art grammar that enabled him to see the details of an object such as a face as part of an overall schema. Chess masters

5.9 A face and the portrait drawn by Humphrey Ocean while an fMRI scan was made. A lateral view of Ocean's brain appears on the computer screen. (Photo by Solso.)

tend to "chunk" bits of the puzzle into conceptual units. The same cognitive propensity probably exists in a wide variety of experts, be they automobile mechanics, interior designers, chefs, radiologists, musicians, or artists. All experts "see" alike; but they all cogitate about what they see at a higher level of abstraction than nonexperts.

The idea that a professional artist cogitates at a deeper level than a nonartist is bolstered by the rCBF of the frontal areas shown in columns three and four of

plate 15. As shown, Ocean displayed greater activation of the right prefrontal areas than did the nonartist, suggesting that artists don't see the world differently, they "think" the world differently. A nonartist or inept artist might slavishly copy a face feature by feature without attending to a deeper meaning behind a face or an aesthetic interpretation of the person being represented. Perhaps the genius of Leonardo and that of Ocean lies in their ability to see well beneath the surface of their models, to divine the intrinsic character of those whom they paint, or to uncover personality traits of people that might be made manifest on canvas. Artistic talent, from this cognitive analysis, may not necessarily be voiced (that is the realm of the poet or actor) or even consciously felt by the artist, but certainly it is instantiated in visual renditions. What Leonardo did, and Ocean does, is to express human facial traits in such a way that much more than a mechanical reproduction of a person is shown to all the world.

Whether they are born with such intellectual perspicuity or develop it through years of training is, of course, the question psychology has grappled with for centuries. Further understanding of this problem will be found in long-term developmental studies that will trace brain structures and processes over a lifetime. While it is impossible to know what Leonardo's brain looked like when he was a child, an adolescent, a young man, or an old man, it is possible to gather such data on contemporary geniuses. However, from a review of the extensive literature on exceptional people in the arts (e.g., Mozart in music), it seems probable that these exceptional people are born with unusual abilities. Training may considerably improve nontalented artists and musicians, but it is doubtful that any randomly selected young person could become a Leonardo or a Mozart (contrary to what John Watson [1878–1958], the famous behaviorist, wrongheadedly suggested in the twentieth century).

The "Artist's Brain" project purposefully selected a portrait painter as its subject because of the previous information about the FFA. Results obtained from landscape artists would probably be different, as would those from abstract or surrealist artists. At present these types of experiments have not been done. Also, in our experiment with Humphrey Ocean, only one control subject was used; although the results are in line with current theories of the mind, the study should be confirmed with a larger sample of both control subjects and professional artists.

When a Face Is Not a Face

In figure 5.10 an inverted face is shown. Without returning to figure 5.1, decide if this inverted face is the same as the one you saw at the beginning of this chapter. Now, confirm your judgment by referring to the face on page 138. People

5.10 Is this the same face as you saw at the beginning of the chapter?

frequently have difficulty identifying inverted faces even of very well-known people. (You might test this notion by showing an inverted picture of Tom Cruise to a friend and asking him or her to name the person.) While neurocognitive evidence has confirmed that face perception-cognition is localized in the FFA (see above), the neural mechanisms involved in the perception of other objects—landscapes, houses, chairs, scissors, eyeglasses, and so on (see Farah, Wilson, Drain, and Tanaka 1995; Haxby et al. 1999; Kanwisher, Tong, and Nakayama 1997)—are not activated by the FFA. While faces commonly appear in art, they almost always appear in an upright position, the position in which we see them in ordinary life.

It appears that the FFA evolved with clearly specialized functions—to perceive and process human faces in their normal orientation. Such results further confirm the idea that faces are special, neurologically and behaviorally. Art reflects this special consideration.

THE FACE INVERSION EFFECT (FIE)

The Russian-born Marc Chagall sensed the importance of viewing faces in an upright mode and turned the idea "on its head" with provocative works that show some faces inverted, as in *The Poet* (see figure 5.11). The image of an upright human face is so well ingrained in the brain that when we see it in another orientation, such as inverted, recognition is difficult. This raises questions as to what it is that we look at when we see faces. Do we, for example, see faces as holistic configurations, or do we see a face as being composed of a set of features, such as the eyes, a nose, a mouth, and so on?

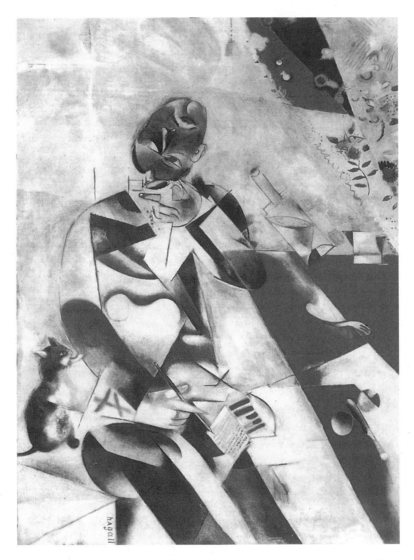

5.11 Marc Chagall, *The Poet* (1911). Philadelphia Museum of Art. Chagall presents a visual conundrum.

5.12 Look at these faces. Do you recognize them from earlier faces? Is there anything odd about them? Invert the faces for a startling effect.

The "face inversion effect" (FIE; sometimes called expressional transfiguration [ET], or the Thatcher illusion, named after the former Prime Minister of Britain who was featured in an experiment using her face) is illustrated in figure 5.12. Is there anything unusual about these faces? Turn the book upside down and see the unusual effect.

When you look at these faces in the upright position, you notice that they appear grotesque. The effect has been demonstrated frequently with a wide range of faces. Note that two features have been incongruously oriented in our figure: the eyes and mouth are turned upside down relative to the overall face. The implication of this demonstration is that when the brain is confronted with an upside-down face, the highly specialized FFA is somewhat bewildered, and so facial processing is done by other visual systems. These systems, designed to handle a large number of unusual shapes, do so by the method of analysis by components. Since the individual components in figure 5.12 are normal, the inverted face looks OK, but the same (reversed) features embedded in a whole face viewed upright looks weird.

The fusiform gyrus seems narrow in its accommodation of faces (close doesn't count), but if a face is a "ringer," i.e., if it exhibits the prototypical image of "faceness," then it is clearly recognized.

In spite of the tyranny the FFA holds over facial processing, there is another side to facial processing that suggests that the way people view faces may be somewhat shaped by their past experiences with faces, as in the case of perceptual adaptation. Curiously, the face inversion effect seems to work only with human (or humanlike, e.g. cartoon figure) faces. Recently, I tried to create the FIE using dog pictures. The startling effect you just experienced with the faces in figure 5.12

simply did not happen with dogs. Perhaps one has to be a dog expert to experience the effect with them.

The FIE has been studied neurologically by Rothstein et al. (2001) using fMRI technology. Here, a group of subjects were shown right-side-up faces, inverted faces, inverted faces with eyes/mouth transformed, and right-side-up faces with eyes/mouth transformed, much like the examples shown at the beginning of this section. While viewing a series of these faces, the subjects made evaluations as to the bizarreness and unpleasantness of the face, with predictable results (the right-side-up face with transformed eyes/face was judged the most bizarre or unpleasant). Past research results of emotionally laden visual stimuli (e.g., pictures of terrible automobile crashes) have shown increased activation in the visual, amygdala, and general limbic areas. The visual area is implicated in most tasks of this sort and its activation is no surprise. The limbic area is associated with emotional and arousing experiences. While increased amygdala activity was noted in the Rothstein study, the researchers used a repeated measure design, which allowed the subject to adapt to the grotesque faces. These results suggest that there are brain structures engaged in processing emotional faces, but that with repeated exposure a type of short-term adaptation takes place. Our common experience bears this out. (See figure 5.5 for another example of facial distortion and emotionality by Francis Bacon.) In the next section, we see the effect of adaptation on facial judgments.

Freud's Brain

Recently, a dreary portrait of Queen Elizabeth II was unveiled by the acclaimed British artist Lucian Freud. His notable paintings of bare-assed men and women give credibility to the theory that individual tendencies are phylogenetically predetermined, since Lucian is a grandson of Sigmund Freud. He is best known for his shameless renditions of middle-aged, unfit men and woman lounging around in the buff—including his own spread-eagle self-portrait. In spite of his reputation for more than honest paintings, the royal House of Windsor commissioned Freud to do an official portrait of the Queen. The result is shown in figure 5.13 for your appraisal.

As he had done with a portrait of his own mother several decades before, Freud painted the Queen with warts and all. Upon its unveiling, critics pointed out that Her Royal Highness sported hirsute stubble, had a neck as burly as a footballer, looked like her own dog after he had suffered a stroke, and was somewhat reminiscent of Winston Churchill after a bad night of imbibing. We understand that the Queen was not amused by the portrait. Yet Freud devoted 70 separate sittings to the project and undoubtedly took his job seriously. One may only surmise (with

5.13 Lucian Freud, *Her Majesty Queen Elizabeth II* (2001). Royal Collection. Queen Elizabeth as seen through the eyes and brain of Lucian Freud.

some neurological certainty) that his FFA was glowing during the sittings and, based on our observations with Humphrey Ocean, that the associative part of his cortex was also burning brightly. How could such a picture be produced by such a talented artist? An answer may be suggested by some further cognitive research.

My colleagues Michael Webster and Otto MacLin (Webster 2002; Webster and MacLin 1999) have presented convincing evidence that people, including artists, are constantly making adaptations to faces that really change the way they see faces. The principle of light adaptation is well established in the psychological literature. (The essential notion is that if one person is exposed to a white light and another to a red light, each person's retina will adjust his vision in different ways.) What Webster and MacLin have shown is that facial adaptation occurs in a rela-

adapt test match

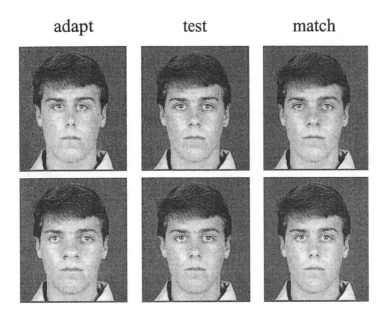

5.14 Facial adaptation experiment. In the first part of the experiment subjects looked at a contracted (upper left) or expanded (lower left) face. After adaptation, the middle face appeared to be "too expanded" or "too contracted," depending on the type of adaptation. (From Webster 2002.)

tively short time. In one phase of an experiment they had subjects look at a "normal" face (see figure 5.14, center column). Then subjects became familiar with a slightly distorted face (figure 5.14, left column). After viewing either constricted faces (upper-left face with eyes close together) or expanded faces (lower-left face with eyes far apart), people tended to judge the original face as being too expanded or too constricted, respectively. The memory for the original face had thus become distorted because of the experience with the distorted faces. If you experience a world with people whose eyes are close together (or far apart), your judgment of "normal" faces quickly shifts.

A similar effect is visible from a cultural standpoint. The anthropologist Bronislaw Malinowski (1884–1942) lived among the Trobriand Islanders for several years and, after adaptation (and probably being a single man among sexually relaxed women), found his judgments of "beauty" shifting to agree with the local cultural norms. The above research suggests that beauty is, indeed, in the eye of the beholder, or to put it more precisely, beauty is in the eye of the adapted mind. Given this information, we might view Freud's Queen with a more knowledgeable mind, if not a more accepting one.

We all bring stable neural structures to the world of art, and we now have localized the area in the fusiform gyrus that is implicated in facial processing. The meaning of faces, as seen in daily social encounters and in art galleries, is the result of neurological processing schemas and past experiences and knowledge. One additional feature, introduced by Webster, is the idea that we view the configurable properties of a face (color, light intensity, complex figures or faces) with an eye and brain that are continually calibrating that face with previously viewed faces. To illustrate how far the situational evaluation can change with adaptation, Webster reported that when some people in his experiment first saw the "pinched faces" or the "wall-eyed faces" they laughed, but that, after looking at them for a while, the faces seemed quite normal, even mundane. People who work with unusual-looking people, whether carnival freaks, Disneyland characters, or Las Vegas showgirls, often report adapting to them to the degree that a wildly tattooed bald little woman, a Goofy character, or a statuesque alluring dancer are seen simply as "nice people at work." Freud looked at Queen Elizabeth II's face many, many times. He had hours to accommodate his mind to her face and to the person he was painting and, if we rely on current psychological findings, his view after that experience was probably much different from anyone else's. Of course, he added his own painterly hand to what he saw. To those without the same adaptation she looks like . . . well, what is your view?

COCKEYED EYE PLACEMENT

In Freud's portrait the Queen's face is shown in neat symmetry—even the locks of her hair are balanced—which gives the painting the look of a bad passport picture. The question of symmetry is an important principle of visual psychology, especially Gestalt psychology, which holds that our visual world is organized in stable forms. Recall that in the introduction we saw examples of how a triangle could serve to organize our visual impressions of paintings in ways that also had ideographic implications. The world of art and architecture is filled with examples of balance, harmony, and proportion. On the other hand, a perfectly balanced picture is . . . boring, the bête noire of artists. The human face is (generally) symmetrical, yet painters usually show the face not centrally positioned on the canvas, as in the case of the Queen's portrait, but off-center—only one eye falls in the center of the horizontal plane. In a very careful analysis of the position of portrait figures within their frames, Christopher Tyler (1998, 2002) has found uncommon compositional consistency. One eye is centered with remarkable uniformity. Figure 5.15 shows a sample of

5.15 Classic portraits created over 600 years, showing asymmetrical alignment of faces on the canvas. The vertical white line indicates the center of the picture. Portraits (from left to right) are by (top row) Rogier van der Weyden (1460), Sandro Botticelli (1480), Leonardo da Vinci (1505); (second row) Titian (1512), Peter Paul Rubens (1622), Rembrandt (1659); (bottom row) Gilbert Stuart (1796), Graham Sutherland (1977), and Pablo Picasso (1937). (From Tyler 1998.)

classic portraits over the past six centuries. The tendency to place one eye in the center of the canvas and the other off-center may be found from Renaissance art through modern art. Note that the portrait at lower right by Pablo Picasso, the very personification of nonconformism, adheres to this unwritten (and untaught) dogma. Tyler has extended his survey of portraits to paintings as far back as the Fayyum period of ancient Egypt, with the same results. The adherence to this rule is almost mystifying in its regularity over the centuries (more than twenty), over a range of artists (282 of them), and over the number of works examined (hundreds). Tyler has also studied the location of mouth position and of the single visible eye in profile portraits; the distribution of these positions is shown in figure 5.16.

5.16 Top: the distribution of the most-centered eye in 165 portraits over the past 600 years (similar data reported over 2,000 years); middle: the distribution of mouth positions, which is much broader than for eyes; bottom: the distribution of eye position in profile portraits where only one eye is visible, which is even broader than for the other positions. (From Tyler 2002.)

The reason behind the phenomenon is open to speculation. Tyler suggests that it may be due to some hidden principles that may be operating in our aesthetic judgments. In a survey of books on painting techniques, only one could be found that even addressed the topic of centering an eye in a portrait. The mystery grows even more curious if we look at the placement of the mouth (and probably the nose and other facial features), which seems more variable. One may speculate that eyes, like faces, are special—an observation supported by a plethora of data (see chapter 3) and ample observational sources. It is through our eyes that we gain access to the visual world, to art, and to other people. Of all the features of our everyday face, the eyes tell most about character, emotions, even health and interests. They are the first thing observed when we look at a person. They are also features by which identities are known—which is the reason the Lone Ranger, Batman, and elegant Venetian women disguised them. Also, if you reexamine the inverted distorted faces shown earlier in this chapter (see figure 5.12), you will notice that the eyes

The Face as a Lie Detector

Truth is written all over people's faces, at least initially. A baby is happy, she smiles; is distressed, she frowns and genuinely means it. In all instances, the inner feeling and outer expression correspond. Yet, for whatever motive, people find it convenient to deceive. The face belies inner feelings. Sometimes people use "face-saving" techniques to cover their own inadequacies, while at other times they try to disguise deeper, more serious personal transgressions. Recently, scientists at the Salk Institute have developed a high-speed computer program that analyzes people's microexpressions from videotapes and assesses them in terms of deception. Many portrait painters, such as Goya (see figure 5.3), have been sensitive to the nuances of facial expressions and incorporated them in their paintings.

and mouth are correctly oriented. When we focus on Tom Cruise's eyes in the inverted picture we see nothing irregular, but when the face is right-side-up with inverted eyes, the face becomes grotesque. Eyes also glisten, which is eye-catching. So powerful are the eyes for understanding the world, for making social contact, and for showing all sorts of emotions, from love to lying, that it seems inevitable that an eye—the cynosure of the face—should occupy the focal point of the picture. We look at a portrait's eyes first before scanning the other features of the face. The eye is the cardinal point of the face which commands the initial focus. Is it any wonder we call the center the "bull's eye," that wannabe movie stars wear dark glasses, and that Venetian blinds were invented?

The Face as a Reflection of the "Inner Person"

Since Darwin's seminal work on the expression of emotions, the question of the universality of facial emotional expressions has appeared in the art literature and especially in the literature of social psychology and anthropology, with one camp contending that facial expressions are universal to the species, the other camp that facial expressions are the result of socialization. Preparing his work during the height of the British Empire, Darwin sent out questionnaires to British subjects in eight parts of the world: Africa, America, Australia, Borneo, China, India, Malaysia, and New Zealand, querying how natives expressed astonishment, shame, indignation, concentration, grief, good spirits, contempt, obstinacy, disgust, fear, resignation, sulkiness, guilt, slyness, jealousy, and "yes"/"no." The answers he got back from his correspondents indicated that the same expressions of emotions were seen in these

distant countries as in England. Darwin concluded: "It follows, for the information thus acquired, that the same state of mind is expressed throughout the world with remarkable uniformity" (Darwin 1872).

Modern social psychologists fault Darwin's methods and some anthropologists doubt his conclusions, but Paul Ekman (1993, 1999), using modern, more refined techniques, replicated the main findings of Darwin. Ekman collected photographs of people expressing six emotions (happiness, sadness, anger, fear, disgust, and surprise) and showed them to inhabitants of many cultures, including the remote Fore foragers of Papua New Guinea. These diverse subjects were asked to label the emotion being expressed or make up a story about what the person in the picture had just gone through. As an example of the response he got, a Fore subject might respond to the "fear" photograph with "He must have seen a boar." Ekman then reversed the process and asked the native to act out how he might look if "your friend has come and you are happy," "you are angry and about to fight," and so on. The correspondence between the photograph of facial expression and the emotion being expressed was remarkably similar across cultures, and thus, Ekman and others argue, "our evolution gives us universal expressions, which tell others some important information about us" (Ekman, 1999). While some would have us believe that all behavior, including facial expressions, are the result of imitation and behavioral shaping—a child learns which facial experiences are rewarded and which are not—the results of empirically based work clearly suggest otherwise. These observations have been supported by studies of very young neonates and congenitally blind people who exhibit basic facial affect without the normal perceptual-learning loop. Of course, we fine-tune our facial expression in response to environmental forces, just as we learn that the word "apple" is associated with a red spherical fruit, but internal predispositions for emotional, facial expressions seem consistent over populations.

Thoughts about Universal Facial Beauty

Darwin and Ekman showed that the human population, in general, expresses and perceives facial expressions in a similar way. Portrait artists have also reflected this tendency and, given the diversity of facial expressions (see plate 14 and figure 5.13), manage to express emotions that are understood by all. Of course, there are local featural "dialects" which are frequently "taken wrong" by strangers, but basic emotions seem to shine through regional, idiomatic gesticulation. The larger issue uncovered by Darwin and Ekman is that, at a higher level of abstraction, facial expressiveness may be an important signaling element related not only to social interactions (which may be epiphenomenal) but also to survival through sexual reproduction. It is sug-

gested that the expression of facial emotions and facial beauty are primary sexual signaling features shared by all members of the human family. Therefore, if the blueprint for facial expressions is largely genetically established, it is not surprising that a reason for the universality of facial emotionality is to attract (or repel) a potential breeding partner. Crudely put, facial appearance has stud/bitch valence. Universality of emotional expression is only the manifestation of this deeper reason. Sexual attractiveness and sexual actions are related to beauty. Our interpretation of emotions and beauty, especially as related to the face and body, are motivated by sexual appetites that might lead to successful reproduction.

As with the universality of emotional expression, there seems to be similar agreement as to what constitutes physical attractiveness across cultures. The faces shown in plate 14 and figure 5.15 (as well as many more) suggest that the recognition of beauty is strongly influenced by a type of "beauty indicator" that resides in all people. While culture may overlay unadorned faces in sometimes peculiar ways—with the use of neck rings, tattoos, odd hairdos, fiendish makeup, and the like—most people agree that some faces are really beautiful and others not.[2]

Studies of comparative anthropology uphold the idea that beauty in one culture is (generally) beautiful in another and that such ecumenicity is related to sexual attractiveness (see Wilson and McLaughlin 2001). Attractiveness is often tied to health, which is an indication of fertility and sexual virility. In women, for example, beauty is defined by "feminine" symmetry, clear skin, well-spaced eyes, full lips, small nose and chin—physical traits indicating fertility, caring, and compassion. In men, the physical traits include well-defined symmetric features, strong jaw and face, open eyes, and the like—physical traits that suggest the bearer is virile, strong in battle, and able to care for his mate and children. Although such stereotypic descriptions of beauty do not take into account individual differences, which are considerable in any society, they are operationally defined variables (not value judgments) by which cultural comparisons are made.

Recent neurocognitive studies have also supported the idea that deep in the brain there may be cells that respond to "beauty," at least for men who look at pictures of women. In one study at Massachusetts General Hospital, Aharon et al. (2001) asked heterosexual men to look at photographs of women and men of varying degrees of attractiveness (something like the scaling of "beauty" mentioned above). In one group, a series of photographs showed attractive women, average women, attractive men, and average men. The subjects (who incidentally lingered longer on the attractive women's pictures) were asked to evaluate the attractiveness of each picture while their brains were being scanned to indicate regions of cerebral activity. Aharon et al. report that specific areas of the brain were implicated in

response to facial beauty. Men's "reward circuitry" of the brain became active when they looked at attractive women's faces but not at men's faces. Specifically, beautiful female faces activated the areas sometimes called the reward circuits in the nucleus accumbens. An extended set of subcortical and paralimbic areas normally associated with reward systems also got turned on. All faces are special, but some are more special than others (with grateful acknowledgment of George Orwell).

Curiously, the same region also is activated by food, recreational drugs, and money, which raises the question of whether we have a "sex, drugs, greed" center in the brain. (Judging from observations of teenagers, yuppies, and some talk show hosts, the answer is clear.) While getting turned on to a beautiful face and to food may be related to primary instincts, and the effect of drugs may be "hard-wired," the acquisition of money, and perhaps the thrill of gambling, is a secondary, acquired motive that got attached to reward cells through frequent contiguous association.

"AESTHETIC CELLS"

Just as "facial cells" evolved for facial processing, it is posited that specialized types of "aesthetic cells" are implicated in our evaluation of sensory events. Here I use the term "cells" to mean a *network of cells* activated in response to a specific task such as judging the beauty of a face, considering balance as an aesthetic property of a building, or evaluating the harmonious combination of colors in a painting. These cells may be localized, but they also may be distributed, since making aesthetic evaluations often requires information from disparate areas. Such is the nature of how the computational brain processes information. While facial/body "aesthetic cells" have a large sexual-reproductive element that likely engages parts of the limbic system, other cells may be related to our inherent sense of balance, harmony, and beauty. These parts of the brain may serve as useful indications of whom to select as a mate, what types of structures to build, where game might be found, what types of food are healthy, and what environments are beneficial (as a partial list). The conscious AWAREness of art and aesthetics is a direct outgrowth of these cortical structures which originally developed to have sex, eat proper foods, and survive the vicissitudes of nature. The search for hidden principles that may be operating in our aesthetic judgments is narrowing.

I suggest that at the very basis of aesthetic judgments, whether of buildings, plants, environments, faces, or art, are parts of the brain that evolved for the purpose of directing our actions in ways that lead to salubrious states, such as good food and sex, while avoiding those actions that are less rewarding, such as poor food and

sex. These cells especially suited to dealing with aesthetic judgments are innate (though with cultural "tuning"), are pragmatic (for survival purposes), are universal, are sexual, and play a vital role in social interactions. Both anthropological and neurological evidence points in the direction of "aesthetic cells" that carry out important biological homeostatic functions and which, as a lovely by-product, gave humankind art. These specialized cell assemblies, evolved for the purpose of helping the AWARE brain locate its position in a three-dimensional terrestrial world and find a vital sex partner, are also the cells that give us an appreciation of Raphael's Madonna, van Gogh's Doctor Gachet, Warhol's Marilyn, Max's Zil, and Rembrandt's self.

6 Illusions: Sensory, Cognitive, and Artistic

This life's dim window of the soul
Distorts the heavens from pole to pole,
And leads you to believe a lie
When you see with—not through—the eye.

—William Blake

If we believe William Blake, our sensory system, upon which all earthly knowledge is based, has been scamming us from the very beginning. Billions of people for years have lived with the impression that what they see, taste, smell, feel, and hear is a factual representation of the terrestrial-celestial universe. We bet our lives on it.

The news that our senses have been misleading us may be shocking to artists and scientists who have lived with the collective fiction that "what you see is what the world is like." Knowledge of sensory infidelity brings into question all aspects of life. Yet what Blake thought about the deceptive "window of the soul" has been confirmed repeatedly in sensory laboratories for decades, and—as if we didn't have enough trouble seeing the world as it really is—it is suggested here that our cognitive-linguistic system further restricts our access to truth. Even the brain, the soul of thought, is implicated in this sapient ruse.

There is an encouraging side to this perceptual-neurocognitive perversion of truth. Given the type of brain and body we inherited and the physical and biological constraints imposed on us, our means of gathering information and making sense of that information is wonderfully efficient. For us, in this world, it's about as good as it can be.

Of course, there is a contrarian view that asserts that the world is exactly as disclosed to us by the five windows. There is, however, a portentous codicil to this supposition: "insofar as we can tell." In other words, while the senses may distort "reality," they are the only means we have of knowing. What we sense is the closest version of truth to which we may aspire. Living in this fictional land of Oz allows

us to successfully "understand" the universe, engage in meaningful commerce, write delightful poetry, build physical models, create beautiful art, and eat a few sweet berries while seducing our way through the rainbow.

Nihilistic philosophers, who believe in an extreme form of skepticism denying all existence, may, mistakenly, find reassurance in this idea. The position is neither nihilistic nor skeptical but is based on an understanding of the sensory and cerebral neurology that presents a view of the universe in a way we humans comprehend but is, in many ways, unlike the universe. The difference between nihilism and illusions created in the sensory-cognitive interpretation of phenomena is that nihilistic ideas deny existence, whereas the "illusions" view accepts the premise of real events, just admitting that they are frequently distorted. The sensory-cognitive interpretation of the universe, which includes the way we create and appreciate art, is not new to scientists and philosophers. Before he was condemned for heresy and burned at the stake, the sixteenth-century Italian philosopher Giordano Bruno (1548–1600), who used Copernican principles to form a theory of an infinite universe, wrote: "Se non è vero, è ben trovato" (It may not be true, but it makes a good story) (Mackay 1991). Applying this to sensory-cognitive processes, we might rephrase it to read, "It may not be true, but it's as good as it gets."

Here we will look at several types of illusions that affect the way we consider an art piece: sensory illusions, created by a distorting perceptual system; cognitive illusions, a type of intellectual paralysis caused by the linguistic coding of visual information; and finally, artistic illusions created by a visual scene. But before we consider what an illusion is, first consider what reality is.

Sensory Illusions: Truth or Fiction?

The prominent psychophysicist S. S. Stevens of Harvard University delighted in showing that the mathematical relationships between physical forces, such as photons and electrical currents, were not empirically isomorphic with the psychological perception of those stimuli. A one-to-one relationship between physical energy and psychological sensation did not exist, but rather the relationship was best described as "curvilinear."[1] Consider light as an example. A very small increment in light intensity in a darkened room has a great psychological effect, while the same small increment in a brightly illuminated room has practically no effect and may not even be detected. From the perspective of the "sensory deception" view, our eye is not giving us an invariable view of reality;

"You can't handle the truth!"

—Jack Nicholson in A Few Good Men

from the perspective of the "best approximation of truth we can get" view, the non-linear impression is the only estimate of reality our sensory-cognitive system can handle—and Euclidean measures of the physical universe be damned.

VERIDICAL PERCEPTION

As we learned in our discussion of art and evolution (chapter 2), perception of the world, the heavens, and all that the eye can behold consistent with the "actual" state of these things is called *veridical perception*. It is the fiction that citizens of Oz find collectively comforting. Blake knew it was a lie, but perceptual scientists nevertheless embrace the term as if to distinguish between "real" perception and "illusionary" perception. The view expressed here is that all perception is both real *and* illusionary.

• Real perception: Perception is real in the sense that sensory perception is the only natural means humans have of making contact with the world. Furthermore, the signals gathered by the sensory system provide the only information the sensory-cognitive system can understand.

• Illusionary perception: Perception is an illusion in the sense that the physical universe is always filtered through and distorted by a sensory-cognitive prism.

This complex version of perception is a more refined approximation of how truth is represented. However, as one who is forced to play the Oz game, I will use "veridical perception" here to refer to the perception of those things that may be corroborated by outside measures, such as physical instruments.[2]

Our reliance on physical instruments to validate psychological sensations is neither a perfect solution nor totally apt. Physical measurements are not perfect, as our colleagues in physics have pointed out with the advent of quantum mechanics during the "second scientific revolution" (of about 1925), as measurements of physical phenomena are susceptible to contamination by the instrument of measurement. As if we didn't have enough trouble in seeing reality with a deluding sensory system and a brain that corrupts incoming signals, it now appears that outside "objective" physical measures also distort truth.

Regrettably, the human mind was not designed to know truth, only to get by in a changing world fraught with terrestrial dangers. Perception, or for that matter cognition, did not develop to solve problems in Boolean algebra, understand the beauty of cantatas, or measure subatomic particles—those things were stowaways waiting to appear after more serious matters, such as the acquisition of food and sex, were satisfied. The fact that we even consider such lofty topics as "truth" and

the "nature of nature" is a testament to the wily versatility of the brain. It is not an indication of its ability to understanding these things, let alone have a comprehensive appreciation of the cosmos and all it beholds. Human brains do that at the same level as dogs do calculus.

Physicists suggest that the truth about particles may be a matter of agreeing on a statistical ensemble of observers, none of whom sees the whole undistorted picture. In important ways, psychologists trying to understand the nature of how people view art have a parallel intellectual universe. The person who looks at art not only sees the physical phenomenon but also experiences "noise" which is inherently introduced by the sensory system. Interpretation of art, especially ambiguous art, allows for the intrusion of greater cerebral variance. Yet we do this—view and understand art—very well indeed! We also understand some of the rudiments of biology, literature, music, sociology, and physics well (among many other topics), especially with a brain designed to avoid low-slung branches, find food, and reproduce. While universal truth may be dissonant to the human mind, sweet berries, music, illusions, and art are our *bel canto*.

Most of our discussion of perception and truth will deal with those topics as commonly conceptualized in our Oz. As suggested, we are unable to measure cosmic realities and, even could we measure them, we would not understand them. Alas, universal truths today are not much closer to being revealed than they were to Plato.[3] However, we do know much more about the senses and how they interpret visual signals, including art. And from that knowledge, models of human perception may be built. This chapter is about such ideas.

Cognitive Illusions: Twisting Truth

If our perceptual system corrupts incoming sensory signals, surely, you might hope, the virtuous brain will tell us the truth. If that were true, then perhaps the world would be a less contentious place. At least arguments based on what people think they see would be lessened and rational thought would prevail. Take the case of two spectators watching the same hockey game, one a Red Wing fanatic and the other a radical Maple Leaf devotee. Both have nearly identical sensory experiences, yet, when the star player for the Wings fires the puck at the net and the Maple Leaf goalie valiantly hurls his body on the puck, each partisan comes to an opposite conclusion: the Red Wings fan calls it a goal; the Maple Leaf fan calls it a save. Our chauvinistic zeal is not confined to the hockey rink but permeates every corner of life's existence, not the least of which is the world of art where opinions, prejudices, and twisted truths sometimes make ice controversies look cool.

SPECIES-SPECIFIC EMPATHIC PERSPICUITY

What the eye distorts, the brain corrupts. This neglected characteristic of the perceptual-cognitive sequence is important in the psychology of art and the appreciation of conscious AWAREness. Perception and cognition in humans is shared with other members of the species in *species-specific empathic perspicuity (SSEP),* which is simply the tendency for one member to tune in to the thoughts of another by reason of having similar perceptual-cognitive experiences. All people are bound by an invisible thread that connects us in a web of humanity. Your percepts are universal; your reactions to art are the same as your neighbor's; your thoughts are the same as mine. Naturally, as world experience colors perception, individual differences in interpreting basic sensory signals emerge—just as hockey fans interpret events differently, although they share basic perceptual-cognitive experiences. Even though hockey fans and art critics may arrive at different conclusions, the vehicle through which conclusions are derived is the same. All members view art with very similar visual-cerebral apparatus and, because of SSEP, have no need to express consensual experiences such as "I see a face," "I see blue and green colors," or "I see a cross." Our empathic perspicuity tells us those things. To illustrate the principle consider the following example.

When touring the Vatican with a friend, you both gaze upon Raphael's *The School of Athens* (see figure 6.1) in the Stanza della Segnatura adjacent to the Sistine Chapel. Immediately, you see an illusion of depth created by linear perspective and, without uttering a word, empathetically apprehend that your friend's perception is similar to yours. People intuitively sense that some objects in this great mural appear to be closer to us than other objects, distinguish figures from the background, see colors, lines, and faces, and gain an overall perspective of the content of the scene. These common perceptual phenomena are apprehended by all humans. They are relatively independent of learning, memory, or personal background.

On the other hand, understanding the *meaning* of a piece such as *The School of Athens* engages our knowledge base, which is accumulated through world experience, learning, and thinking about relationships. Knowing that Raphael depicted his well-known contemporaries as Athenian characters—the central figure of Plato idealistically pointing skyward is likely a romanticized portrait of Leonardo da Vinci (Raphael's hero); the brooding figure draped over a cube of marble in the left foreground, Michelangelo (his rival); and even a tiny self-portrait of Raphael himself peeks out from under the arch at the far right. Furthermore, the "larger meaning" of the mural is made apparent as we engage knowledge about topics ranging from

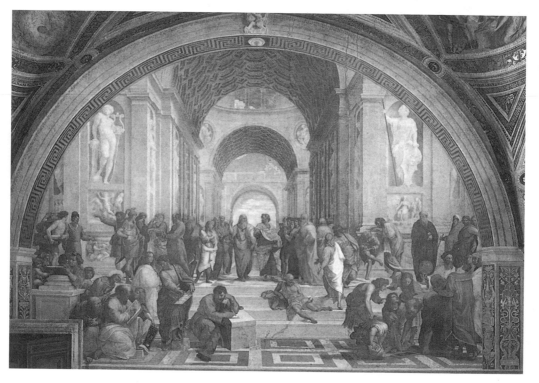

6.1 Raphael, *The School of Athens* (1510–1511). Stanza della Segnatura, Vatican Palace, Rome.

the Greek philosophers of the fourth century B.C. to Vatican politics in the six-teenth century and beyond.

The natural aspects of perception are "hard-wired" into our peripheral and central nervous system and are, alas, species-specific. It is difficult for a human to be empathetically perspicacious with his favorite horse (although some cowboys would vigorously argue against such an observation), and, presumably, it is difficult for a horse to be empathetically perspicacious with his owner (a notion that is equally contested by some cowboys). The neighborhood of perceptual empathy is somewhat limited, and although none of us have ever been a member of another species (at least that we can validate empirically), it may be that other creatures are more limited in their capacity for empathetic perspicuity. Worms, birds, and fish seem to be mostly oblivious to what their kinfolk are consciously experiencing, outside of detecting some social actions necessary for survival. One reason humans

are so infused with collective empathy is because we have more complex means by which to ensnare others in a common web of intellectual pathos.

LINGUISTIC PRISON

After the sensory system has detected many of the important features in *The School of Athens,* or any other painting, and the brain has sorted out the visual perceptual primitives, higher-order cognitive processing—language, meaning, and associative *"I kill with words . . .* reasoning—takes over. We "see" relationships, in- teractions, and meanings in the painting that are related to historical and philo- sophic events stored in our long-term memory. Language contributes significantly to the understanding of art by adding richness to the basic, natural decomposition of a visual scene. Furthermore, it is through language that we communicate to oth- ers what we "see" in a painting. It is a forceful, convenient, and conceptual means of expression. But is it truthful, or does it too convey a lie?

Alas, language also contributes to the mutual intellectual conspiracy that is el- emental to social discourse. Through a common language, humans establish a kind of *linguistic species-specific empathic perspicuity* in which verbal symbols represent com- monly agreed-upon meaning. The agreed-upon vocabulary further coalesces hu- man bonds that, in addition to a common neurology, share a similar means for abstract representation of an object, such as a piece of art. When an art professor decrees that Mona Lisa is *"magnifique!,"* we understand exactly what he means as easily as if he had asked for a banana. It is difficult for an adult *Homo sapiens* to appreciate art outside *he with a dagger."* of his lexical microcosm. Think about it. From cave paintings to abstract expressionism, the way —*Verdi,* Rigoletto humans react to paintings is to transcribe sensory impression into words.

By forming semantic links with fellow humans, we are able to express com- mon thoughts about all things conceptual, including art. In many subcommunities, specialized words and meanings are invented for the joint purpose of effective communication within the group and establishing an argot to exclude outsiders. Jazz musicians, computer geeks, art critics, wine connoisseurs, football players, and teenagers are notorious for concocting esoteric expressions. While communica- tion is greatly facilitated by the invention of a system that contains common seman- tic symbols, the deeper effect is that language restricts the range by which percepts might be represented. Furthermore, much of the richness of sensory stimuli is

seriously stultified by being expressed linguistically. Many things are just too delicious for words, yet we are compelled to give a word to everything, from a beautiful sunset to fantastic lovemaking.

Human conceptualization is restrained by a limited lexicon, while the experience of beholding an art object may transcend idiomatic semantic expression. Yet our semantic firewall is what civilized man uses primarily to perceive and think about sensory events, including art. The human spirit cries out for nonlinguistic means of expression that tell of one's inner feelings. Very young (prelinguistic) babies do this well, and many teenagers are also "out of control" in their desire to express inner feelings of ecstasy. One may speculate that music was invented (or maintained) when words failed to express feelings adequately. The same might be said for mathematics, gestures, actions, and other forms of semiotic communication that are used to express thoughts—thoughts that might otherwise be mute. And, one might ask, which is more functional—to kill with words or with a dagger? The very intellectual tool that released the mind from a stimulus-reaction mentality, that made possible worldwide migratory campaigns, that provided conceptual material for abstract thoughts, that launched the technical revolution and even brought to the world art and conscious AWAREness, also imprisoned the mind in a self-restraining lexical network. Most people are oblivious to the semantic yoke they wear.

Consciously AWARE people view objects and actions linguistically. That impressive development in the history of the species—"left-hemisphere types" call it *the* most important intellectual change—made it possible to establish complex societies, make laws, and write good (and bad) poetry, among other civilized activities. When we apply words to art and science, we continue to perpetrate a synthetic narrative that the world is like a yellow banana. People use language to express art, then "nudge, nudge, wink, wink . . . you know what I mean" and blithely move forward to create the next sequence of sensory and semantic constructions. It is perfectly acceptable (and may, in fact, be the only way we can function), because we are communicating with a kind of Ozian linguistic species-specific empathic perspicuity that expresses whatever thoughts we have that words can tell. I believe that art is more than words can express.

Essentially, we "see" with words—a curious way for perception to work which, insofar as we can tell, may be unique to humans. By placing our view of art (and science) inside a semantic box, we lose the ability to see things uncluttered by lexical content. Semantic contamination contributes to the cognitive incongruity between truth and the perception of reality in a world that is based on consensual val-

Art doesn't transform. It just plain forms.

—Roy Lichtenstein

idation. One reason art is important is that it penetrates the lexical prison that restrains the mind of man. Art stimulates the brain directly. Direct perception also appears in other forms besides art, such as geometry, architecture, gestures, music, and actions (such as direct physical contact and the dagger's deeds).

Now let us return to *The School of Athens* and reexamine it in light of the above ideas. When viewing art, people experience:

• A common neurological sequence of events in which angles, colors, faces are initially processed by a complex system of cortical neurons. From retinal stimulation which projects to the primary visual cortex, a torrent of interactive neuroglial streams are unleashed in which specialized processing takes place.

• An overall, Gestalt view of the scene in which all components are integrated within the visual plane. In *The School of Athens,* the visual display is enclosed in a semicircle grounded by a horizontal frame. Within that frame, further organizational patterns are perceived.

• A figure-ground categorization in which some features stand out from others. The central figures, Plato and Aristotle, initially command our attention, but other figures, such as the artist in the near foreground, also are cut out from the background.

• An illusion of dimensionality. Figures appear as distant or near, a vanishing point is sensed, objects occlude other objects, and far distant scenes are perceived through atmospheric perspective.

• A verbal description of the painting, either spoken or internal. Succinctly stated, the left-hemisphere language-processing part of the brain and frontal associative areas (among other areas) are activated. The mural is interpreted semantically. We "understand" relationships, deduce meanings, draw conclusions about the artistic, social, religious significance of the painting—all done with words which add intellectual complexity. Words enhance and distort what the eye sees.

• A desire to express our visual-semantic impression. People gush, "How beautiful, how realistic, how intriguing, how profound," and so on, to voice their visual impression of the scene. Some out of control right-hemisphere types, small children, and uncivilized people may jump up and down.

We now turn our attention to "real" visual illusions commonly used in the perception laboratory.

Visual Illusions

Perceptual Illusions

Perceptual psychologists have been fascinated with visual illusions for over a century, because they illustrate the incongruity between the real world and the world within the mind. That is a fundamental issue in psychology, and, of course, philosophers have pondered the question for millennia. Some parts of the puzzle have been solved, as in the case of simple visual illusions—the types that used to be printed on cereal boxes and match covers. In figure 6.2 a couple of the standard "eye foolers" are shown.

The "mind's eye" (and brain) distort our perception of the length of lines in these examples, a distortion caused by the surrounding cues; in the case of the classic Müller-Lyer illusion the "wings" distort our length estimates, making the figure at left look longer than that at right. Some theorists believe this illusion is caused by our frequently seeing the edges of corners (such as in the corner of a room), which are perceived as being far away (hence larger) because the walls come toward the viewer.

In the Ponzo illusion, the distortion is caused by the surrounding converging lines, which suggest depth perception in which distant objects, such as a tree many meters away, subtends a small part of the retina yet is perceived as being large. Here, a "distant" object, the faraway horizontal line, is interpreted as being larger than the foreground line.

The principle illustrated is an example of Emmert's law, which holds that objects, such as the horizontal lines, that yield retinal images of the same size will be

6.2 Illusions caused by immediate visual context. Left: the Müller-Lyer illusion. The lines within the "wings" are the same length. Doubt it? Measure them. Right: the Ponzo illusion. Here too, the horizontal lines are of equal length. Because the converging outside lines suggest a terrestrial vanishing point, the mind's eye sees the more distant line as being farther away, hence longer, as more distant objects in nature are seen as smaller.

Seeing What One Is Prompted to See

The power of verbal labels to influence what we see can be seen in the following example. Look at the figure below:

Skyline

Now, look at the same figure rotated:

Letter

What do you see now? In this case, once you "get it" and see the letter, it is difficult to see it as any other object.

Words have a pronounced effect on what we see, which may either facilitate perception or make it difficult to see things outside the linguistic box.

**6.3 Illusions that require the observer to fill in the missing pieces. In the Poggen-
dorff illusion (left), the diagonal line at lower left, when extended by the viewer's
imagination, does not seem to line up with the upper diagonal line. Yet, if you mea-
sure them, they fit perfectly. At right, the broken line shows where people imagine
the line should extend. In the modified Müller-Lyer illusion (right), the distance be-
tween the apexes of the left and center "wings" and that between the center and
right "wings" are equal, even though the space on the left looks much longer than
the one on the right.**

perceived as being different in size if they are perceived as located at different dis-
tances. Artists from the earliest cave painters on have practiced this law, but it was
during the Renaissance that artists systematically used contextual cues to create the
illusion of depth and three-dimensionality.

Some visual illusions call upon the observer to supply missing material, as in
the case of the Poggendorff illusion and the modified Müller-Lyer illusion shown
in figure 6.3. Both of these illusions have been part of the standard psychological
repertoire for 150 years—the Poggendorff illusion was first published in 1860—
but the effect was known to artists before that time. (See later discussion of Rubens.)
The illusions of "misalignment" and "unequal gaps" are compelling, even though
much of the illusion is created by the interior lines being imagined by the observer
rather than sensed. Such is the power of our mind to see things as they ought to be,
rather than as they are. This illusion is a bit more fundamental than the illusion cre-
ated in the mind of hockey fans, which is based on culturally learned biases—a
more "cerebral" illusion.

The propensity to "see" things that do not exist, apart from those truly psy-
chotic hallucinogenic episodes, is illustrated in the illusions shown in figure 6.4.
These types of figures are called *illusionary contours,* as illusory lines and outlines of
forms are perceived. Examine figure 6.4. Do you "see" the horizontal and vertical
lines in *A?* These "lines" are clearly perceived by most viewers. On closer inspec-

A B C

6.4 Phantom figures: two imaginary lines, a triangle, and a column. In *A* we "see" a horizontal or vertical line; in *B* a white triangle seems to float above the surface of the page and is whiter than the background; in *C* there are two illusions: there appears to be a white column surrounded by semicircles, and the diagonal line seems to be misaligned.

tion, we understand that the illusory lines are defined by the parallel white lines. In *B* you have the sensation that you are looking at a white triangle (commonly called a Kanizsa triangle) which is described by just having three corners physically present. In *C*, a compound illusion is created. The illusion of a white column is created by the surrounding semicircles. That illusion is so strong that it further creates a Poggendorff illusion with the diagonal line: here an illusion creates another illusion.

In spite of the strong subjective impression, somehow we know that these visual objects are illusionary. Some of the salient features of visual illusions are: they appear to be figure rather than ground, they appear to hover over the background, and they are more saturated than the background (in figure 6.4*B* and *C* the illusion appears to be whiter than the background). There are some additional compelling features of these illusionary contours. In the case of the Kanizsa triangle, if you stare at the imaginary triangle for a few seconds and then cover the little "Pac–Man" circles, *the illusion of the triangle still exists.* The same thing happens for the column in 6.4*C*.

Here we offer two explanations for the natural tendency to see things that do not physically exist, both based on a model of limited processing capacity. We're not crazy when we see illusions—quite the opposite. Seeing illusions is not only normal, but necessary for survival.

• When we see an illusion, it may be a very clever means to see things based on only fragmentary cues—psychologists call this *redintegration*. When only part of a visual field is present, there is a tendency to make an object whole or to form a good Gestalt and, by doing so, to "see" a basic object easily understood. When we "see" illusions, we disambiguate features that otherwise seem to be a jumble of unconnected visual noise.

• In addition, identifying figures as being distinct from background was of fundamental importance in adapting to terrestrial objects. In order to "see" objects, strong line and edge detectors evolved in the eye and brain. Furthermore, the criteria for detecting lines or forms, such as a triangle, a circle, and even a face, were not exact. Thus, poorly defined lines, incomplete objects, and even illusionary lines and forms were admitted as valid images and processed as if they were physical forms.

In the next section, we will see that some illusions are so convincing that they stimulate brain regions in a similar way to actual stimuli.

NEUROLOGICAL ACTIVITY ASSOCIATED WITH VISUAL ILLUSIONS

Tracing the pathways from visual input to the eye and to the brain has been made possible through traditional psychophysical methods, as well as recent developments in neuroimaging techniques. Not so many years ago, optical illusions of the type just discussed were considered witchery; many worked their way into the magician's bag of tricks and are still used today. Artists employed optical illusions for centuries. Now illusions are the subject of serious neurological studies.

Investigations of the neurological substrates of illusions make fascinating science as well as raising some interesting theoretical issues. Subjective experience tells us we "see" a line, triangle, or column, and these experiential phenomena have been corroborated by laboratory studies. The deeper question is, Is seeing an illusion neurologically similar to seeing the actual object it represents?

The question is important. If illusions and real objects share the same neurological space, this gives support to the idea that the brain, not the eye, contributes to perceptual distortion. Are the illusionary lines, triangle, and column simple shell games played out in the physical world that are misapprehended by the eye, or are

illusions actually represented by the brain in a way similar to physical stimuli? We will now look at the neurological studies of illusions.

The Ponzo illusion, which is so prominent in art and everyday life, is neurologically curious. Return to figure 6.2. No doubt the top line in the right-hand drawing appears longer (as well as more distant). Suppose you present the illusion in color, with red lines and a green background. The illusion continues much as it does in black and white, but suppose the illusion is presented in color with the lines isoluminant (equal in brightness) with the background. Surprisingly, the illusion diminishes. It seems that there is a segregation of function within the visual pathways involved in the Ponzo illusion. Specialized cells are turned on only by isoluminant stimuli, as in the case of lines and backgrounds of equal brightness. These cells appear to be depth-insensitive. (See Livingstone and Hubel 1988 for further details, including perceived movement, color, and depth.) As we shall see shortly, artists have effectively used the Ponzo illusion (or a variation of it) in their work to create an illusion of depth, intuitively using figure-ground renditions composed of contrasting luminance. It may be that we evolved excellent cues for depth perception that work best with well-illuminated features and background, as might be found in nature.

Perhaps even more startling neurological support for visual anomalies is found in studies of contour illusions and the Kanizsa illusion. Meticulous work has been done in the Netherlands (see Peterhans and von der Heydt 1989, 1991; von der Heydt and Peterhans 1989) with monkeys, whose visual cortex is similar to that of humans. Using tiny threadlike electrical probes, the von der Heydt group demonstrated that cortical cells respond to contour illusions much as they do to actual visual signals. If shown a moving vertical white line on a black background, single cells in the visual area called V2 (an area associated with color, form, and depth perception) respond. The striking finding, however, is that the same cells also respond to an illusory contour (like the one shown in figure 6.4A) presented in the same orientation. The effect has been replicated many times with different stimuli. Such findings have led some to conclude that there are *contour cells* that integrate output from earlier structures (the primary visual cortex V1).

Cortical activity has also been demonstrated with the Kanizsa triangles (see figure 6.4.B) by Peterhans and von der Heydt (1991). The cells that "fire" to a real triangle in the V2 area also react to a Kanizsa triangle. From these experiments, it appears that at least some visual illusions have a basis in cortical physiology. In light of these studies, terms such as "visual illusions" and "optical illusions" now seem somewhat misleading, as the illusionary effect seems to be cortical and, in some instances, specifically V2-related. While some think "visual" and "optical" to be more peripheral, the term "V2 illusions" will probably not replace the other terms.

And, in fact, we do not know all there is to know about the interactions between higher-order processing centers and visual illusions. The careful work just reported has isolated parts of the brain that suggest a correspondence between visual signals and visual illusions. Much more is involved in the psychology of art, but these observations are important steps in our understanding of this hugely complicated and fascinating topic. We now turn our attention to a broader class of illusions devised by artists and architects to make the world appear as they imagine it.

Artistic Illusions

Artists have used illusions in their works from the beginning for the simple reason that illusions reflect the way the eye and brain see the world. It is only within the past century that some of the mysteries of how the world (and the life contained therein) looks to the brain have been disclosed in the perceptual-cognitive-neurological laboratory. Sometimes artists have used perceptual illusions to make a painting look "natural," even though it might not be geometrically correct, as we will see later. Sometimes artists have used perceptual illusions to make a joke about the incongruity between what we "know" the world looks like and what the world is like—at least as validated by independent empirical measurements.

Roger Shepard, a distinguished perceptual psychologist at Stanford as well as a clever artist, has tweaked our funny cortex with dozens of delightful illustrations, two of which appear in figures 6.5 and 6.6.

The table tops in figure 6.5 are actually the same in size and shape, a sensational mind-bender. To prove this, trace one of the table tops and cut it out. Then move the tracing to the other table. Even after empirically confirming the geometric equivalence of the shapes, the mind still has difficulty accepting the evidence.

In figure 6.6, the two creatures are identical, yet, because of the contextual cues which suggest that the monster in the rear is farther away than the one in front, our brain interprets the rear one as being larger. Furthermore, there is a strong inclination to ascribe psychological values to these characters. We might

Art necessarily is illusion. In the immense history of life on earth, art is but a very recent development. Since its emergence with Homo sapiens, there has been insufficient time . . . for the evolution of extensive neural machinery adapted specifically to the interpretation of pictures. The implication is inescapable: Pictures most appeal to us, to the extent that they do, because they engage neural machinery that had previously evolved for other purposes.

—Roger N. Shepard

6.5 Shepard turns the tables on the eye and brain by showing two tabletops that are identical in size and shape. (From Shepard 1990.)

6.6 Shepard shows two unequal–sized monsters: the big aggressive guy in the back is trying to catch the terrified little guy in the front . . . but hold on! Are the two really unequal in size? (From Shepard 1990.)

conclude that the little guy in the front is horrified at being chased by the big, angry guy in the back who is bearing down on him. In a demonstration of this illusion I made an exact cutout of the figure, superimposed it over the back figure, and moved it to the front figure. When projected, the illusion is compelling: people "see" the big guy getting smaller. When reversed, he gets bigger. There is a sensation of physical growth and motion which everyone . . . well, almost everyone . . . "knows" does not really happen. It is an illusion. But then, what is truth?

Early Illusions in Art

One can find no finer example of an artist's intuitive knowledge used in creating an aesthetic illusion than the so-called "Chinese horse" found in the Lascaux cave in France. (See figure 6.7.) The art was created about 17,000 years ago. The image of the horse is ochre on top and white on the bottom, with a characteristic M shape on its belly—common among early Magdalenian animal paintings. The hard white limestone surface provided an excellent canvas for the black charcoal outline. The illusion created is one of a moving horse with all legs attached, even though the viewer has to provide a mental link between the body and galloping hoofs and legs. We easily see that. So, too, did the cave painters, who never (we suppose) had a lesson in art, figure drawing, or perspective.

These earliest painters lived near the Vézère River, which flows through a wide valley densely covered with verdant poplars and underbrush, and surrounded by high cliffs honeycombed with dozens of caves. This was a perfect location to spend a life in the 170th century B.C. The climate was not too severe, the river was rich in seafood (which contained Omega3), the valley abundant in game and berries, and the caves were a swell place to practice art and, probably, some kinds of ritualistic ceremonies. Notice the marks above and in front of the horse, which may be symbolic. Some theorists postulate that the caves were used as chambers for puberty rituals and that the art produced was part of that rite. That may be true. However, I think they were used primarily because the caves were a superb place to draw images still alive in the heads of the artists—images made possible because humans were consciously AWARE of the world as it was and how those sensations are represented in the brain and then by the brush.

Illusions in Egyptian Art

Egyptian artists were not known for their innovations. Quite the contrary, they accepted with religious devotion the canons of proportionality set down in the Old

6.7 This very early artist intuitively created the illusion of motion and depth in the so-called Chinese horse, which measures about 1.4 meters long. Note that the horse's left legs are not attached to its body but instead float, giving depth. The effectiveness of this sophisticated technique depends on the mind's eye to complete the visual illusion. This technique did not reappear in the history of art for thousands of years and gives unusual grace and charm to this painting.

Kingdom, and woe to the artist who depicted people—especially members of the Pharaonic family and deities—outside the rigid formula. Nevertheless, some very interesting illusionary effects may be found in tomb paintings, especially in tombs of lesser officials, and in the depiction of slaves. Greater artistic license was granted in some of these paintings than in the way the powers—earthly or heavenly—were shown.

Figure 6.8 depicts a reflecting pond with objects being shown from a psychological rather than an actual view. The artist has shown trees that surround a pond as they might appear on a horizon. The top trees stand upright, those to the side emanate from the left side of the pond, while those on the bottom maintain a

6.8 A pond in the garden of Nebamun in Thebes, 18th Dynasty (about 1400 B.C.). British Museum, London. Note the position of the trees, fish, fowl, and lotus.

veridical view of trees on the horizon. The fish, fowl, and lotuses in the pond are neither beneath, on top of, nor in the water, as they would appear naturally, but are all placed on the water in an impossible orientation. However, and this is an important point in understanding the psychology of Egyptian art, the objects in this picture are shown without distortion so that they might be reproduced in the afterworld. The intention of tomb art was not to be seen on a bright Sunday afternoon in Paris by idle tourists, but to carry an image of important items into the hereafter so that when the lucky stiff got there he could enjoy earth in heaven.

 An ingenious visual illusion of musicians—a class of people not as carefully protected by the technical canons as were nobles and deities—is shown in figure 6.9. Considerable artistic license was applied to these musicians and dancers. The young female dancers on the right are represented by fluid lines that suggest move-

6.9 An Egyptian visual illusion showing music. Thebes, 18th Dynasty. British Museum, London.

ment and grace. One of the musicians keeps the rhythm with cymbals (or hand clapping) and the other, presumably, plays a melody on what must have been a very tricky double flute. Consider how the artist showed music. Certainly, the rhythmic flow of the dancers' lithe bodies produce a visual illusion of musical sounds. Notice also the musicians' ringlets dancing in agitated tempo to the beat of the tune—a technique that made it to the funny pages during the twentieth century.

Illusions in Rome and Beyond

No other edifice from antiquity creates as sensational an illusion as does the Pantheon in Rome. The building fused Roman engineering and beauty in a temple for all gods. It is also huge and remained the largest domed building in the world for centuries. Its enormous size is a tribute to inventive engineering techniques, but its psychological impact is caused by a compelling visual illusion that makes the interior appear even more grandiose. The cella of the Pantheon is fashioned after a giant sphere (as shown in figure 6.10), and what could be a more fitting shape to

6.10 Diagram of the Pantheon in Rome. Notice how the interior is based on a sphere with a hemispheric vault.

honor all the gods? From the outside the building appears to be a large, somewhat stubby-looking cylinder, but on entering one sees a strikingly different effect. The interior vault is not perceived as a hemisphere but soars skyward in the shape of a celestial spheroid, capped with an open oculus. A magnificent rendition of the interior and the visual illusion created is shown in Panini's *Interior of the Pantheon* shown in figure 6.11.

As shown, the dome appears to be spheroidal, almost like half of a football in shape. Thus, the ceiling seems much higher as people strain their necks to gaze at it and at the open eye in the center. The oculus is entirely exposed to the elements and, as shown in the painting, lets in views of the sky, stars, moon, and sunshine (notice the circle of light on the wall), as well as rain and occasionally snow. As impressive as the visual illusion is in Panini's painting, the sensation is even more astonishing when one sees it in person. It is difficult to imagine that the dome is actually a hemisphere, not ellipsoidal.

The illusion of greater height is achieved by placing niches to the gods around the circumference (Raphael is buried in one of them), accentuated with huge columns in between. Thus, the walls contain a strong vertical orientation. But it is the coffering in the dome that most significantly contributes to the feeling of height. The visual effect is achieved by using the principles of perception illustrated earlier in the Ponzo illusion (see figure 6.2) and Shepard's monsters (see figure 6.6). Please take a moment to review these figures and then look at figure 6.11. Notice that the panels at the lower part of the dome are large and become progressively smaller as they reach the oculus at the apex. Since the large ones at the bottom are close and since we assume that distant objects are smaller, the upper part of the dome, where

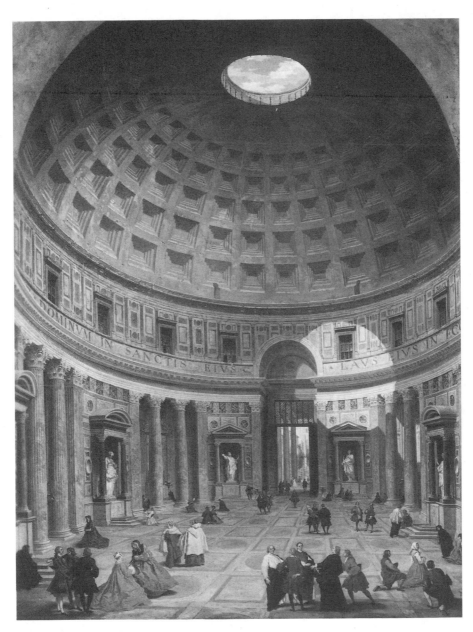

6.11 Giovanni Paolo Panini, *Interior of the Pantheon* **(1740). National Gallery of Art, Washington, DC. When viewed from inside, the dome appears to be spheroidal and much more grandiose than one might expect from the outside.**

the small coffers are (reasons the brain), must be very far away. The same effect is shown in the Ponzo illusion and even more clearly in Shepard's monsters, where the blocks in the tunnel are very similar to the ceiling design in the Pantheon. The effect is further enhanced by making each panel a visual illusion unto itself with a series of nested rectangles.

"Mr. Poggendorff, Meet Mr. Rubens"[4]

For centuries, artists and architects showed people visual illusions of a fantastic world. Renaissance painters were particularly adept at creating three-dimensional impressions from a two-dimensional canvas, wall, or ceiling—a topic to be discussed in the next chapter. Baroque painters, who initially crafted their art in Rome, exhibited unusual skill in communicating pathos in their paintings. In the original meaning, baroque referred to irregular, contorted, and even grotesque interpretations of art. It certainly is "busy" art. The Flemish painter Peter Paul Rubens developed a personal style that even today carries his name. The Poggendorff illusion (figure 6.3) was discovered in 1860,[5] but 250 years earlier Mr. Rubens encountered a Poggendorff problem in his monumental work *The Descent from the Cross,* which is the central piece in the triptych located in the Antwerp Cathedral. (See figure 6.12 and plate 21.)

In the dramatic moment shown, Christ is being tenderly lowered from the cross. Our attention is directed to Jesus who, in typical baroque manner, is brightly contrasted from the dark background. Rubens has also shown nine faces expressing different emotions, each contributing to the complexity of the work.

The artist did run into a knotty problem. With the mid part of the parallel lines of the ladder occluded by a man (which was central to the overall composition of the piece), the right strut in the lower part of the ladder would seem not to align with the upper part shown above the man's head. The Poggendorff illusion would be created. The solution to the problem: shift the upper part to disambiguate the illusionary effect caused by this illusion. Did Rubens understand that the lines in his finished product did not match? X-ray photography of an earlier sketch (in the Courtauld Institute in London) shows that the lines had once been physically aligned but later were changed. It is likely that Rubens knew what he was doing and decided to make the painting psychologically correct rather than geometrically correct. He was, after all, a member of the school of art that contorted reality, but here the contortion was psychologically congruent and graphically incongruent.

6.12 Peter Paul Rubens, *The Descent from the Cross* (1612–1614). This is the central fig-
ure in a triptych located in Antwerp Cathedral in Belgium. Note that the lower part
of the ladder (bottom right) does not physically line up with the upper part. Yet the
psychological effect is not discordant. The illusion of visual congruity is maintained
because Rubens made the ladder visually correct rather than graphically correct.

First-Order Isomorphism and Proto-Isomorphism

In this chapter, I have tried to show that many of the illusions used in art and architecture are based on some fundamental laws of visual perception. The incongruity between images "out there" and the perceptions "in here" is used to illustrate the way the brain processes illusionary information and how the visual-cognitive systems handle such inconsistencies. From another point of view, the relationship between internal representations of visual information and the physical stimuli that provoke them reflects a type of cerebral efficiency that is truly wondrous.

For the sake of argument, consider the type of brain required for an exact isomorphic correspondence between physical stimuli and mental representations of those events—a condition called *first-order isomorphism*.[6] The idea suggests a one-to-one match between the physical energy in the universe and the psychological representations in the mind. Casually speaking, such a creature would be a kind of knee-jerk being—energy in, energy out. Very simple organisms operate like this.

A complicated organism of that design, such as a consciously AWARE man, would require a huge number of cognitive templates in order to understand even simple signals, such as the letters on this page. To comprehend the world of art, an isomorphic brain would be required to have countless millions of patterns to match to the diverse number of art types, colors, shapes, and the like. Even with the billions and billions of neurons in the brain, each with numerous synaptic connections, a system of isomorphism is neither practical nor attainable.

A more parsimonious model of the mind is one that is constructed on an ancestral platform of intelligent neurons that are highly efficient in making adaptations to environmental conditions. It is simply wrong to believe that we are born into this world with a totally unprogrammed mind resembling a tabula rasa upon which all experiences are written and encoded. While life experiences and our adaptation to an ever-changing world shape our perception of art (and the whole of our sensory experiences), these environmental episodes are always understood in the context of a sensory and cognitive system that evolved over millennia. Because of the physical limitations of brain size and the need for an efficient ambulatory computational brain, the extent to which incoming information can be perceived and processed is necessarily limited.

We do not perceive the world isomorphically but *proto-isomorphically*, by which I mean that prototypic impressions of the world are built on a preestablished platform of neurons and processing programs. One of the most salient (and frequently overlooked) characteristics of the human mind is its proclivity to establish categories, especially when it comes to visual images. We see a four-legged furry animal, and

then another, and then another, all slightly different, and learn to categorize them all under the superordinate "dog." We do not have a template for each dog we have seen in the past or will see in the future, but have a prototype of dogness that is capacious enough to recognize a cocker spaniel, golden retriever, Chihuahua, poodle, shih tzu, beagle, dachshund, dalmatian, German shepherd, Yorkshire terrier, and Great Dane. That remarkable taxonomic predilection gives tremendous computational power to the brain by economically reducing redundant "dog slots." Brain neurons are efficiently organized by such a system, and access to information is likewise optimized. The human brain simply cannot process all it beholds, but it can process diverse information effectively if it is conceptualized.

Art and science (e.g., chemistry, physics, botany) are prime examples of didactic subjects that have undergone extensive systemization, especially during the Renaissance and age of Enlightenment. Much of the erudition of the scientific-technological revolution has been preoccupied with "carving nature at its joints." Less metaphorically stated, it is because of our limited processing capacity that we need the world sorted into units the brain can understand. By forming prototypes of dogs, art types, elements, plants, and the like, we function effectively, while at the same time we are able to recognize a dachshund from a golden retriever; impressionism from abstract expressionism; carbon from mercury; and a rose from a dandelion. More on this topic in chapter 8. Illusions are the intellectual appendixes of such a metamorphosis. We see, really *see,* illusions because our brain evolved to see the fiction better than the fact.

7 Perspective: The Art of Illusion

Oh, what a lovely thing is this perspective!

—*Paolo Uccello*

Long before humans used their eyes, brains, and muscles to guide complex sensory-motor actions, such as assembling a delicate watch or threading a tiny needle, our distant ancestors used the same instruments to hunt elusive rabbits, pick fruit, avoid flying rocks, judge distances over an expansive plain, and remove tiny thorns from their feet. These were all matters of life and death.

It was not enough to know *what* an object was (although it was important to know one's mate from a rock, edible apples from sour ones, and so on). It was also important to know *where* it was. Knowing that the furry animal was a rabbit, while part of the act of perception, was incomplete unless you knew where he was. As we have seen in previous chapters, the two main cortical streams are dedicated to the what and where questions.

Much of the interest in the cognition of art has been directed toward visual localization and the perception of depth. How our distant ancestors (and we) perform each of the common acts mentioned above is a difficult question requiring a complex answer. However, a large part of the problem deals with being able to see things "in depth." The native propensity to see, to understand, and to guide one's behavior is contingent on the reciprocal action of the eye and brain as they differentiate near objects from distant objects—a topic called visual perspective, the theme of this chapter.

Seeing a 3D World with a 2D Eye

For practical purposes, the world has three physical dimensions—height, width, and depth—plus the dimension of time. Visual signals from the physical dimensions

enter the eye and are recorded on the retina, which has but two dimensions: height and width. We human animals are two-dimensional visual creatures seemingly trapped in a three-dimensional world by the geometry of the retina. Nevertheless, the brain interprets two-dimensional visual images as having three dimensions by use of contextual cues and knowledge of the world as gained through a lifetime of experience. Thus, a three-dimensional world is recorded by a two-dimensional eye and then interpreted as three dimensions by the brain (the 3D/2D/3D problem). We may have a 2D eye, but there is no doubt that we have a brain that sees in 3D and beyond. These facts have baffled and bemused philosophers and scientists for centuries (see Berkeley for interesting philosophic considerations). Only within this century have scientists unraveled some of the mysteries surrounding the 3D/2D/3D problem.

So compelling is the predisposition to see the world in 3D that our eye and mind constantly decode flat stimuli as having depth. It seems that artists have, from the very beginning, known how the eye and brain use information to create the illusion of depth. One of the techniques used by artists is perspective: a method of representing a three-dimensional object on a two-dimensional surface, such as an artist's canvas. Some of the techniques of perspective have been known since the time of Ptolemy, and the early Romans developed well-reasoned mathematical models of linear perspective, even if they did not employ them completely.

When painters of architectural scenes wish to show colors of things seen at a distance, they employ veiling airs.

—Ptolemy (2nd century A.D.)

Uccello's Perspective: A Workshop in a Developing Technique

Contemplate *The Battle of San Romano* by Paolo Uccello in figure 7.1. Uccello, who was obsessed with creating three-dimensional figures on a two-dimensional canvas, lures the viewer into this painting by a number of visual illusions, of which linear perspective is but one. Notice the use of larger figures in the foreground and smaller objects in the background, and how closer objects cover (occlude) distant objects. Careful inspection reveals two distinct scenes separated by a hedgerow: one, in the foreground, where soldiers are engaged in a battle, and another scene in the background in which bucolic characters romp seemingly oblivious to the riot. There is little attention to middle distances, and thus the background appears to be flat, as if only a backdrop to the central action taking place in the foreground.

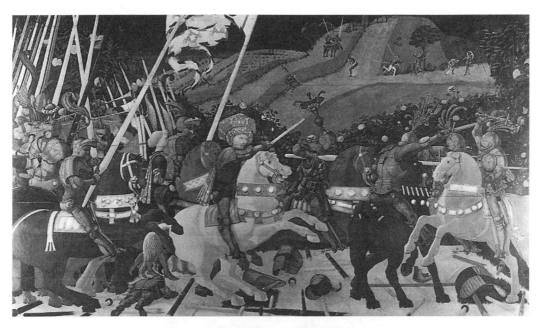

7.1 Paolo Uccello, *The Battle of San Romano* (c. 1455), with detail. National Gallery, London.

Pay particular attention to the fallen warrior at the very bottom left of the painting (see detail). Here Uccello has used the technique of foreshortening (illustrating an object shorter than it is to create a three-dimensional illusion). It looks, more or less, natural—the way our eyes might see a recumbent figure.

The fallen warrior is important for another reason. Many of the salient figures in the foreground are generally oriented toward one central point, which is an important feature of linear perspective. The fallen soldier is aligned with other strong visual cues, for example the lances that are parallel to the body (see figure 7.2). From our discussion of Gestalt psychology, we learned that the mind's eye organizes these prominent features on the basis of similarity. The overall effect of similarly aligned features is to create an unconscious sensation that the entire scene is oriented toward an imaginary single point of reference. The eye organizes the real world by finding similar lines, which are interpreted as depth cues. So, too, does the eye achieve a sense of depth in this picture.

Uccello (and other Renaissance painters) employed other visual techniques to create an impression of depth. These include making distant objects smaller and higher than near objects, covering background objects with near objects, and making objects in the background seem less distinct than foreground objects. While one can see clearly the details of the bridle on the center horse, the features in the background are obscure. In addition, the artist has used bold contours in the foreground, fuzzy contours in the background; warm colors (reds and yellows) in the foreground, which seem to advance, and cool colors (blues and greens) in the background, which seem to recede. While it is clear that Uccello didn't get it just right

7.2 Parallel forces in _The Battle of San Romano._

7.3 Chalice perspective: a study by Uccello.

(the men in the background would be the size of Goliaths if they appeared in the foreground at the same scale), this early attempt to use several perspective techniques does, nevertheless, create a sense of depth.

In figure 7.3 we see how meticulous Uccello was in applying perspective to an inanimate object.

Principles of Depth Perception: Where Is It?

Comprehension of physical objects is based on the way the eyes and brain process visual stimuli, as we discussed in some detail in chapters 3 and 4. In addition to answering what an object is (primarily in the ventral stream), the brain answers where an object is (primarily in the dorsal stream). In addition, we ask questions of a dynamic sort, such as what the thing is doing and how I might interact with it. This is a bit of an oversimplification, as there are additional streams and interactions that contribute to perception; but knowing where and what an object was were critically important perceptual features in adaptation. Perception, including depth perception, initially was based on a platform of preestablished neural networks. Experience further models the process.

We know *where* an object is largely because of visual depth perception, which we will consider next. In a later section we will address the question of what an

object is doing (see the discussion of kinetic cues below). In everyday perception, from which reality is inferred, all sensory cues are processed together, as beautifully crafted musical instruments are each designed to play their parts in the symphony. Each sense plays its part, but perception is the result of all senses acting in concert.

Binocular and Monocular Cues

Long before perceptual psychologists analyzed the types of perspective used by artists to create a sense of depth, artists discovered the basic principles of three-dimensional art. A brief history of the use of visual cues by artists over thousands of years may be found in Solso (1994).

In the perception of dimensionality, there are two types of cues involved, binocular and monocular, and within each of these classes are several subclasses (figure 7.4). *Binocular* cues are those derived from the use of two eyes. Images that fall on one retina are not identical to the images that fall on the other, and information regarding this disparity is translated by the brain as a depth cue. Binocular perception of depth is particularly important in working with objects close to the eyes but, contrary to common opinion, is not critical for most forms of depth perception. People who, through accident or disease, are left with only one good eye drive cars, play baseball (several major league players have been blind in one eye), and see most forms of art very much as you do. Furthermore, people with only one good eye from birth also have a good sense of depth. However, close work requiring depth

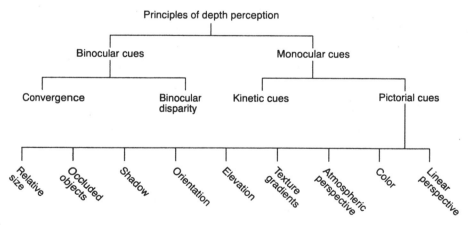

7.4 Classification of depth cues.

7.5 Area subtended by objects in left eye (*A*) and in right eye (*B*).

perception is markedly impaired with single-eye vision. Try this little experiment. Remove and replace the lead in a mechanical pencil. (Do not use any other aids, such as steadying your hands by touching them.) Now close one eye and try to do this. (Threading a needle will produce the same effect.)[1] Chances are you had difficulty doing fine work with only one eye.

The ability to perform this simple hand-eye coordinated act is based, in part, on binocular disparity (sometimes called binocular parallax), in which the image that falls on one eye is (slightly) displaced on the other eye, and on convergence, the action of the ocular muscles as they move the eyes while focusing on an object.

In figure 7.5 we can see how the pencil and lead fall on different parts of each retina. Furthermore, the disparity between eyes is shown in the differences between distances (represented by the line segments over *A* and *B*). These differences (for close objects), although small in actual span on the retina, are powerful depth cues for the brain. By the laws of simple geometry, we can easily see that more distant objects subtend visual space of very nearly identical size on each retina (the retinal disparity becomes less disparate) and thus the effect largely disappears. The science of binocular vision is important in perceptual psychology and in seeing some

modern forms of op art, but, for the most part, the viewing of traditional two-dimensional art is more reliant on monocular cues.

Monocular cues are those that require only one eye, though they normally also involve both eyes (despite the name). Among monocular cues are visual stimuli available from the inspection of a stationary visual scene, such as the scene represented on canvas by an artist. Sometimes the term *pictorial* cues is applied to this type of scene, in distinction from another class of monocular cues that are based on motion.

Movement cues, called *kinetic* cues, work when either the observer or the scene is in motion. Thus, when I look out my window and hold my head still, I know that the tree in the foreground is closer to me than the river, or the park, or the distant snow-capped mountains because of the pictorial cues available. If I move my head from side to side the relationships between near objects change slightly. The tree in the foreground covers a part of the river and uncovers another part. Sometimes this monocular depth cue is called *motion parallax,* as motion provides the essential information on which depth perception is based. These cues to depth perception are essentially the same for one eye alone or two eyes functioning together and will be discussed later.

Monocular depth cues abound in art and everyday life. We learn at a very young age to use these cues to judge the relative location of objects. So powerful are these cues that it is possible to create an illusion of depth by presenting them on a two-dimensional surface. Psychologists have recently classified these cues, but for centuries artists have used the full range of monocular cues to indicate depth.

RELATIVE SIZE

The size of the retinal image varies in inverse proportion to the distance of an object. Near objects appear larger than far objects because they occupy more space on the retina. In the perception of real-world stimuli, an object 5 feet away casts an image on the retina twice the size as the same object viewed from 10 feet. Correspondingly, artists represent distances by the same geometric proportions, with near objects larger than distant ones. Relative size is a compelling depth cue, as shown by the drawing in figure 7.7. We immediately sense that these three circles might be the same size, but located at three different distances. However, if you are told that the first circle is the size of a half-dollar, the second of a quarter, and the third of a dime, then the three circles appear to be of different sizes but located on the same plane. This feature of size is called *familiar* size and is based on our

Perceived Distances and Familiarity

Given the perception that these five faces range from close to far, which face is at the same distance as the ball? The answer depends on how large the ball is. Suppose the ball is a basketball. Which face is on the same plane? Now suppose the ball is a Ping-Pong ball. Distance judgments are made on the basis of size as reflected on a person's retina (bottom-up processing) and on knowledge of the object (top-down processing).

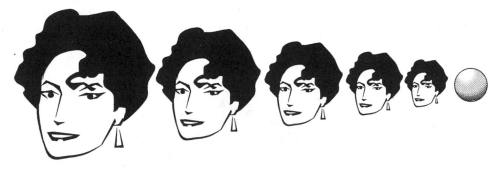

7.6 Perceived distances and familiarity: an example of top-down and bottom-up processing of information.

knowledge of the dimensions of well-known objects. These objects are processed in a top-down fashion. (See box, and the discussion of top-down processing in chapter 8.)

OCCLUDED OBJECTS

Another type of depth perspective is obtained by the use of occluded objects (also known as interposition), in which foreground objects cover, or partly cover, distant objects. In figure 7.8, three geometric forms are shown all on the same plane, yet the impression is that the triangle is partly on top of the rectangle and circle and that the rectangle partly covers the circle. Hence, we infer that the triangle is the form closest to us, the circle the most distant. It is possible, of course, that we have it all wrong. Perhaps the "circle" is not a circle at all, but a weirdly shaped form with slots and wedges cut out that coincide perfectly with the seemingly interposing rectangular and triangular forms. But we are much more likely to "see" a whole circle that is simply behind (and therefore more distant than) two other forms.

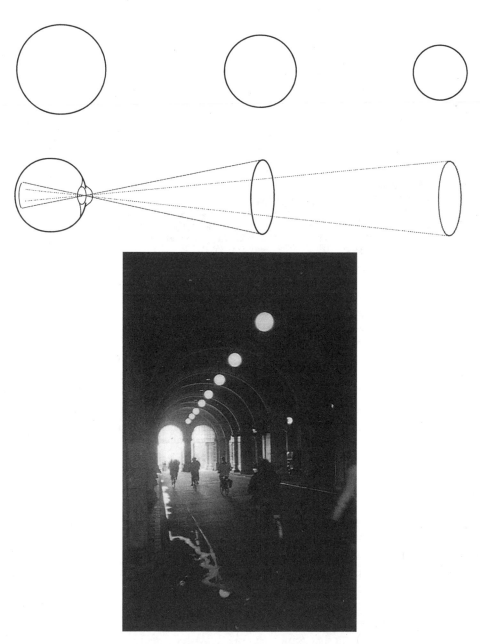

7.7 Which of the circles at top is most distant? The lower drawing shows the inverse relationship between object distance and retinal size. (Compare the receding line of globes in the photo.) Photo by R. Solso.

7.8 Which object is nearest? Farthest? Why?

7.9 Depth cues supplied by shading. If the tops of the circles are light, they look like bumps. If the bottoms are light, they look like depressions. (From Ramachandran 1988.)

SHADOW

Depth can be ascertained by shadows, such as the way a shadow may be cast on the underside of a ball, suggesting a solid, three-dimensional object as contrasted with a flat two-dimensional one. The interpretation of these depth cues has proved to be a tricky and complex matter. Consider the disks in figure 7.9. Our mind and eye interpret these as being members of two classes, one class concave and the other convex. Those circles, or hemispheres, that "jump out" from the page are those that are light on the top and dark on the bottom. It seems our brain interprets these signals as if light were shining on a three-dimensional object from above. That makes sense. Most natural light appears from above. Therefore, a dark shadow on the underside

(even if it's the "underside" of a two-dimensional object) suggests to an observer that this is a three-dimensional object, something like half of a ball. If you rotate this figure 90 degrees, the illusion frequently disappears (although you can hold onto the image in that rotated orientation, and even beyond). If you continue to rotate the picture to 180 degrees, the formerly convex circles become concave and the formerly concave circles become convex! This object is fun to experiment with, and there are no prohibitions against twisting it every which way. In figure 7.10 some of the principles of depth perception are shown with a single ball. Highlights suggest nearness and the darker parts distance.

The illusion created by shadows is compelling. Take the rather pedestrian photograph shown in 7.11. Here the object looks like the crater that it is. How-

7.10 Light and shadow on a ball.

7.11 Shadow as a cue for depth. Turn the photo upside down and the crater becomes a hill.

7.12 Notice how the shadows cast by the stairs emphasize the sense of three-dimensionality. Photo by R. Solso.

ever, if the picture is rotated 180 degrees, the crater suddenly becomes a mountain. This visual misinterpretation may seem quite benign, unless, of course you are navigating a space probe on some pockmarked surface, like the moon. There, determining if an object is a mountain or a hole in the ground is likely to be critical.

For another example of how shading helps determine dimensionality in the real world, examine figure 7.12. With the shading on the left side of the drum and the highlights on the right side, we sense a three-dimensional container. Our sense

of depth (as well as our sense of beauty) is further accentuated by the way the shadows cast by the stairway stream across the three-dimensional white surface of the large storage tank.

When you view art, be aware of the powerful effects light and shadow have on our interpretation of scenes. Artists during the Renaissance and the impressionist period were especially sensitive to these effects and used them skillfully.

ORIENTATION

Related to shadow effects, but decidedly different, is the effect that orientation, or the alignment of an object, has on depth perception. Many two-dimensional forms are seen as having three dimensions when viewed from one orientation, but as having only two when viewed from another. Consider the objects in figure 7.13.

Most people see object A to be "flat" and describe it as "two diamonds hanging on a bar," while object B appears to be a cube—a three-dimensional object. Yet if you rotate the page 45 degrees clockwise, you will see that the objects are identical except for orientation. This somewhat baffling phenomenon is largely ignored by perceptual psychologists and, as far as I can tell, has never been addressed seriously by artists. Yet the effect, as shown in this illustration, is compelling. I suspect the effect may have something to do with the strong horizontal bar upon which the diamonds are hung.

Another plausible cause is our familiarity with boxlike, three-dimensional objects oriented at right angles to the ground. This effect is particularly forceful when accompanied with a verbal label (as your author has not so subtly supplied in this case). Thus, the effect of orientation seems to be largely due to top-down processing, in which our eye and brain seek out images that remind us of something else we have seen. Since three-dimensional boxes are commonly seen, it is likely that we have a strong "box prototype" (see chapter 8 for a discussion of canonic

A "Two diamonds B "Cube"
 hanging on a bar"

7.13 The effect of orientation on perception. Which of these objects appears to be a three-dimensional figure? (From Solso 1991.)

forms). Thus, when we look at object B we interpret it in terms of the object in memory that it best approximates.

ELEVATION

By elevation I mean the relative vertical position of objects within a picture frame. Close objects appear toward the bottom of a painting, distant ones toward the top. Art simply reflects reality, in this case. Children represent distant objects by use of elevation without (it appears) any instruction. It is the way they see the world. It is the way they represent the world. From prehistoric to Egyptian to Asian to Renaissance to impressionist to (some) modern art, elevation has been used as an indication of depth, sometimes without regard to size or linear perspective.

TEXTURE GRADIENTS

A very robust set of pictorial cues that produce the sense of depth are those associated with texture. Consider the river stones shown in figure 7.14. The image that is projected on the retina is of a few "large" stones in the foreground, fanning out to numerous "small" stones in the background. The image shows a continuous change, a textural gradient, that depends on the spatial layout of the relevant surfaces; and we use this textural gradient as a cue for depth perception.

ATMOSPHERIC PERSPECTIVE

Another type of pictorial cue is based on atmospheric perspective, in which distant objects are represented as we might see them distorted in the physical world. Distant objects appear to be less precise, small details are lost, and colors become paler. The effect is caused by the way the atmosphere distorts objects. For example, colors shift in vividness and become softer, with a hint of blue tone. This effect is due to characteristics of the troposphere, or the air near the earth, which is filled with stuff.

In Los Angeles, for example, the stuff is called smog, a mixture of smoke (or, more generally, hydrocarbon exhaust) and fog (or, more generally,

If in painting you wished to make one seem more distant than the other it is necessary to represent the air as a little hazy. . . . Paint the first building its true color; the next in distance make less sharp in outline and bluer; another which you wish to place an equal distance away, paint correspondingly bluer still; and one which you wish to show as five times more distant, make five times bluer.

—Leonardo da Vinci

7.14 Stones in a river bed. Photo by R. Solso.

water particles). This stuff distorts distant objects in a way most humans find ob-noxious. There appears to be a gunky pall over the city, and distant objects, rather than shifted toward the bluish end of the visual spectrum, are shifted to a kind of dirty brown. In "clean" mountain regions, Lake Tahoe for example, distant objects are distorted but in a different way. Here water vapor in the air filters the light from distant objects, much as when we look through sunglasses, in a way that shifts the reflected light to the blue end of the spectrum (see plate 16). Different cli-matic conditions, regions of the world, and even times of day each have their own distinguishing atmospheric signatures, which have been captured by land-scape artists since Uccello and before. These cues, subtle as they may seem, tell the viewer much about a scene, depth information being but one of the several mes-sages conveyed.

The artists of the Renaissance, neoclassicism, romanticism, and impressionism often used atmospheric perspective with much greater finesse than in the example by Uccello. Interestingly, during the later of these periods the strict use of linear perspective, which presents a rather stiff image, was eased, and a softer, more gracious effect was achieved without losing a sense of depth.

Color

In the real world of daily visual perception and processing of information, we experience the natural shift in colors of objects of varying closeness, and an object's color is an additional component of the process of knowing where the object is. In keeping with the effects of atmospheric perspective, warm colors seem to advance while cold colors recede. For example, an orange or yellow object (warm colors) placed on a blue or green background (cold colors) seems to stand closer to the observer. This generalization is likely related to the way we see these colors in the real world, in which atmospheric distortion has a cooling effect on colors proportional to their distance from the viewer (largely due to the refracting effect of water vapor in the atmosphere).

In addition to this environmental reason, some theorists (e.g., Wright 1983) suggest a physical basis for colors acting as cues to depth, in that different colors come into focus at slightly different distances from our eye. To illustrate this, look at a color transparency, such as a common 35 mm slide. When viewed in a bright light (not projected), the reds seem to stand closer while the cool colors (e.g., blues) seem to stand farther away.

Linear Perspective

Of the many different techniques used to create visual perspective, linear perspective is mathematically most interesting. In linear perspective, the overall geometry of a painting suggests that its salient features converge on a single point, called the *vanishing point* (see figure 7.15), near the back center. We are so used to seeing these cues of visual perspective that artists came to incorporate them in their drawings. Uccello, who was one of the earliest of the Italian painters to experiment with perspective, did not calculate the precise linear coordinates in composing *The Battle of San Romano;* and hence we get the impression that something is not quite square with this painting. Later Italian painters, especially during the later Renaissance, became so obsessed with the geometric correctness of their compositions that many paintings look like architectural renderings.

7.15 Visual cues of depth illustrating a vanishing point. Photo by R. Solso.

Kinetic Cues: What Is It Doing?

The most ecologically powerful depth cue is movement. Along with other cues, it tells us what something is doing. Things close to our eyes seem to dart by quickly, while distant things seem to move slower. Look at a high-flying jet as it slowly moves across the sky. Although its speed may approach 600 mph, because it is far from our eyes and therefore subtends a smaller visual angle it appears to move slowly. Now, consider a fast-moving automobile close to your eyes. The subjective experience is that the near object is moving much faster than the distant airplane.[2] The principle involved is called *motion parallax* and is one of the most powerful cues for three-dimensionality.

Motion parallax is missing in traditional art forms, although some very interesting experiments are being done with computer graphics that simulate many of the effects of motion parallax.[3] Its absence in two-dimensional art is important for our consideration of perspective. As absorbing as painting is, and as correct as it sometimes is from a perspective viewpoint, it never completely fools the eye.[4] This failure has everything to do with motion parallax. All you have to do to break the mesmerizing effect of perfectly drawn pictures is move your head . . . oh, ever

PORTRAIT vs. GEOMETRIC FIGURES

Expert

Novice

Plate 15 The results of fMRI brain scans for the artist Humphrey Ocean (top row) and for a nonartist as each drew a sketch of a human face. Note in the first column that both exhibited increased blood flow in the facial fusiform area (FFA) but that the nonartist seemed to exhibit greater activity. In the third and fourth columns, the artist seemed to exhibit greater activity in the right prefrontal cortex than the nonartist, suggesting a greater cognitive involvement. (From Solso 2000.)

16

Plate 16 Lake Tahoe.

Developing and Using an Art Schema

Four very different styles of art are arranged in chronological order. The first is the tomb drawing of Nebamun from ancient Egypt (unknown artist), which on stylistic grounds can be dated to the reign of King Amenophis III (1417–1379 B.C., 18th Dynasty, New Kingdom). It is characterized by the lack of linear perspective, by its unique eyes and faces drawn in profile, and by the hieroglyphics in the background.

The next painting shows the sixth-century founder of Zen Buddhism, Bodhidharma, an Indian prince who traveled to the south of China and meditated before a cave wall for nine years in pursuit of enlightenment. This rare sixteenth-century icon shows a figure who is intensely focused. During this time Zen monks fled the political chaos in China and emigrated to Japan. Note the red robe emblazoned with a typical phoenix pattern in gold.

Next we see Renoir's *La danse à la ville*, an impressionist painting. Here reality is captured in the feeling of vibrancy and intimacy of a couple dancing. The impression is dreamlike, florid, idealistic, with a hint of eros.

17

18

Plate 17 Egyptian tomb painting from the 18th Dynasty: note the details in the birds and fish. British Museum, London.

Plate 18 Sixteenth–century Chinese art. The founder of Zen Buddhism: note the concentrated gaze and composition. The Art Institute of Chicago.

Finally we see an example of modern art by the Dutch painter Piet Mondrian, who used basic colors and simple geometric patterns.

With even this limited knowledge of these four art styles, you have learned a type of art schema. Should you be shown other exemplars from each of these periods, you would likely be able to activate your (limited) art schema and correctly identify them by category. Of course, with greater experience of these types you would develop greater sensitivities within each classification, as well as a better appreciation for the prototypical examples. By learning some of the salient characteristics of an art period, you organize information in long-term memory and thus increase your memory load as well as your ability to think rationally about artistic concepts. In addition to the small tutorial presented in this box, you bring to each piece of art your own varied background which comprises your personal schema. Return to these diverse examples of art spanning nearly 3,500 years. What do you see, given the knowledge you now have as merged with your personal schema?

19

20

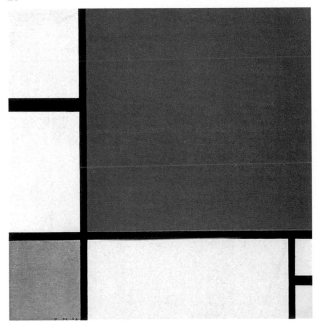

Plate 19 Impressionist art. Auguste Renoir, *La danse à la ville* (1883): a light, romantic painting showing a happy couple. Musée d'Orsay, Paris.

Plate 20 Modern art. Piet Mondrian, *Composition with Red, Blue, and Yellow* (1930): colored rectangles delineated by black lines. Private collection; © Beeldrecht/VAGA.

 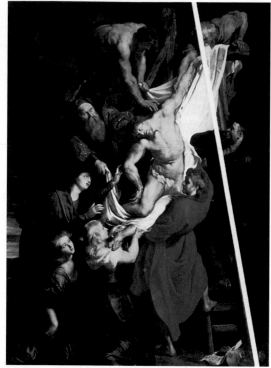

Plate 21 Peter Paul Rubens, *The Descent from the Cross* (1612–1614): the lower part of the ladder does not physically line up with the upper part, as indicated by the yellow line (at right).

Plate 22 Motion parallax: people moving.

so slightly. (More distant paintings, such as ceilings painted in large churches, require somewhat greater motion.) On a two-dimensional canvas, the relative position of near and far objects remains the same. In real life, relationships among visual objects change all the time due to our head/eye movements and movements of the objects themselves (see plate 22).

Depth perception, which is very important for creatures living in a three-dimensional world, is achieved in large part through kinetic cues. This is evident through the nearly continuous motion of our eyes, and, if that were not enough, our head swivels around with the slightest of excuses. I believe these motions serve to tell us where we are and where things in our view are. Much has been written about the techniques used by artists (especially Renaissance artists) to create a three-dimensional illusion. But few scholars even mention what appears to me to be the most important depth cue *not* available to these artists, motion parallax. The importance of relative motion as a powerful depth cue is, however, central to perceptual theorists, such as J. J. Gibson (1950, 1979), who suggest that most of our knowledge of the three-dimensional structure of the world is derived from the way an impression moves across the retina during locomotion.

Recumbent Figures: Why They Are So Hard to Draw

Buildings and other geometrically regular forms are relatively easy to show in perspective, and artists since the early Renaissance have amazed their audiences with exquisitely drawn pictures of these objects. Painters sometimes created surprising visual effects by producing unusual angles of view, called *scorci*. Drawing figures in perspective, however, proved to be more challenging, and recumbent or unusually positioned figures were nearly impossible. This problem was faced by Uccello, whose fallen warrior was illustrated in figure 7.1. Undoubtedly Uccello struggled with this figure and drew a good approximation of how a fallen warrior would appear. In figure 7.17, we have redrawn the fallen man as an upright figure, given the best estimate of the overall perspective presented in the painting, with somewhat surprising results. As shown, the warrior is diminutive when standing up. Had a true perspective been used, the figure would be in scale with other upright people in the painting. Because we see people standing more often than we see them lying down, the problem of drawing a foreshortened recumbent figure is even more difficult. The artist, then, has two cognitive-perceptual problems to overcome: he or she must draw a reclining figure in (geometric) perspective and must overcome the archetypal image of how people look when commonly perceived.

Bramante's *Trompe-l'oeil*

Tourists to Milan are usually so busy visiting the magnificent cathedral, the church of Santa Maria delle Grazie, and the famous opera house of La Scala that they overlook a small church only a five-minute walk from the cathedral in the center of the city. The church of San Satiro was mainly designed by Donato Bramante near the beginning of the sixteenth century, although the campanile dates from the ninth century and the facade from 1871. Bramante, who is better known for submitting the original plan for St. Peter's in Rome, faced a problem in the planning of San Satiro. A city street blocked extension of the apse (that part of the main sanctuary that extends beyond the transept and in which some liturgical ceremonies take place). Specifically, it was impossible to build a church deep enough both to be aesthetically pleasing

7.16 Church of San Satiro, Milan, and ground plan showing the actual depth of the apse in Bramante's *trompe-l'oeil*. Photo by R. Solso.

and to accommodate the parishioners. Bramante solved the problem by creating a magnificent *trompe-l'oeil,* a visual deception based on false linear perspective, in the apse. The result, as shown in figure 7.16, looks like any number of other churches. However, what appears to be an apse of 6 or more meters has been condensed into a tiny space, with the altar constructed in scale and placed in front of the false apse. The illusion is created by painting in false pillars of diminishing heights and a vaulted ceiling oriented toward a vanishing point, and, in general, converging all other major visual cues to a distant point. Compare the photograph with the ground plan and especially notice the arrow. This column is the *same* column as shown by the arrow in the photograph! The altar is actually in front of this column. As convincing as this il-lusion is upon entering the church, it soon disappears as you move forward, and the deception is totally destroyed if you view the apse from the transept. Don't miss it if you visit Milan. (Send a postcard.)

7.17 How Uccello's fallen warrior (*A*) would have looked standing up (*B*). How Uccello should have drawn the warrior using accurate perspective techniques (*D*). We have had this fellow stand up (*C*), and he is more realistic than Uccello's man.

One means of drawing recumbent figures in perspective is to imagine (or even sketch) a "three-dimensional" rectangular frame in which principal body parts can be arranged (see figure 7.18). This technique was used in early teaching manuals for artists, as shown in figure 7.19. Here schematic heads ("block heads") are shown in such a way that the artist can see the geometric relationships between facial features from different orientations.

The use of this technique may be applied to the best-known example of extreme foreshortening, Mantegna's *Dead Christ* (see figure 7.20). The artist selected

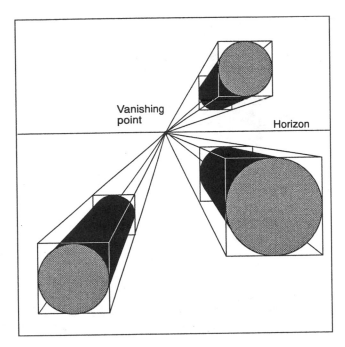

7.18 The use of three-dimensional rectangular and cylindrical forms to guide an artist in drawing objects in perspective.

7.19 An early teaching manual for drawing heads. (From Gombrich 1963.)

7.20 Andrea Mantegna, *Dead Christ* (c. 1501), with added schematics. The use of cylinders to gain perspective is an artists' technique. Acute foreshortening problems can be overcome by superimposing cylinders or rectangles.

an unusual vantage point from which to portray the recumbent Christ. From this perspective, all of the features of the body appear to be distorted. In figure 7.21 we see the original rendition (at bottom) and two copies made sometime later. These copies have altered the original perspective so that the Christ figure is more accurately shown. In spite of his intellectual appreciation of the mathematical laws of linear perspective, it would seem that Mantegna's previous experience with recumbent figures and his respect for his subject persuaded him to use artistic license here. Hence the facial features of the dead Christ are out of proportion to his feet. By violating the strict canons of linear perspective, Mantegna presented a far more powerful image of the dead Jesus, giving the viewer an intimacy and shocking proximity to the body, and especially to the face. Look at the reproduction at top right. The overall feeling one has from this rendering is of remoteness, distance, and aloofness, as contrasted with the almost voyeuristic image below.

These figures were hard to draw, not because the laws of linear perspective were unknown (they were not) nor because the artist lacked technical skill (he did

7.21 **Mantegna's painting (bottom) and two later copyists' "corrected" versions. Note the relative size of the head in the three versions.**

not), but because our *perception* of the world is swayed by our concept of how things *should* appear. Lurking in the brain of all normal humans is a collective image or prototype of people, objects, things, ideas, and the like. We see the world through a thousand hypotheses. We see things that fit well within our preconceived notion of how things should appear, not necessarily as they actually do appear. The way we acquire the idea of "how things should appear" is one of the most fascinating chapters in the cognition of art. We have a pretty good idea of the psychological experiences that are the ingredients of prototype memories. Those exciting new discoveries are waiting for you in chapter 8.

8 Art and Schemata

The lowest form of thinking is the bare recognition of the object. The highest, the comprehensive intuition of the man who sees all things as part of a system.

—*Plato*

Schemata

In the previous chapters, I argued that understanding art involves both the physical and the psychological sides of the topic. This concluding chapter discusses a special class of psychological phenomena that cluster around what cognitive psychologists call schemata (singular, *schema;* plural, *schemata* or *schemas*). A schema is part of one's mental framework for representing knowledge: specifically, we use the term here for how one might represent an array of interrelated concepts in a meaningful organization. Schemata provide context in which everyday experiences are structured and understood. They also apply to the way we represent the arts, science, literature, music, and history.

Through our vast experience with the objects and ideas of the world, we form generalized impressions, or "idealized" forms, much like the Platonic forms. Thus, when I ask you to conjure up an image of, say, a teacup, it is likely that your image is one of a "standard" teacup: that is, more or less, an idealized image. If I showed you an odd-shaped teacup and asked you what it was, you would probably call it a teacup. You may never actually have seen the idealized image you conjure up (or the odd-shaped teacup either), yet the mental image is clear. These images reside in memory and derive from numerous experiences with a large variety of teacups.

As early as 1890, William James, a founder of American psychology, knew the importance of (unconscious) individual differences in perception and memory:

Let four men make a tour of Europe. One will bring home only picturesque impressions—costumes and colors, parks and views and works of architecture, pictures and statues. To another all this will be non-existent; and distances and prices, populations and drainage arrangements, door and window fastenings, and other useful statistics will take their place. A third will give a rich account of the theaters, restaurants and public balls, and nought beside; whilst the fourth will perhaps have been so wrapped in his own subjective broodings as to tell little more than a few names of places through which he passed. (James 1890, p. 286)

Because each of the four men carries a unique mental structure of the importance of things, each sees and records different impressions.

Schemata represent the structure of an object, scene, or idea as well as relationships between concepts. Consider the case of the modern artist Piet Mondrian, whose *Composition with Red, Blue, and Yellow* is shown in plate 20. If your personal knowledge of the artist, the time the painting was done, and the school of art represented is limited, then you might view this work as being a rather simplistic arrangement of colored and white rectangles. However, if you were an art dealer, you might see dollar signs around this painting; if you were an art critic you might place the piece in the category of artists who were influenced by cubism and a reductionistic philosophy; if you were a fashion designer, you might be inspired to think of this as an article of clothing, such as a dress or necktie (and some did). In each instance, the specialists may have such an elaborate schema that it overwhelms many subschemas, with the result that the art dealer may only see the monetary value of the work, the art critic only the classification of the piece, and so on. In addition to classification of an object, schemata include information about relationships between schemata and within a schema. In this example, the art dealer may see the value of the piece in relationship to other art objects or other works by Mondrian.

When we look at a street scene, we activate the "street schema," which informs us of the features we might see and how they interact. We expect to see a fire hydrant near the street and not flying high in the air. When we view art, we also activate various schemata that expect certain objects and juxtapositions. The activation of schemata, in turn, allows us to make inferences about the art and to construct a larger interpretation and understanding of it. Most immediately activated are "art schemata," which are influenced by one's knowledge of the art and one's own personal world view. We reflect on art from the viewpoint of that personal

schema, but we also can put on different hats as we activate the general schema of the piece. If the painting, for example, is by Degas, we might further activate our "impressionist schema"; if by Andy Warhol, our "pop art schema"; if art from the Han Dynasty, our "Chinese schema"; if by Rubens, our "baroque schema"; if Michelangelo, our "Renaissance schema," and so on. Additional themes are also present that influence our perception. These schemata are part of our collective knowledge of the world. See plates 17–20 for examples of developing and using art schemata.

A schema for baroque art, for example, might include a group of European paintings between 1550 and 1750, although some art historians restrict the period to the seventeenth century. In this classification of artists, one typically thinks of Caravaggio, La Tour, Rubens, Vermeer, Hals, Rembrandt, and Veláz-quez (the group after Caravaggio called "high baroque"). A schema is more than a collection of images from a certain time period, however. It involves the interconnections between art exemplars and the *Zeitgeist,* or spirt of the times, and one's own personal view on art. Baroque art is characterized by its complicated relationship with science, music, the Catholic church, politics, and the philosophy of the time. The very word "baroque" is defined as a rich and sometimes bizarre or incongruous style, and baroque art had the same type of relationship with the social-scientific-religious ideas of the time.

Baroque: The style in art and architecture developed in Europe from about 1550 to 1750, emphasizing dramatic, sometimes overworked effects. Baroque designs are characterized by bold curving forms, elaborate ornamentation, and overall balance of diverse parts.

To further illustrate schemata, think of how you might consider Nazi propaganda art of World War II. The ingredients of schema construction are derived from experience with examples (or exemplars), which combine with one's personal world view. Thus, after looking at a series of pictures, posters, and artwork from this period you might form an overall impression of the essential characteristics of the art which would merge with your own view of humanity, culture, and ethics. The same basic formula applies to the way schemata are composed in other areas, such as botany, political systems, chemistry, psychology, English literature, and musical types, to identify only a half dozen areas. Your "Nazi art schema" is composed of your experience with art pieces, your view of humanity, and the rules that relate these things.

Now, consider what the schema for such art might be for a survivor of the Holocaust. Or how would this art be considered if you were an advertising executive, if you were a member of a militant right-wing organization, if you were the

acquisitions officer at a museum, or if you were a clinical psychologist? One's representational knowledge about this type of art is forged by past events and current information. No matter how similar are the neurological streams among all people, our interpretation of art is significantly influenced by who we are and what experiences we have felt. The viewing and creating of art does not stray far from one's contextual schemata—nor far from one's personalized world view and one's knowledge of the art pieces and relationships.

Knowledge is not haphazardly arranged in the brain, but is systematically organized around themes, or schemata, that are important structures in the understanding of art as well as of all reality. Consider how representational psychology functions in the seeing and understanding of a classic piece of art.

Mona Lisa: A Case Study

When you visit the Louvre in Paris and see Leonardo's portrait known as *Mona Lisa* (see figure 8.1), you will see the physical features of that painting essentially identically to how all other humans see them—because the light reflected from the painting and the initial processing by one's neurophysiology are fixed by physical laws. In this example, notice the misty ambience that permeates the painting. Leonardo created this effect by *sfumato,* the subtle transition of tones that gives a hazy softness to the contours. In addition, you can clearly see certain contours, note figure-ground relationships, detect colors, discover contrasts and "good gestalts," and so on. Basic visual information is similarly organized by all people.

The *meaning,* or semantic value, derived from these basic forms, however, is subject to wide individual differences. When *you* see Mona Lisa's enigmatic smile, you see it differently than might your companion, or I, or Marcel Duchamp, or indeed Leonardo. But for centuries, the painting and especially the smile have been evocative.

The "message," meaning, and interpretation of art depend on your previous specialized knowledge of painting and related phenomena. That knowledge, plus your vast idiosyncratic knowledge of the world, contribute to the (internal) context in which art is viewed. If you know something of the history of Renaissance art, the work and personal life of Leonardo, the religious dogmas of the time, the medium used, and so on, then when you actually see *Mona Lisa* you have already formed an opinion about what you are seeing. Even if you slept through Art 1, you look out at the world with a thousand hypotheses—about people, fashion, landscapes, facial hair, smiling women, and the unique attributes of great art. Even now, as you read and think about art and cognition, your mind is alive with the formation of ideas

8.1 Leonardo da Vinci, *Mona Lisa (La Gioconda)* (c. 1503–1505). Musée du Louvre, Paris.

about paintings in general, and *Mona Lisa* in specific. Actually seeing *Mona Lisa* is a test of your hypotheses about the world (the world as anticipated by your mind) and what the world is (as represented by your senses). The interplay between the internal (cognitive) representation of reality and the external (physical) representation is a fascinating problem in cognitive psychology, art, science, and philosophy.

If you have ever toured a gallery with a friend, you know that differences in the interpretation of art vary widely because each person looks at the world through a different schema; even among professional art critics sharp differences are commonplace. What is surprising is that some art critics disagree strongly even though their background, education, and experiences are very similar. Each of us carries around with him or her a vast and unique mental storehouse of information about the world. And, since higher-order perception is determined by our past knowledge (a kind of personal "cerebral encyclopedia") and one's personal schema, your view of Mona's smile is probably different from mine.

TOP-DOWN PROCESSING: LOOKING AT THE WORLD WITH A THOUSAND
HYPOTHESES

Humans actively seek answers to questions. So prevalent is curiosity that some psychologists believe it to be a basic human motive. Hypotheses about the nature of reality are essential to *top-down processing,* or perception that is motivated by hypothesis testing. When we read text, for example, we not only detect the letters and words, which are bottom-up features, but we also perceive these characters in terms of our expectations. The expectations are aroused by contextual components.

As an example, consider figure 8.2. When read, it is "THE CAT"; yet upon close inspection, the H in THE is the same figure as the A in CAT. If this H/A were presented in isolation, we would be uncertain as to its correct identity. The physical context provided by adjacent letters and our knowledge of the language determine our identification of it. The rules of reading are so much a part of our daily lives that they are applied automatically, as if we do not have to think about them. We process letters rapidly and with little conscious attention because we have experienced these patterns thousands and thousands of times.

TAE CAT

8.2 An example of context determining perception. The same letter is seen as an H or an A depending on its context.

8.3 Look at the display of triangles. Which direction do they point? Look again. Does the direction change? Can you control the direction?

Top-down processing also affects the way we see geometric figures, as in the case shown in figure 8.3. For many people the triangles seem to point to the right. But if we try to reorient them so they point upward and slightly left, we can do so with amazing ease. Or we can will the triangles to point downward and left. The amazing mobility with which we can change their direction is achieved by entertaining a hypothesis about direction. That hypothesis is so strong, in most viewers, that suddenly the whole flock of triangles fly in a specified direction.

While we look at the world with a thousand hypotheses, we settle on a limited number to consider at any given time. We are discriminating in what we attend to and select for processing for a very good reason. If we considered all hypotheses simultaneously, we would be overwhelmed. Even in the simple display of triangles presented above, it is nearly impossible to will them to point in two different directions simultaneously. The question is: How is it possible to consider so much sensory information with a limited-capacity cognitive system?

SOLVING THE PROBLEM: TOO MANY GHERKINS; TOO SMALL A JAR

The world is jammed with signals that we (artificially) separate by sensory modes—visual, gustatory, auditory, tactile, and olfactory. The glut of signals our sensory system must consider is something like trying to stuff too many gherkins in a small jar. Yet there is a solution to this dilemma, and it lies in selectivity and packaging.

Selectivity. Of those signals within the spectrum of human sensation, the vast majority are not selected for processing. Until I focused my attention on the flute music playing, the distant turtle dove cry, or the (annoying) hum of my computer, I was deaf to those stimuli because I was concentrating on other things—such as the words on this page and the inner ideas that drive this writing. Part of human AWAREness is the focusing of attention on selected items.

Studies of human attention have shown that our senses, our windows to the world, are relentlessly searching the ken of perception for important signals upon which to focus attention and process further. To do otherwise (and some people attempt to do this) simply overloads the system, with reduced cognitive efficiency. We tune out unnecessary stimuli and tune in attended ones. We only select desirable gherkins for processing and storage.

Packaging. The selected information (the gherkins to be stored) is combined in a representative packet—information is chunked into meaningful units. As brain structures evolved more efficient ways of processing adaptive patterns of thought, the means by which information was stored in long-term memory also evolved a remarkable system of taxonomy, or classification, and this greatly expanded the information load of each unit. More neatly sliced and organized gherkins can be stored than a bunch of unprocessed, disorganized pickles.

The human mind does not store percepts isomorphically or in a one-to-one correspondence. Rather, selected percepts are stored in proto-isomorphic structures (see chapter 6 for further discussion). This means that sensory impressions are stored as abstractions of percepts, not as cerebral clones of sensations. The rules of abstract representation, such as how you might view World War II Nazi propaganda art, are becoming known through prototype research.

PROTOTYPES

Prototypes are abstractions of stimuli against which similar patterns are judged. They serve a very practical need. Even with the billions of cortical neurons working in parallel, it is impossible to store *all* the sights and sounds (and other sensations) of this teeming world. It is possible, and far more economical, to store impressions that embody the most frequently experienced features of a class of objects. Experimental work on prototypes has shown how powerful they are and how they can be formed.

In one experiment I conducted with Judy McCarthy (Solso and McCarthy 1981), we created a series of visual stimuli (faces) that were derived from a prototype face. For the sake of internal consistency, we composed a face from the plastic cells

in a police identification kit. These kits contain an assortment of features; for example, there are several dozen styles of hair, noses, lips, eyes, and other features. After the prototype face was constructed, a series of exemplar faces were put together in which some of the prototype's features were included. Figure 8.4 shows one of the prototype faces and samples of exemplars. The exemplar faces were shown for a few seconds to subjects who volunteered to participate in the study. Then they were given a recognition test that included some of the original set of faces, some new faces, and the prototype face. We expected that some subjects would falsely recognize the prototype face (which they had never seen before) as an "old" face, but were unprepared for the robustness of this false alarm. An overwhelming number of people not only identified the prototype face as a previously seen face, but also gave confidence ratings that indicated they were more confident of their decision than they were for any of the other faces, even more confident than they were for faces they had actually seen. We called this phenomenon "pseudomemory," as the memory for the prototype face was stronger than the memory for actually perceived faces and was derived from frequently seen features rather than from a single face that contained all the features. Since the original experiment, the results have been replicated using differently composed faces, with young children, with a six-week delay between the presentation of original faces and test faces, and with samples from around the world.

This form of memory, which I am convinced is the predominant way information is stored in long-term memory, is important in the conceptualization of art for two reasons.

First, it is useful in understanding the classification of art periods and of individual artists' styles. The process of forming these cognitive categories follows the same rules as the formation of pseudomemories. From experiences with single examples of say, baroque art, we form a general impression of this style, so that upon seeing a painting for the first time that embraces the important features of this period, we immediately "recognize" it as a member of the baroque period. Theoretically, it would be possible to create a prototype painting of a period (or of an artist) that would include the salient features of the category (much as the prototype face contained salient features of the exemplar faces). Although I know of no experiment that has done this, it is probable that most observers would recognize the prototype as representing a specific period or artist (which is not to say that they would actually accept it as an original).

Second, it is likely that our impression of a given painting follows the same procedure as prototype formation mentioned above. Recall the discussion of eye movements in chapter 3, and how the process of viewing a painting is accomplished

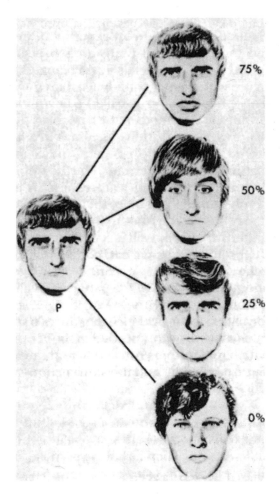

8.4 Prototype face and exemplar faces. The face designated P served as a model for the exemplars, which shared 75, 50, 25, and 0 percent of the features of the P face. Only exemplars were shown to subjects, yet people from Moscow to Beijing to Istanbul to Palo Alto falsely identify P as a face that was shown. The confidence rating that the face was shown even exceeded that for faces actually shown.

through a series of eye movements and fixations. During each fixation, information is perceived and passed on to the brain for further processing and associations. The final impression is a composite of these many impressions, much as the formation of a prototypical memory is accomplished through perception of features that are recombined in memory.

EXPERIMENTAL STUDIES OF PERSONAL SCHEMATA

Experimental psychologists have demonstrated just how powerful individual perspectives are in determining top-down impressions of reality. In one experiment by Anderson and Pichert (1978), it was possible to create a type of personality schema that influenced perception. In the experiment, subjects were asked to assume the role of a certain individual. In one case some of the subjects were asked to assume they were thieves; in another case, some were asked to assume the role of a prospective home buyer. In each case, an entire (imitated) structure of personality, or a schema, was activated. The two groups then read a brief story about a wealthy family home that included such details as the fireplace, the musty basement, leaky roof, silverware, coin collection, television, and so on. Afterward, the groups were tested for what they recalled from the story. Predictably, the "thieves" recalled the valuable items that could be stolen and the "home buyers" items related to the quality of the home. In this case the personal context influenced perception and memory.

COPS, NURSES, ARCHITECTS

The idea that activation of a personal schema could influence the perception of art objects was tested by my colleague Kim MacLin (formerly Beal) and myself in a series of studies (See Beal and Solso 1996; Solso, Muskat, MacDonald, and MacLin 2000). In one condition, subjects were asked to write a paragraph on the typical day in the life of a nurse, a police officer, or an architect. A nurse might write about administering medicine, taking blood pressure, preparing records, changing dressings, and the like; while a police officer might write about arresting suspicious characters, surveying a crime scene, going out for Krispy Kremes, and the like. Then they were shown a series of photographs and art objects. An example is shown in figure 8.5. After viewing the pictures, the subjects were asked to tell what they saw. In the case of the example, the people with the nurse schema generally saw and remembered events related to health care. Those in the police schema group saw and remembered things related to crime and surveillance, such as the appearance

8.5 Photograph of a typical scene at the Musée d'Orsay, Paris. Induction of a police schema resulted in people seeing and remembering "criminal" activity and the presence of a surveillance camera. Photo by R. Solso.

of the camera in the upper part of the scene. One "police officer" suggested that the woman to the left, who was actually a teacher, was a "hooker."

Convincing evidence has been collected indicating that schemata influence perception and recall of visual events, even if the schemata are artificially induced. We see the world through a veil that presents it to us, not as it is, but as we expect it to be. How comforting.

INCONGRUITY AND SCHEMATA

We also see art with an eye created by our personal schema, much as the "thieves," "cops," and "nurses" remembered things in which they were interested. Each person has formed a personality that is laden with attitudes about how the world should appear. But what if we see things that do not coincide with our expectations of how things should appear, such as when watching a magician, or seeing a painting that is, in some way, distressing to our eyes? We have all had these experiences, and we

all go about resolving the conflict between what we see and what we expect to see in slightly different ways. For generations, artists have known that people experience a type of psychological dissonance when the eyes see things incompatible with one's hypothesis about how the world actually is. Some modern and pop artists have shocked us by showing iconoclastic or scatological images (such as a contemporary photographer who showed one man urinating into another's mouth). While some of this art is dissonant only because it is clearly offensive, other pieces require a deeper interpretation to resolve their sense of dissonance, a topic we now consider.

Visual Dissonance

Visual dissonance is defined as a state of psychological tension caused when one experiences a disparity between what one expects to see and what one actually sees. The concept is related to a well-known phenomenon in social psychology called *cognitive dissonance,* which happens when we perceive a discrepancy among our attitudes and/or our behavior. Our eyes see the world of art with a thousand expectations based on our personality and our cognitive structure (knowledge system). Sometimes those expectations are fulfilled, sometimes not. In the case of unfulfilled expectations, the viewer is required to resolve his or her tension, or simply to abandon the piece and consider another. An important part of human motivation is found in dissonance reduction, in that people do not (normally) choose to live in a state of psychological tension. In psychological terms, such a state is aversive, to be avoided or resolved.

The technique of producing unexpected visual forms is widely practiced by modern artists, who seek to gain our attention, and to further our intellectual effort, as we attempt to reconcile our expectations with what we see. Some viewers may choose to resolve the conflict by simply turning away with the rhetorical rejoinder, "I can't believe what I saw." While denial of sensory impressions might make a clam happy, most of us try to overcome the dissonance through cognitive means.

There are three basic means to reduce visual dissonance: (1) reducing the importance of one of the dissonant elements, (2) reinterpreting one or more of the elements, or (3) changing one of the dissonant elements. We will illustrate these principles by considering a painting by the surrealist artist René Magritte (see figure 8.6). Look at this figure. What do you see? What does it mean? Do you experience any visual dissonance? Perhaps your first reaction was the same as mine, namely, "Shouldn't the guy's *face* appear in the mirror?" (An alternative reaction is, "Shouldn't the guy be facing you, with the back side correctly reflected?") There is something radically "wrong" with this painting, or the laws of physics have

8.6 René Magritte, *Not to Be Reproduced* (1937).

suddenly been suspended. When one looks at this painting, a type of visual disso-
nance develops in the sense that what one "sees" is contrary to the "reflected im-
age" schema that is part of our accumulated experience of the world. How can one
work oneself out of this cognitive maze? Here are some common means of dimin-
ishing the dissonance.

• "The painting is not important." In this strategy, visual dissonance is reduced by
denying the importance of all elements of the painting. It is an easy solution, as the
person may simply dismiss the painting as frivolous and move on to the next paint-
ing (if viewing this painting in a museum, for example). Alternatively, one might
deny the importance of some (or all) physical laws.

• "The painting means more than what is literally depicted." Here the viewer looks
beyond the mere physical representation of the painting. Such interpretation could

lead to a hypothesis about symbolic meaning and personal character, such as that the figure in the painting (or all of humanity) is so negative that he cannot even reflect his own frontal image. Deeper, nihilistic thoughts of the nature of man might ensue.

• "This painting would be more consistent with my impression of the world if it truly reflected the person's image." In this case, an active person might repaint the painting with the frontal image. Another, more intellectually demanding version of the strategy is to deny the laws of reflected images or to invent new laws. For example, one could argue that Magritte had concocted a really wonderful mirror that showed the back side of whatever is presented to it.

Much of art has been purposely designed to generate a form of creative tension in the viewer that cries out for resolution. In many forms of classic art, the artist presented social issues that embarrassed the establishment, while many contemporary artists present visual statements about art, religion, psychoanalysis, as well as social conditions. All of these are intended to motivate the thinking person to find a deeper message in the art. Although these disturbing art forms may not be as comforting as viewing a Norman Rockwell illustration, they demand active participation in the construction of "reality."

COGNITIVE DISSONANT ART—MONA REVISITED

Another example of cognitive dissonant art is shown in figure 8.7. Here Marcel Duchamp shows us his *Mona Lisa,* who, unlike da Vinci's, is sporting facial hair. The title of Duchamp's Mona Lisa is *L.H.O.O.Q.,* which, pronounced letter by letter in French, means "She's got a hot ass." (Perhaps we can now understand the meaning behind Mona's enigmatic smile.) Duchamp thought art should function as a "cerebral pistol shot," and few can deny that the frivolous *L.H.O.O.Q.* gets our attention. The viewer sees something inconsistent with his or her expectation and is prompted to resolve the dissonance. One physical manifestation of this inner reaction is the movement of our eyes. We move them so they focus on the dissonant features, gawking unabashedly at the moustache and goatee.[1]

Another variant of Mona Lisa that further illustrates visual dissonance within a social context is offered by Andy Warhol. When Leonardo painted his *Mona Lisa,* it was an original, one of a kind, and intended to be viewed as such. Many consider it to be sacred, a hallowed icon not to be defaced as the graffitist Duchamp has. But since the original painting was done, technological developments have occurred,

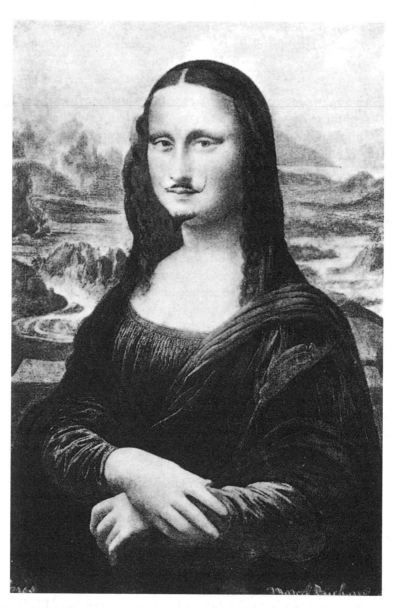

8.7 Marcel Duchamp, *L.H.O.O.Q.* (1919).

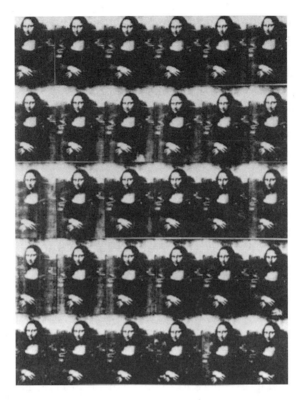

8.8 Andy Warhol, *Thirty Are Better Than One* (1963).

including photography and mass reproductive techniques, that alter the social po-
sition of the work of art. All of these techniques have made "originals" available to
a mass audience. In figure 8.8, the pop artist Warhol has taken the best-known por-
trait in the world and reproduced it 30 times, satirically calling it *Thirty Are Better
Than One*. To many, Warhol's Mona is patently offensive, a banal reproduction of
one of the world's greatest pieces of art. It is "common" and "cheap." From another
point of view, however, the viewer is forced to overcome his or her cognitive dis-
sonance and look beyond Warhol's image. The viewer might consider the context
of the twentieth century, which has trivialized the singular masterpieces of art, lit-
erature, and music through mass reproduction in which the counterfeit is usually a
degraded imitation of the original. Many of these counterfeits are junk, like the
popular kitsch art that might use the Venus de Milo as a timepiece, with a clock
embedded in her belly: a visual diet that matches the gustatory diet of the masses.

Such is the nature of the unreal world we have created. But such an interpretation requires a thinking brain filled with knowledge, not junk.

"Great" art pieces are iconically stored in the collective memory of civilization in undefiled condition. There Mona Lisa does not sport a goatee; George Washington does not have a nose ring; Tutankhamen is not shown smoking a fat cigar; Venus has no arms and the Discus Thrower no jock strap; Degas's ballerinas wear tutus and Rembrandt's portraits are overclad. Icons sometimes become idols, as we will see in the section on canonic representations.

> *You don't tug on Superman's cape.*
> *You don't spit into the wind.*
>
> —*Jim Croce*

Canonic Representations

Canonic representations of a given concept or class of things are memories that best represent that concept or class. They are "central" views, whether the view is of an object, a person, an emotion, or an idea. Canonic representations may be expressed in mental images activated when a theme or subject is mentioned. Thus, when you are asked to image a typewriter, a woman, a clock, or a book, your mental image is likely to be a central image of these objects. They may also be expressed in artistic production, as in the case of Rockwell's faces of the world (see figure 8.16).

Canonic representations are formed through experience with members of a category, called exemplars. I once asked the members of a class in the cognition of art to "draw a cup and saucer." Some of the results are shown in figure 8.9. Although this is a hodgepodge of drawings reflecting individual differences in sketching ability, the remarkable fact is that almost all students drew prototypic cups and saucers. Surely the students have seen numerous cups and saucers from all different angles, and yet they chose to draw them from a similar perspective. Why?

One explanation is that throughout one's lifetime, experiences with common objects are stored in permanent memory—not as singular instances, but as items organized around a central theme. We have all seen thousands of cups and saucers, but we have not stored all of them in memory. We have stored some; but more importantly, we have formed a generalized impression of this class of objects that serves as a type of master model to which new items may be compared. We recognize and classify a variety of disparate objects (cups and saucers) as members of a class by rapidly comparing them with an "idealized" image of the class. In reality, however, even drawing a representation of the category is an act of abstraction. Is no art realistic? We will consider that issue shortly.

8.9 Canonic representations of cups and saucers.

Subverted Canons

In the "Fur Cup" (as this *objet d'art* is affectionately known) Meret Oppenheim exhibits a version of a cup, saucer, and spoon that, to most viewers, presents an interesting psychological problem. On one hand, the cup and saucer resemble canonic forms, but on the other hand, wrapping these common objects in animal fur seems weird. Furthermore, cups are used to drink from, and the thought of a sip from this cup is most distasteful. Some critics, noting the proclivity of many surrealist artists to embrace Freudian psychoanalysis, have interpreted this work in terms of sexual symbolism, in which the spoon becomes a phallus and the cup a vagina, both covered with pubic hair libidinously linking the two. Such conjectures are left to the reader to judge. What is certain is that this object demands our attention, and one reason is because a canonic form (cup) is given new meaning through the use of conflicting contextual cues (fur).

8.10 Meret Oppenheim, *Object: Luncheon in Fur* **(1936).**

8.11 Egyptian style of representing a pond, trees, and people. (From Gombrich 1982.)

Early Canonic Views

An early canonic representation is illustrated in figure 8.11, in which an early Egyptian artist views a pond. Of particular interest in this drawing is the orientation of objects. Trees, for example, are shown as they would look as perpendicular objects viewed straight on. Egyptian artists chose to show each object from its most "natural" position and drew what they knew to be its most prominent and characteristic attribute. Perhaps this is why their paintings of people look so odd to our eyes: an arm might be shown in one perspective, the shoulders in another, and the eyes in a third.

This treatment of objects raises the interesting issue of time and art. While we have all seen the objects represented in these Egyptian drawings, we have not seen them in these orientations at the same time. In one sense, the Egyptian artist was emancipated from time constraints, and thus saw no inconsistency in showing canonic forms of different objects simultaneously. The artist drew TREE, LOTUS,

8.12 A child's canonic drawing: a town square in Connecticut drawn by a 12-year-old boy. (From Lewis 1966.)

and POND, not a tree, a lotus, and a pond—and selected the view of each that carried the central theme.

There is a remarkable parallel between these early examples of art and children's art. In figure 8.12, a 12-year-old gives his version of a town square. Never mind that this is an "unrealistic" picture (the lad had not been indoctrinated with the rules of artistic convention); the objects are shown as representing commonly seen people, buildings, and trees. These views give us insight into the artist's mind, and tell us a great deal about his or her memory for classes of objects. Our memory for common objects is based on the storage of important features of the class of objects. These frequently experienced features are restructured and stored as an abstraction that is the canonic form.

THE PICASSO CONNECTION: SEEING "EYE TO EYE" WITH THE PHARAOH

The use of different viewpoints for various canonic figures in the same painting goes back to Egyptian tomb art, but this technique reached dazzling heights during the brief period of cubism and throughout much of modern art. The uncontested master of cubism was Picasso, who drew partially recognizable features from

different views on the same canvas. He experimented with perspective, space, colors, and time in creative ways with splendid artistic skill, while collecting praise from many critics and unparalleled scorn and ridicule from others.

Picasso was influenced by Cézanne, who encouraged artists to look at nature in terms of cones, cylinders, and spheres, as he believed a painting should be organized by those "basic" forms. Picasso took the advice literally, and began to experiment with building a picture from basic forms. Within these forms, elements are added not as visual reproductions of objects, but as we might conceptualize objects. A painting of a violin or a woman should be a reflection of our brain as much as of our eye. When we conceptualize a violin or a woman, we are free to see it (her) from all different angles, to color it (her) oddly, to think of other objects, and to emphasize certain features and deemphasize others. Violins and women have more than one side.

This principle of picture construction bears a close resemblance to what has been discovered about human information processing of visual events. Our memory for a person, say a woman, is not based on a series of "cerebral snapshots" of women we have neatly filed away in memory stores, but on salient and meaningful features of women that are stored, in memory, as an abstract representation of that class. For each person, these storage systems contain some unique elements, but there are remarkable similarities between people. Your cerebralized woman and mine are not identical, but are probably very similar.

Picasso's work abounds with basic, or canonic, forms used in unusual ways. Consider how he drew body parts and faces in *Les demoiselles d'Avignon* (figure 8.13). Body parts are distorted, profile views and frontal views appear within the same figure, details are forgotten or emphasized, and features are twisted in sometimes grotesque ways. Yet there remains a theme that holds the entire picture together. These representations are similar to the way human memory functions. When we perceive objects—horses, violins, people—the features may be distorted, forgotten, or exaggerated, but our collective memory is of the most representative form, which embodies all of our impressions.

The technique of pluralistic forms of representation has precedents in the art of Africa and Egypt, although the level of refinement—both conceptually and artistically—is expressed differently. Figure 8.14 shows an African mask and the faces of two Egyptian women. Compare the mask with the woman in the upper right-hand part of *Les demoiselles d'Avignon*. Now, compare the eye of the woman on the left edge of Picasso's painting with the eyes of the Egyptian women. One explanation for the striking similarity is that Picasso was familiar with these older art techniques, especially African art, and imitated the style.[2] There is, perhaps, a deeper

8.13 Pablo Picasso, *Les demoiselles d'Avignon* (1907).

reason. Both Picasso and the African and Egyptian artists chose to represent objects not as they appear to the eye, but as they appear to the mind. And the mind is capable of plural views of things. If such a hypothesis is correct, then these art objects are means to access the minds of their creators. Insofar as we are all able to respond to them, they reveal the minds of all humans.

ART CATEGORIES

The same cerebral vehicle is used when we think of a category of art. Rococo art is characterized as highly decorative, nonfunctional, and with too much attention to fussy little details; impressionist art as displaying natural objects that are vibrant and create a mood, or "feeling"; Egyptian art as consisting of clear lines, absence of linear perspective, people drawn in profile; and so on. Even if we have not previously

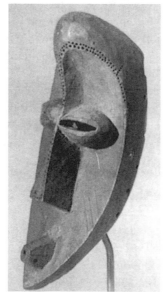

8.14 Egyptian women and African masks.

seen a particular piece of art, we can easily identify it as belonging to one of these categories or to another category stored in memory. It is unlikely that we would mistake a painting by Renoir as belonging to Egyptian or rococo art. We have formed an impression, or an idealized image, of these art types through numerous experiences with paintings that share common features of the category.

INDIVIDUAL DIFFERENCES

People differ, and individual personalities also represent a type of idealized form, much like teacups. When you characterize the personality of a close friend or a popular figure, you select the salient and more or less permanent traits of that personality. Thus, you might recall the person's commitment to a belief or attitude. It is further possible to subdivide these traits into subordinate features, such as religious beliefs that are expressed zealously, or political attitudes that are displayed in support of a particular candidate. Further subdivisions are feasible until a composite structure of the personality is attained. These personality structures are particularly relevant to our discussion of the cognition of art as they influence what we see and remember, much as James's four visitors to Europe see and remember different things.

Different styles of art affect people differently. While some prefer the near-photographic realism of modern illustrators, others choose the misty perspective of impressionist art. Still others enjoy the "unconventional" art of ancient Egypt, or the surrealist qualities of some modern artists, or the "correct" art of the Renaissance. Each style reflects the aesthetics of the artist as he or she attempts to touch the mind and soul of humanity.

Representational Art—Abstract Art

All art is representational . . . at least partly. In the case of "realistic" art, as in illustrations by Norman Rockwell, a depicted object is made nearly identical with what the eye senses. Here a pumpkin looks like a pumpkin, a man like a man, a woman like a woman, and a chair like a chair . . . almost, for even in really "realistic" art, the pumpkin, man, woman, and chair—although thoroughly recognizable—are somehow slightly "idealized" (see figure 8.16).

ROCKWELL

In figure 8.15, Rockwell shows people from various races and nationalities in quasi-photographic realism. While the folks in this painting are definitely shown as individuals, they are also drawn to be idealized representatives of categories of

8.15 Norman Rockwell, *Do unto Others* (1961). Canonic faces of people from around the world.

people (the kind psychologists call prototypes). The American working man near the center is likely a farmer (note the suntanned face and light forehead—distinctive features of farmers, who work out-of-doors and wear hats). He embodies all the conspicuous features of that group: strong, rough hands, well-worn blue shirt, tousled hair, an "honest" face, and so on. The illustration is worth study (although some art critics may dismiss such paintings as mere illustrations or "calendar art," not "serious art"),[3] and, from the perspective of a cognitive psychologist, it has much to tell. The theme in figure 8.16 is also familiar: it is the personification of home, Thanksgiving, Mom, patriotism, and "the American way"—a place, a symbol, and a sentiment that represent an idealized portrait of more abstract concepts. There is an American archetypal theme in this picture that is derived from the understanding of features. This is Rockwell at his best. He shows people as they like to be seen and as we like to see them. Even though objects and people are generally shown as they appear to the eye (the wicker chair is drawn in perfect perspective), Rockwell's things are somehow slightly better than they are in real life. The artist has taken some license with this slice of Americana and shown a hint of abstraction. He has shown us people, places, and things as we wish they appeared and has captured epitomized images—those that we all hold in our long-term memory. For these reasons the

8.16 Norman Rockwell, *Thanksgiving* **(1945).**

people are "familiar." Perhaps they are like people in our own family, or like people we know—someone who might live in our town—or someone we wish to know, or perhaps they have features of people we know.

Everyone can invent a story to go with these illustrations. Return to *Thanksgiving*. Notice the small details (Rockwell did): his shoes, their hands, how he sits on the chair, her look, their features, the perspective of the tablecloth, the wallpaper. Who are these people and what are they saying to each other? (Think about your eye movements and fixations as you consider these matters.) The storymaking of these *Saturday Evening Post* covers went on each month in many American homes for decades, and the story enhanced the picture and vice versa.

On the opposite end of the representational continuum is abstract art. All art is abstract, more or less, as was shown in the scenes by Rockwell. That is, art is not reality[4] but always a representation of something else, whether an object, a person, a feeling, or even an idea. In figures 8.18 and 8.19 we show two specimens of a more overtly abstract art. In much abstract art, no subject is identifiable or intended; it is impossible to see a person, a tree, a potato, nor are we meant to. Doing away with a tangible subject was thought by some to "free" art from earthly conventions that inhibited expression. Music provided an excellent model for many painters (Kandinsky for example) of an aesthetic expression that could be

This Is Not a Pipe

What does Magritte mean when he writes "This is not a pipe?" Of course it is! What is reality? Is this *really* a pipe? Of course not, it is a picture of a pipe. Magritte has drawn a visual "gotcha" while posing a serious question of reality.

8.17 René Magritte, *The Betrayal of Images* **(1929).**

achieved without semantic content. So too, some reasoned, a type of visual euphony could be created purely from the effects of color, lines, and shapes. Doing away with a physically recognizable subject, however, does not mean that these paintings are without a theme.

LÉGER

In the first of these works, Fernand Léger's *Woman Holding a Vase* (figure 8.18), the painting is clearly of a woman holding a vase (although we need to apply more

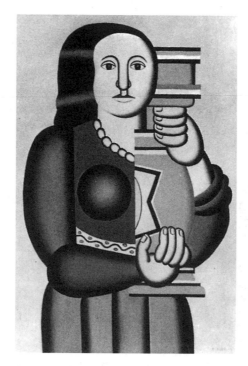

8.18 Fernand Léger, *Woman Holding a Vase* (1927).

imagination to see these things than we would had Norman Rockwell drawn them). Léger shows us but half a vase and balances it with the circular breast of the woman. The composition is far less a photographic impression than an expression of the artist's version of the essential emotive aspects of the subject. The painting is distinguished by its "chunkiness," and forms are tightly controlled within definite boundaries.

KANDINSKY

Kandinsky's *Cossacks* (figure 8.19) is more typical of abstract art, and a naive viewer would be hard pressed to make sense out of these few lines seemingly carelessly strewn across the canvas. Indeed, the artist intended to produce a type of visual music in which one senses the psychological effects of pure colors. The reds should strike the eye and brain like a piercing arrow. The artist gives us a clue to the subject in the title, *Cossacks* (sometimes called *Battle*). With this verbal label, we can

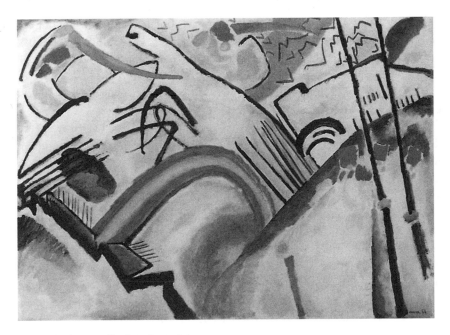

8.19 Wassily Kandinsky, *Cossacks.*

begin to make out the headgear, muskets, and movement associated with those warriors. In both of these examples of abstract art we see the application of top-down processing, in which the viewer adds his or her interpretation to what you might call an artistic Rorschach test. It is cerebral art, which means that the viewer must apply his or her intellect to appreciate it fully. These abstract works, because they require interpretation, are susceptible to misunderstanding and controversy. Yet however ambiguous they are, there remains a central theme in each. An underlying reality of womanhood or of cossacks can be found (or invented) in the mind of the beholder.

Each of the paintings in this chapter contains a central theme of some sort. Each strikes the eye and primary visual cortex of all viewers with the same likenesses, but then the cortical stream fans out in search of meaning which is supplied by human context—a context enriched by schemata provided by the painting and by the person. Psychologists have been intensely interested in the cognitive aspects of topics related to themes, including prototypes, canonic representations, proto-isomorphism, top-down processing, and representational-abstract art. In these last examples, Rockwell shows us visual prototypes of people, things, and feelings, while

the abstract artists, Léger and Kandinsky, show us conceptual prototypes of people, things, and feelings. All these examples, and any others we could have chosen, are thematically supported by concepts centered in the heart and mind of the artist which are, more or less, copied in the mind of the observer.

A Cognitive Neuroscience Theory of Aesthetics

Throughout this book, I have been searching for visual truth with one fundamental question: How are things in the physical world (such as Mona Lisa and all her friends) represented in the mind of man? I hope you are convinced by now, as I am, that the neurological processes in all humans are approximately the same; that the historical development of art and the emergence of conscious AWAREness were concurrent and interactive (with consciousness an antecedent to art); that internally represented impressions are not the same as events in the "real world"; that perception and cognition evolved for purposes of survival and procreation; that all art (as well as all perception) is distorted by the eye and brain; and that we see the world of art (and all other percepts) through individual and collective prisms which are consensually agreed to represent "truth."

Reality: Two Views
At the close of World War II Picasso is said to have been confronted by an American soldier who complained that he could not understand Picasso's paintings because everything was distorted; the eyes were displaced, the nose in an odd place, the mouth twisted beyond recognition, and so on. "And what do you think a picture should look like?" asked Picasso. The G.I. proudly whipped out his wallet and showed a tiny photograph of his girlfriend: "Like this!" Picasso studied the photograph and said, "She's kind of small, isn't she?"

The neurological trail grows cold after leaving the primary visual cortex and various "streams" that ensue. Nevertheless, it is possible to make some intelligent inferences about how the brain processes sensory information after this leaves the PVC, with the aim of proposing a (preliminary) theory of aesthetics.

It has been proposed here (and elsewhere) that the human sensory-cognitive system emerged from our blind planet as a scheme for survival. Beings might successfully adjust to a threatening and changing world if they could sense and understand menacing signals and avoid them, as well as being attracted to beneficial ones.

As we saw in chapter 1, adaptive changes in the eye and brain brought along a sense of what was important for immediate survival (central objects) and a sense of adventure, also important for long-term survival (peripheral objects). It was impor-

tant to know where water could reliably be found for immediate needs, but also important to explore new sources for future needs. These inquisitive tendencies seem to be part of the genetic makeup of man and other species and to lay the biological foundation for our attraction to representational art (see the picture of a Russian soldier in the color montage of plate 14) as well as our curiosity for abstract art (a picture of a women with nose, eye, and mouth displaced, as in Picasso's *Weeping Woman* in figure 5.4). It is suggested that the same tendencies apply to our sense of proportions, symmetry, and balance. Of course, there are many layers of socialized learning and other forces that influence our interpretation of representational and abstract art pieces, but at the core is our attraction to both central and peripheral objects.

Within that general taxonomy of central and peripheral things, another dichotomy was formed: those things to which one is attracted and those things by which one is repelled. Nuances followed shortly. We enjoy smelling a rose, but are repulsed by dung; we seek tasty dishes, but avoid spoiled food; we look at pleasing scenes and shun the unattractive. Initially, all of these reactions to environmental stimuli were in some way tied to survival needs, but gradually the stimuli acquired secondary valences. Things became "beautiful," not just "pleasing." Food became "delicious" more than simply consumable.

In art, it was possible to represent nonpresent but attractive objects symbolically, and it is no accident that the earliest recognizable forms were of vulvas, Venus figures, exaggerated busts, and animals—things men like. And even though modern imaging technology was not there to prove limbic activity, it is a fair assumption that pleasure cells in the brain got turned on when men were looking at or creating an image of a woman's sexual parts. Early art showed pleasing things.

Early men and women also discovered that art could be abstract as well as realistic. From cave drawings onward, people engaged in some form of abstract art that required the observer to supply an interpretation, some cognition, some insight to the piece. The patterns woven into baskets shows balanced symmetry *and* novelty. Although such artifacts have not survived from the Pleistocene, examples of patterned baskets and cloths may be found in Native American artifacts. These beautiful examples are basically symmetric with some creative variance. We would find complete symmetry in our lives to be boring because it does not feed the intellectual hunger for diversity, for novelty, for variety, for tinkering with the offbeat. All of these attributes you recognize as necessary features for the development of an artistic and technological world wrought by a consciously AWARE brain.

Art is far, far more complicated than this elementary interpretation, but the basic foundation of art began with a sensory–cognitive system whose function was

to survive, and creative exploration was an essential ingredient in that quest. Art, and every other human invention, were by-products of this simple necessity. If psychology adds significantly to the story, it is in terms of understanding the more nonrepresentational forms of art—those forms that are not conspicuously tied to attraction/aversion stimuli, yet have functional value in the overall search for creative solutions to everyday problems.

Humans (as well as other animals) are attracted not only to central, reinforcing stimuli that satisfy needs, but to peripheral stimuli—those things outside the norm. The animal literature is rife with studies that show the effect of central *and* outlying stimuli on behavior. Consider the case of foraging in rodents: if several food sources are available, each with unlimited supplies, animals not only feed at the nearest source but sample from all sources. Furthermore, the pattern of sampling follows a logarithmic function, with feeding maximal at the near source and then falling off as the distance increases. Although needs might be totally satiated by central supplies, wider foraging enhances survivability in the long run. In the early stages of our species, diverse sampling (as well as central consumption) insured finding resources when the main source was depleted. Similar acts of sampling extend to social behavior, including sexual diversity. Modern humans also exhibit natural tendencies for diverse sampling behavior. We return to familiar places (for recreation, for food, for entertainment), but also occasionally explore other venues. It seems that a fundamental factor in the survival formula is: Attend to focal matters, but also sample exotic things.

Our "prewiring" with such a platform generalizes to other aspects of behavior, including mundane schedules carried out in everyday acts, profound scientific plans, and the creation and enjoyment of art. While popular art is predominantly "realistic" or central (popular art includes dogs playing poker), it also includes the slightly irregular or nonrepresentational (such as abstract art).

In many cases organisms react to secondary cues with even greater enthusiasm than to the central ones. This tendency to react to generalized forms helps account for the human attraction to nonrepresentational art, which is particularly popular during the modern period. While realistic art may be comely, innovative art may be exquisite. At one time in our history, it was important to return to the bush that produced sweet berries, but it was also important to explore other similar bushes; to seek game in the reinforcing places, but to look for game in similar places—to be comforted by realism, but exhilarated by abstraction. The hunt for art is akin to the basic hunt for life inculcated into the hearts and minds of all people. Picasso didn't create it; he showed us what was inside us.

ART AND SCIENCE: TWO SIDES OF THE SAME COIN

Picasso was fond of saying that he "did not search, he found." Such a notion is compatible with the idea that artists do not invent art, but find expressions of reality that are compatible with the basic structures of the mind. We naturally understand realistic art. In this regard, there is a stunning parallel between two disparate spheres of knowledge: art and natural science. Artists do not invent art any more than physicists invent particles, or neurologists invent the brain, or psychologists invent the mind. Art, physics, physiology, and even scientific psychology are worlds waiting to be discovered by a mind. And valid discoveries (in art, science, and psychology) are those that are exquisitely calibrated to stimulate the human neural system in ways consistent with its sensory–cognitive architecture, acquired through the course of evolution. These disciplines of art and science may differ in superficial traits, but are linked together at a deeper level.

The common denominator between art and science is the degree to which expressions in each domain are compatible with the human mind. Einstein's elegant theories of the universe are true (and beautiful) to us because they are consistent with the capability of the human mind to understand such ideas; Wordsworth's poetry says exactly what we feel "inside"; Mozart's music plays sympathetic chords deeply planted in the human mind; Picasso's new techniques, juxtapositions, and perspective are beautiful (and true) to us because they harmonize with the mind: they are consistent with the capacity of the human mind to understand these visual stimuli. As scientists discover laws of the universe that are congruent with mind, artists discover visual images of the world that are harmonious with mind. Both explore the truth and beauty of the mind; at an abstract cognitive level, they are identical.

"LEVEL 3" ART

A serious theoretical issue regarding the structural properties of art and language is raised by the preceding ideas. For some time, people have conceptualized language as having (at least) two distinct levels. On the surface is the medium—the oddly shaped little letters on this page, or the sounds of a voice—and below is a "deep structure" that contains the meaning of the message.

Paintings can likewise be interpreted as having a multidimensional notation system. There are, on one hand, the surface characteristics of art: the lines, colors, contrasts, shapes, contours, and other features that make up the physical art objects. Surface characteristics, for example, may be a green expanse, partly in shadow and

partly brightly lit, occupied by small, white, four-legged shapes; or a somewhat glossy black cylindrical object that sits atop what appears to be a human head (male). Then, at the next deeper level, there is the semantic interpretation of these features: part of a pastoral scene; a stovepipe hat. Here features are combined into meaningful objects. From these objects, general categories and schemata are formed from which inferences about the art may be drawn.

There is yet a third level in this scheme of artistic expression (applicable to art, music, literature, and science), which is the most important of all (although all levels are essential and interactive). I call this level simply "Level 3." Here both the featural and semantic interpretations of an object, sound, or idea are grasped, and much more. Level 3 appreciation goes well beyond the elementary perception of features and what they mean. In some instances, Level 3 interpretation of art may be only tangentially related to featural and semantic perception. It even goes beyond what a painting infers. Kandinsky's *Cossacks* is comprised of lines, colors, contrasts, and so on: "features." We all see them. At another level, we understand that some of these lines represent cossacks who are engaged in battle: "meaning." Most of us "understand" what this painting means. Level 3 comprehension is as much a feeling as a cognition; it is the tao of the painting and yet, like the Tao (as Lao-tzu wrote), "the Tao that is the true Tao is the Tao that cannot be told." It is, at the same time, a painting's most direct meaning and its most obscure. It is being "at one" with the art; it is commingling a painting with universal properties of the mind; it is seeing one's primal mind in a painting.

It cannot be explained, but when attained cannot be confused. It is the intense wisdom of art, its captivating beauty, its penetrating philosophy. It is what makes direct contact with the biological archetypes of the old-brained creatures we all are. It is the primeval cord that binds us together and runs through all humanity. It is the invisible thread that unites me with van Gogh, Picasso, and Mondrian; and joins you with . . . ? Level 3 experiences may occur in response to all kinds of art, from prehistoric forms to Peter Max, but emerge most frequently in response to any art that stimulates responsive brain structures. It is "as if" the *painting* understood you and was reading your mind. In music, it is "as if" the music was playing you, not you playing the music. In athletics, it is "as if" the physical activity (such as a "perfect" dive or dance step) was in control of your body, not you. It is a level of cognizance that arouses profound emotions and thoughts, and yet is itself inexplicable. It touches us.

Both scientists and artists dream of elegant paradigms of the universe that are meaningful to the human mind. The "inner" world of the mind and the "outer" world of science and art are conjoined through the physical and philosophic man-

ifestations of the human mind's relentless search for truth and beauty. Science and art are products of the mind; they are of the mind and yet they also *are* the mind. On the surface, we "appreciate" art, literature, music, ideas, and science; at the core, we see our own mind unveiled in these wonderful things that touch us profoundly. The common denominator that unites all is the mind. Scientific and artistic explorations are the most intimate inquiries into the structure and operations of the mind. Art is more than paint smeared on a canvas; it is a mirror in which the human mind is reflected. Art bestows upon eyes the vision to see inward. Mondrian, like many artists and scientists, sought out basic realities of the universe. At a sufficient level of abstraction, his answers and the answers of science to universal questions are the same.

Notes

1 Art and the Rise of Consciousness

1. No less important, historically, was the very influential American school of functionalism, notably Chicago functionalism, led by James Angell (see Hilgard 1987), who proclaimed (Angell's APA Presidential address in 1906) that the mind operates to mediate between the environment and the needs of the organism. American functionalism was applied to many subfields such as child development, clinical psychology, and animal behavior, all of which reflected a psycho-Darwinian adjustment theme. Despite functionalism's promising beginnings, they were cut short by "objective" psychology as championed by behaviorists.

2. Such conjecture is purely speculative and is based on the assumption that an arrow shot into the air continues on its course. However, it does suggest that various enhanced states of consciousness might be achieved in the future, as some experimental means have already undertaken to do. Some people attempt to realize these "elevated states" through drugs, trances, and meditation. In addition, if consciousness is viewed as a variable, it is conceivable that other creatures, say those from alien civilizations, may have a type of hyperconsciousness that reveals itself in a form of total awareness of self and of others. Or perhaps a type of consciousness may have evolved that is specifically related to the range of senses detected by a creature's sensory system—much as a dog's "consciousness" might be dominated by olfactory considerations.

2 Art and Evolution

1. I have spent many enjoyable hours studying arrowheads found in Colorado, Nebraska, and other parts of the West collected by my grandfather, Dr. J. W. Pressly, Sr. These fascinating artifacts range from instruments exquisitely crafted from proper stone to crudely made rough implements obviously fashioned from the wrong kind of rock. Yet each place a shard has been chipped off has attracted my careful attention. Boswell observed in the *Life of Johnson* that "Man is a tool-making animal," and I contemplate the hand that produced these small objects. Who were you? What were your thoughts? How did you live? Die?

2. There are specialists in this sort of thing. Father Breuil, a French Catholic priest of the early twentieth century, described almost every ovoid and subtriangual form as "pudendummuliebre" or resembling the female genitalia. Others deny this interpretation to the point of prudery. Given what we know about the powerful forces of libidinous hormones coursing through young men's bodies and the images they erect therein, my interpretation clearly favors vulvas. Similar sketches used to decorate toilet walls, hidden corners of corn cribs, and grade school textbooks.

3 Art and Vision

1. This representative date is chosen because it saw Galileo's invention of the telescope.

2. Light at 325 nm is about 1,000 times more damaging to the eye than light at 589 nm (yellow). (See Werner 1998.)

4 Art and the Brain

1. The value of "intelligence" as a survival tool is in itself a terrific mystery, especially as the brain—the seat of intellect—is such a fragile, expensive, and awkward bit of survival gear. The improbability of "thinking" as a survival technique is reflected in its rarity on earth, the fact that intelligence did not emerge until the last second of life's terrestrial history, and that intelligent life may be rare to nonexistent outside of the earth.

5 About Face

1. "The Artist's Brain" was part of a larger project called "Artist's Eye Project" initiated by John Tchalenko and sponsored by the Wellcome Trust.

2. While I was traveling in the outback region of Kenya with a group of tourists, a band of Mari natives crowded around our small van. One Mari woman stood out because of what I thought was her spectacular beauty. Thinking my observations were my own, I said nothing to the others, but during dinner that night someone else remarked on the woman's beauty. Then every one of the group, who were from many different countries, confirmed my observation. This Mari woman turned on the "beauty cells" in men and women alike.

6 Illusion: Sensory, Cognitive, and Artistic

1. Without logarithmic transformation, which, in some instances, shows the relationship in linear form.

2. Instruments also suffer from a similar type of calibration problem, which instrument makers are always fretting over.

3. It is difficult to prove an argument of our inability to understand the unknown, as it assumes that the writer knows the unknowable and uses that unknowable knowledge as a basis for showing what we do not know. My logic is based on the acquisition of knowledge over the past three million years, which has been palpable. Even in the time since the ancient Greeks, technical knowledge has increased considerably. Given the past as a basis for predicting the future, I conclude that knowledge of the cosmos will continue to grow and that more of the unknown will become known. Since human cognitive abilities seem to be reasonably fixed by biological constraints and the accumulation of knowledge seems to be expansive, the "end of knowledge" may actually be an "end of the capacity for human understanding." Major questions of the universe, both physical and philosophic, still are unanswered, and, if answered, may not be understood. Such is the nature of trying to teach calculus to a dog. But then, we will never really know what we cannot know except, perhaps, by means of some type of artificial intelligence tutor who will explain it in "Dick and Jane" language. For further discussion of this topic see Solso 1996 (unfortunately the article is only available in Russian).

4. My thanks go to David R. Topper of the University of Winnipeg for pointing out this effect, as well as commenting on an earlier manuscript. See Topper (1984) for further details.

5. Poggendorff ascribes the figure to F. Zollner, a noted perceptionist known for creating many visual illusions. The illusion became know as the "Poggendorff Illusion" when so called by Boring (1942).

6. The term "first-order isomorphism" was introduced in this context by Roger Shepard.

7 Perspective: The Art of Illusion

1. A similar phenomenon can be observed if you try to touch the ends of each index finger. Try it. Now, close one eye and try it. Why is this difficult? What other cues do you use to do this successfully?

2. Try this little demonstration. Select an object for viewing. Hold up your index fingers, with one closer to your eye than the other. Close one eye. Align the object, your distant finger, your near finger, and your eye. Now, move your head to the right (or left). It appears that both fingers move, but the closer one moves farther and faster while the distant object does not appear to move at all.

3. These simulations, called "virtual reality" systems, are particularly effective in training pilots, astronauts, and the like. Even though this technology represents a significant improvement in recreating the world as it actually is, it is far from convincing. As a subject in one of these contraptions, I can say that the experience resembled "reality," but not for a moment

was I convinced that what I saw *was* "reality." Perhaps the next generation of virtual reality programs will come even closer to the real thing and spin off a new art form. It is predictable that they will find a market in arcade and home computer games. (If they become flawless, a person could, theoretically, have all the benefits of, say, an ocean voyage, a dogfight, or a hunting trip without leaving home.) Developments in this exciting new field bear watching.

4. Indeed, we often find fun in creatures visually confused. Take the cartoon world, in which a recurrent theme comes when a sympathetic character (e.g., the Roadrunner) is pursued by a "villain" (e.g., Wile E. Coyote). The pursued quickly paints a black "tunnel" on a mountainside. The pursuer, running like a flying speedball, perceives the black "tunnel" to have depth and is flattened like a pancake. The theme sometimes gets even more ridiculous when the pursuer actually enters the tunnel only to find he is in a train tunnel and a speeding locomotive is bearing down on him. "Yikes! How could that happen!" The stuff of Saturday morning in America.

8 Art and Schemata

1. There is much more to Duchamp's *L.H.O.O.Q.* than meets the eye. The art critic Robert Hughes comments that the artist "combines [Leonardo's masterpiece] with the schoolboy graffito of the moustache and goatee; but then a further level of anxiety reveals itself, since giving male attributes to the most famous and highly fetishized female portrait ever painted is also a subtler joke on Leonardo's own homosexuality (then a forbidden subject) and on Duchamp's own interest in the confusion of sexual roles" (Hughes 1980, p. 66).

2. The Picasso Museum in Paris contains a wonderful collection of African masks juxtaposed with similar Picasso paintings.

3. It may come as a surprise to many that Rockwell greatly admired Picasso. I have been unable to determine whether the respect was reciprocal.

4. For some people "art *is* the only true reality." This topic is an honorable theme for philosophic deliberation but, alas, would take us too far afield if considered here.

References

Aharon, I., Etcoff, N., Ariely, D., Chabris, C. F., O'Connor, E., and Breiter, H. C. (2001). Beautiful faces have variable reward value: fMRI and behavioral evidence. *Neuron, 32,* 537–551.

Aiello, L. (1996). Terrestriality, bipedalism and the origin of language. In J. Maynard-Smith (Ed.), *The evolution of social behavior patterns in primates and man.* London: Proceedings of the British Academy.

Aiello, L., and Dunbar, R. I. M. (1993). Neocortex size, group size and the evolution of language. *Current Anthropology, 34,* 184–193.

Allison, T., McCarthy, G., Nobre, A., Puce, A., and Belger, A. (1994). Human extrastriate visual cortex and the perception of faces, words, numbers, and colors. *Cerebral Cortex, 4,* 544–554.

Anderson, R. C., and Pichert, J. W. (1978). Recall of previously unrecallable information following a shift in perspective. *Journal of Verbal Learning and Verbal Behavior, 17,* 1–12.

Ankney, C. D. (1992). Sex differences in relative brain size. *Intelligence, 16,* 333.

Baars, B. J. (1988). *A cognitive theory of consciousness.* New York: Cambridge University Press.

Baars, B. J. (1996). *In the theater of consciousness: The workspace of the mind.* New York: Oxford University Press.

Barkow, J. H., Cosmides, L., and Tooby, J. (Eds.) (1992). *The adapted mind: Evolutionary psychology and the generation of culture.* New York: Oxford University Press.

Beal, M. K., and Solso, R. L. (1996). Schematic activation and the viewing of pictures. Paper presented at the Western Psychological Association, San Jose, April.

Bell, R. H. (1916). *The philosophy of painting.* New York: G. P. Putnam's Sons.

Birmingham, K. (1998). The science of art and *vice versa. Nature Medicine, 4,* 652.

Boring, E. G. (1942). *Sensation and perception in the history of experimental psychology.* New York: Appleton-Century-Crofts.

Burenhult, G. (1993). *The first humans: Human origins and history to 10,000 BC.* San Francisco: HarperSanFrancisco.

Chase, W. G., and Simon, H. A. (1973). Perception in chess. *Cognitive Psychology, 4,* 55–81.

Churchland, P. S., and Sejnowski, T. J. (1992). *The computational brain.* Cambridge, MA: MIT Press.

Cosmides, L., and Tooby, J. (1992). Cognitive adaptations for social exchange. In J. H. Barkow, L. Cosmides, and J. Tooby (Eds.), *The adapted mind: Evolutionary psychology and the generation of culture.* New York: Oxford University Press.

Cosmides, L., and Tooby, J. (1994). Origins of domain specificity: The evolution of functional organization. In I. A. Hirschfeld and S. A. Gelman (Eds.), *Mapping the mind: Domain specificity in cognition and culture.* Cambridge, UK: Cambridge University Press.

Cosmides, L., Tooby, J., and Barkow, J. H. (1992). Introduction: Evolutionary psychology and conceptual integration. In J. H. Barkow, L. Cosmides, and J. Tooby (Eds.), *The adapted mind: Evolutionary psychology and the generation of culture.* New York: Oxford University Press.

Crawford, M. A., Bloom, M., Broadhurst, C. L., Schmidt, W. F., Cunnane, S. C., Galli, C., Ghebremeskel, K., Linseisen, F., Lloyd-Smith, J., and Parkington, J. (1999). Evidence for the unique function of DHA during the evolution of the modern hominid brain. *Lipids, 34,* 39–47.

Crawford, M. A., Bloom, M., Cunnane, S. C., Holmsen, H., Ghebremeskel, K., Parkington, J., Schmidt, W., Sinclair, A. J., and Broadhurst, C. (2001). Docosahexaenoic acid and cerebral evolution. *World Review of Nutrition and Dietetics,* January.

Crawford, M. A., Cunnane, S. C., and Harbige, L. S. (1993). A new theory of evolution: quantum theory. In A. J. Sinclair and R. Gibson (Eds.), *Essential fatty acids and eicosanoids: Invited papers from the Third International Congress.* Champaign, IL: AOCS Press.

Crick, F. H. C., and Asanuma, C. (1986). Certain aspects of the anatomy and physiology of the cerebral cortex. In J. L. McClelland and D. E. Rumelhart (Eds.), *Parallel distributed processing: Explorations in the microstructure of cognition,* vol. 2. Cambridge, MA: MIT Press.

Darwin, C. (1871). *The descent of man and selection in relation to sex.* London: Murray.

Darwin, C. (1872). *The expression of emotion in man and animals.* London: Murray.

De Grandis, L. (1986). *Theory and use of color.* Englewood Cliffs, NJ: Prentice-Hall.

Dennett, D. C. (1991). *Consciousness explained.* Boston: Little, Brown.

Diamond, R., and Carey, S. (1986). Why faces are and are not special: An effect of expertise. *Journal of Experimental Psychology: General, 115,* 107–117.

Dominy, N. J., and Lucas, P. W. (2001). Ecological importance of trichromatic vision to primates. *Nature, 410,* 363–366.

Donald, M. (2001). *A mind so rare: The evolution of human consciousness.* New York: W. W. Norton.

Dowling, J. E., and Boycott, B. B. (1966). Organisation of the primate retina: Electron microscopy. *Proceedings of the Royal Society, Series B, 166,* 80–111.

Ekman, P. (1993). Facial expression and emotion. *American Psychologist, 48,* 384–492.

Ekman, P. (1999). Facial expressions. In T. Dalgleish and M. Power (Eds.), *Handbook of cognition and emotion.* New York: John Wiley & Sons.

Falk, D. (1990). Brain evolution in *Homo:* The "radiator" theory. *Behavioral and Brain Sciences, 13,* 344–368.

Farah, M. J. (1990). *Visual agnosia: Disorders of object recognition and what they tell us about normal vision.* Cambridge, MA: MIT Press.

Farah, M. J., Wilson, K. D., Drain, M., and Tanaka, J. N. (1995). The inverted face inversion effect in prosopagnosia: Evidence for mandatory, face-specific perceptual mechanisms. *Vision Research, 35,* 2089–2093.

Farah, M. J., Wilson, K. D., Drain, M., and Tanaka, J. N. (1998). What is "special" about face perception. *Psychological Review, 105,* 482–498.

Gardner, H. 1993. *Multiple intelligences: The theory in practice.* New York: Basic Books.

Gibson, J. J. (1950). *The perception of the visual world.* Boston: Houghton Mifflin.

Gibson, J. J. (1979). *The ecological approach to visual perception.* Boston: Houghton Mifflin.

Goldsmith, T. H. (1990). Optimization, constraint, and history in the evolution of eyes. *Quarterly Review of Biology, 65,* 281–295.

Gombrich, E. H. (1963). *Art and illusion.* Princeton, NJ: Princeton University Press.

Gombrich, E. H. (1982). *The image and the eye.* Oxford: Phaidon.

Gombrich, E. H. (1989). *The story of art.* Oxford: Phaidon Press.

Gregory, R. L. (1978). *Eye and brain: The psychology of seeing.* New York: McGraw-Hill.

Haxby, J. V., Horwitz, B., Ungerleider, L. G., Maisog, J. M., Pietrini, P., and Grady, C. L. (1994). The functional organization of human extrastriate cortex: A PET-rCBF study of selective attention to faces and locations. *Journal of Neuroscience, 14,* 6336–6353.

Haxby, J. V., Horwitz, B., Ungerleider, L. G., Maisog, J. M., Pietrini, P., and Grady, C. L. (1996). Face encoding and recognition in the human brain. *Proceedings of the National Academy of Sciences, U.S.A., 93,* 922–927.

Haxby, J. V., Ungerleider, L. G., Clark, V. P., Schouten, J. L., Hoffman, E. A., and Martin, A. (1999). The effect of face inversion on activity in human neural systems for face and object perception. *Neuron, 22,* 189–199.

Hilgard, E. R. (1987). *Psychology in America: A historical survey.* San Diego: Harcourt, Brace & Jovanovich.

Holland, D., and Quinn, N. (Eds.) (1987). *Cultural models in language and thought.* New York: Cambridge University Press.

Hubel, D. H., and Wiesel, T. N. (1963). Receptive fields of cells in the striate cortex of very young, visually inexperienced kittens. *Journal of Neurophysiology, 26,* 994–1002.

Hubel, D. H., and Wiesel, T. N. (1965). Receptive fields of single neurons in two nonstriated visual areas (18 and 19) of the cat. *Journal of Neurophysiology, 28,* 229–289.

Hughes, R. (1980). *The shock of the new.* New York: Knopf.

James, W. (1890). *Principles of psychology.* New York: Holt.

Janson, H. W. (1991). *History of art.* 4th ed. New York: Abrams.

Kanwisher, N. (2001). Faces and places: Of central (and peripheral) interest. *Nature Neuroscience, 4,* 455–456.

Kanwisher, N., McDermott, J., and Chun, M. M. (1997). The fusiform face area: A module in human extrastriate cortex specialized for face perception. *Journal of Neuroscience, 17,* 4302–4311.

Kanwisher, N., Tong, F., and Nakayama, K. (1997). The effect of face inversion on the human fusiform face area. *Cognition, 68,* B1–B11.

Karmiloff-Smith, A. (1992). Precis of "Beyond modularity: A developmental perspective on cognitive science." *Behavioral and Brain Sciences, 17,* 693–745.

Katz, R., and Dars, C. (1997). *The impressionists.* New York: Barnes & Noble.

Kendrick, K. M., and Baldwin, B. A. (1987). Cells in temporal cortex of conscious sheep can respond preferentially to the sight of faces. *Science, 236,* 448–450.

Knobler, N. (1967). *The visual dialogue.* New York: Holt, Rinehart & Winston.

Kuhn, Thomas S. 1962. *The structure of scientific revolutions.* Chicago: University of Chicago Press, 1962.

Land, M. F., and Fernald, R. D. (1992). The evolution of eyes. *Annual Review of Neuroscience, 15,* 1–29.

Lauber, P. (1998). *Painters of the caves.* Washington, DC: National Geographic Society.

Lavater, J. C. (1772). *Von der Physiognomik.* Leipzig: Weibmanns Erben und Reich.

Lewin, R. (1993). *The origin of modern humans.* New York: Scientific American Library.

Lewis, H. P. (1966). *Child art: The beginnings of self-affirmation.* Emoryville, CA: Diablo Press.

Livingstone, M., and Hubel, D. (1988). Segregation of form, color, movement, and depth: Anatomy, physiology, and perception. *Science, 240,* 740–749.

Mackay, A. L. (1991). *A dictionary of scientific quotations.* Bristol, UK: Adam Hilger.

Mithen, S. (1996). *The prehistory of the mind.* London: Thames and Hudson.

Palmer, S. E. (1999). *Vision science: Photons to phenomenology.* Cambridge, MA: MIT Press.

Perrett, D. I. (1998). Effects of sexual dimorphism on facial attractiveness. *Nature, 394,* 884–887.

Peterhans, E., and von der Heydt, R. (1989). Mechanisms of contour perception in monkey visual cortex. II. Contours bridging gaps. *Journal of Neuroscience, 9,* 1749–1763.

Peterhans, E., and von der Heydt, R. (1991). Subjective contours: Bridging the gap between psychophysics and physiology. *Trends in Neuroscience, 14,* 112–119.

Pinker, S. (1997). *How the mind works.* New York: W. W. Norton.

Polyak, S. (1957). *The vertebrate visual system.* Chicago: University of Chicago Press.

Ramachandran, V. S. (1988). Perceiving shape from shading. *Scientific American, 259,* 76–83.

Regan, B. C., Simmens, B., Vienot, F., Charles-Dominique, P., and Mollon, J. D. (2000) Fruits, foliage and the evolution of primate colour vision. *Philosophic Transactions of the Royal Society, 356,* 229–283.

Rothstein, P., Malach, R., Hadar, U., Graif, M., and Hendler, T. (2001). Feeling of features: Different sensitivity to emotion in high-order visual cortex and amygdala. *Neuron, 32,* 747–757.

Sacks, O. (1985). *The man who mistook his wife for a hat.* New York: Summit Books.

Schacter, D. L. (1989). On the relationship between memory and consciousness: Dissociable interactions and conscious experience. In H. L. Roediger III and F. I. M. Craik (Eds.), *Varieties of memory and consciousness: Essays in honor of Endel Tulving.* Hillsdale, NJ: Erlbaum.

Searle, J. R. (2000). A philosopher unriddles the puzzle of consciousness. *Cerebrum, 2,* 44–54.

Shepard, G. M. (1994). *Neurobiology.* New York: Oxford University Press.

Shepard, R. N. (1990). *Mind sights.* San Francisco: Freeman.

Solso, R. L. (1991). *Cognitive psychology.* Needham Heights, MA: Allyn and Bacon. (6th ed., 2001.)

Solso, R. L. (1994). *Cognition and the visual arts.* Cambridge, MA: MIT Press.

Solso, R. L. (1996). Psychology in the 21st century: Beyond the 6th decimal point. *Russian Journal of Psychology, 17,* 3–11.

Solso, R. L. (2000). The cognitive neuroscience of art: A preliminary fMRI observation. *Journal of Consciousness Studies, 7,* 75–85.

Solso, R. L. (2001). Brain activities in an expert versus a novice artist: An fMRI study. *Leonardo, 34,* 31–34.

Solso, R. L. (2002). Art and cognitive science. In *Encyclopedia of cognitive science.* London: Macmillan.

Solso, R. L., and McCarthy, J. (1981). Prototype formation for faces: A case of pseudo-memory. *British Journal of Psychology, 72,* 499–503.

Solso, R. L., Muskat, J., MacDonald, J., and MacLin, K. (2000). Schema activation and perception of visual scenes. Paper presented at the annual meeting of the Psychonomic Society, New Orleans, November.

Solso, R. L., and Short, B. (1979). Color recognition. *Bulletin of the Psychonomic Society, 14,* 275–277.

Tattersall, I. (2002). *The monkey in the mirror: Essays on the science of what makes us human.* New York: Harcourt.

Tong, F., Nakayama, K., Moscovitch, M., Weinrib, O., and Kanwisher, N. (2000). Response properties of the human fusiform face area. *Cognitive Neuropsychology, 17,* 257–279.

Tootell, R. B. H., Silverman, M. S., Switkes, E., and DeValois, R. L. (1982). Deoxyglucose analysis of retinotopic organization in primate striate cortex. *Science, 218,* 902–904.

Topper, D. R. (1984). The Poggendorff illusion in *Descent from the Cross* by Rubens. *Perception, 13,* 655–658.

Tyler, C. W. (1998). Painters centre one eye in portraits. *Nature, 392,* 877–878.

Tyler, C. W. (2002). Eye placement principles in portraits and figure studies over the past two millennia. CWTyler_lab. 1–9.

Von der Heydt, R., and Peterhans, E. (1989). Mechanisms of contour perception in monkey visual cortex. I. Lines of pattern discontinuity. *Journal of Neuroscience, 9,* 1731–1748.

Webster, M. A. (2002). Adaptation, high-level vision, and the phenomenology of perception. In B. E. Rogowitz and T. N. Pappas (Eds.), *Human vision and electronic imaging VII.* Proceedings of SPIE, 4662.

Webster, M. A., and MacLin, O. H. (1999). Figural after-effects in the perception of faces. *Psychonomic Bulletin and Review, 6,* 647–653.

Webster, M. A., and Mollon, J. D. (1997). Adaptation and the color statistics of natural images. *Vision Research, 37,* 3283–3298.

Webster, M. A., Wade, A., and Mollon, J. D. (1996). Color in natural images and its implications for visual adaptation. In B. E. Rogowitz and J. P. Allebach (Eds.), *Human vision and electronic imaging.* Proceedings of SPIE, 2657.

Werner, J. S. (1998). *Color vision.* New York: Walter de Gruyter.

Wilford, J. N. (2001). Artifacts in Africa suggest an earlier modern human. *New York Times,* December 2.

Wilson, E. O. (1992). *The diversity of life.* New York: W. W. Norton.

Wilson, E. O. (2002). *The future of life.* New York: Alfred A. Knopf.

Wilson, G. D., and McLaughlin, C. (2001). *The science of love.* London: Fusion Press.

Wright, L. (1983). *Perspective in perspective.* London: Routledge & Kegan Paul.

Zeki, S. (1993). *A vision of the brain.* Oxford, UK: Blackwell Scientific Publications.

Zeki, S., and Marini, I. (1998). Three cortical stages of colour processing in the human brain. *Brain, 121,* 1669–1685.

Index